Raphaelle Peale
Still Lifes

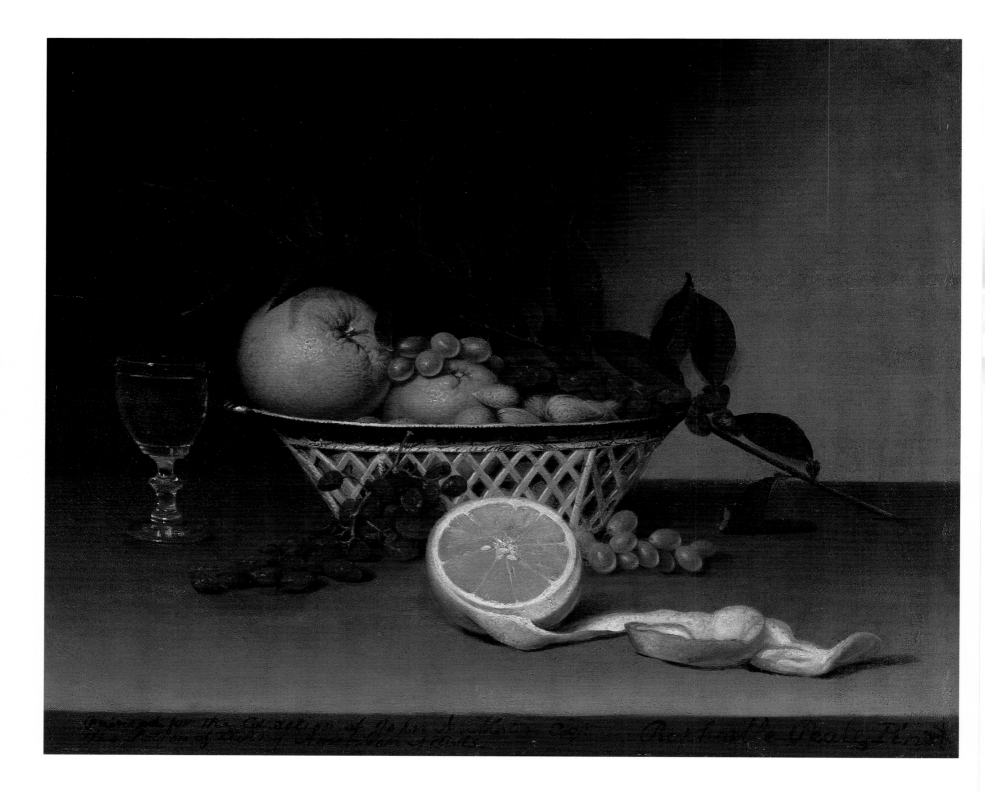

Raphaelle Peale Still Lifes

NICOLAI CIKOVSKY, JR.

with contributions by

LINDA BANTEL

JOHN WILMERDING

National Gallery of Art, Washington

Pennsylvania Academy
of the Fine Arts, Philadelphia

Distributed by
Harry N. Abrams, Inc., New York

The exhibition is made possible by a generous grant from The Pew Charitable Trusts. Additional funds to support its presentation at the National Gallery have been provided by The Circle of the National Gallery of Art

The exhibition is organized by the National Gallery of Art and the Pennsylvania Academy of the Fine Arts

Exhibition dates
National Gallery of Art, Washington
16 October 1988–29 January 1989
Pennsylvania Academy of the Fine Arts
16 February–16 April 1989

This catalogue was produced by the Editors Office, National Gallery of Art, Washington. Edited by Tam Curry. Designed by Chris Vogel
Orange peel ornaments drawn by Mark Leithauser

The type is ITC New Baskerville, set by BG Composition, Inc., Baltimore, Md.
Printed by Schneidereith & Sons, Baltimore, Md., on 80 lb. Lustro Dull text

FRONT COVER: Detail of fig. 39

BACK COVER: Detail of fig. 1

FRONTISPIECE: 1. Raphaelle Peale, *Still Life with Oranges*, c. 1818. The Toledo Museum of Art, Gift of Florence Scott Libbey

Library of Congress Cataloging-in-Publication Data

Cikovsky, Nicolai.
 Raphaelle Peale still lifes / Nicolai Cikovsky, Jr.; with contributions by Linda Bantel and John Wilmerding.
 Contents: Catalogue of an exhibition held at the National Gallery of Art, Washington. 16 Oct. 1988–29 Jan. 1989, Pennsylvania Academy of the Fine Arts, 16 Feb.–16 Apr. 1989.
 ISBN 0-89468-121-4 (pbk.)
 ISBN 0-8109-1474-3 (Abrams)
 1. Peale, Raphaelle. 1774–1825—Exhibitions.
2. Still-life painting. American—Exhibitions.
3. Still-life painting—19th century—United States—Exhibitions. I. Bantel, Linda.
II. Wilmerding, John. III. National Gallery of Art (U.S.) IV. Pennsylvania Academy of the Fine Arts.
V. Title.
ND237.P29A4 1988
759. 13—dc 19 88-28872
 CIP

The clothbound edition distributed by
Harry N. Abrams, Inc., New York
A Times Mirror Company

Contents

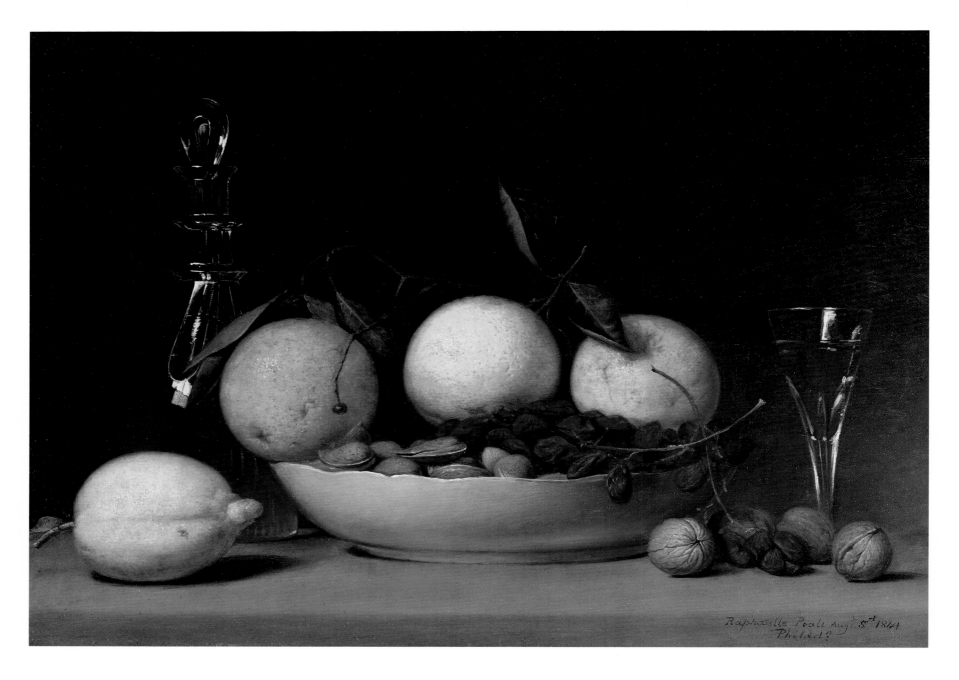

2. Raphaelle Peale, *A Dessert* [*Still Life with Lemons and Oranges*], 1814. Collection of JoAnn and Julian Ganz, Jr.

Foreword

Raphaelle peale was america's first professional still-life painter and one of the finest artists of the new nation. At the turn of the eighteenth century when Peale was active, still life was regarded as a subject of secondary artistic concern. In fact, until now Peale's pioneering achievement has been almost entirely ignored. Since Raphaelle Peale's death in 1825 there has been only one exhibition of his work, and no exhibition has been dedicated to the still lifes that were his greatest effort and most significant contributions to posterity. Today, when the still lifes of Cézanne and Van Gogh, Picasso and Matisse have been central to the accomplishments of modern painting, we can better appreciate the beginnings of conventional still-life painting in this country.

It is fitting that an exhibition that brings one of our country's important artistic talents a new measure of attention should open at the National Gallery. It is even more appropriate that the exhibition has been jointly organized with the Pennsylvania Academy of the Fine Arts in Philadelphia, since Raphaelle Peale spent most of his creative life in Philadelphia and exhibited most of his still lifes at the Academy. This book,

too, is a joint undertaking, containing contributions by Nicolai Cikovsky, Jr., the National Gallery's curator of American art, by John Wilmerding, its former deputy director and now Christopher Binyon Sarofim '86 Professor in American Art at Princeton University, and by Linda Bantel, director of the Museum at the Pennsylvania Academy.

The exhibition at the National Gallery and the Pennsylvania Academy of the Fine Arts has been generously supported by a major grant from The Pew Charitable Trusts. Additional funds to support its presentation at the National Gallery were provided by The Circle of the National Gallery of Art.

As always, we are deeply indebted to the lenders who have entrusted some of their most treasured objects to our care. Their generosity is the best measure of the value of our undertaking.

J. Carter Brown
DIRECTOR
NATIONAL GALLERY OF ART

Linda Bantel
DIRECTOR OF THE MUSEUM
PENNSYLVANIA ACADEMY OF THE FINE ARTS

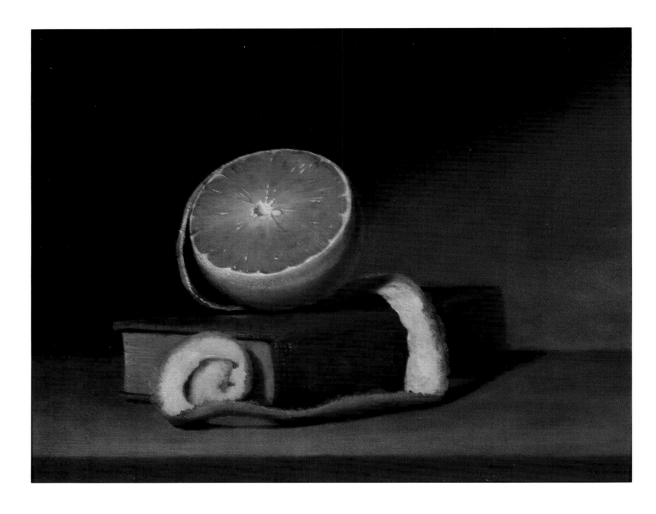

3. Raphaelle Peale, *Still Life with Orange and Book,*
c. 1815. Private collection

Preface and Acknowledgments

THIS IS THE FIRST EXHIBITION DEVOTED TO Raphaelle Peale's still lifes. It is necessarily a small exhibition, because no more than about fifty of his still lifes survive. The exhibition includes thirty-two paintings that represent, in our judgment, Raphaelle's highest achievement as a still-life painter. A small selection of paintings by Raphaelle's father, Charles Willson Peale, his uncle James, and his brother Rembrandt suggests the extent of still-life painting in the artistic enterprise of the first generations of the Peale family.

Several colleagues have been helpful in numerous ways. William H. Gerdts' work on American still-life painting is the indispensable resource for anyone working on that subject, particularly for the study of Raphaelle Peale's achievement and influence. In subsequent publications he has refined and enhanced our knowledge of Peale's work. Phoebe Lloyd has studied Raphaelle Peale with remarkable insight and surprising results and will soon publish her findings.

William Gerdts and James Maroney provided essential assistance in locating Raphaelle Peale's paintings. At the National Portrait Gallery, Lillian B. Miller, Sidney Hart, David Ward, and Rose S. Emerick of The Peale Family Papers provided unfailingly generous and expert guidance to its resources and patiently answered endless questions.

Others who have also been particularly kind and helpful are: Sona Johnston, curator of American art, The Baltimore Museum of Art; Susan Grey Detweiler, curator, The Barra Foundation; Linda S. Ferber, chief curator, and Barbara Dayer Gallati, associate curator of American painting and sculpture, The Brooklyn Museum; Nancy Rivard Shaw, curator of American art, Detroit Institute of Arts; Gunnar Dahl; Beverly Carter, administrative assistant, Paul Mellon Collection; Mr. and Mrs. Paul Mellon; John K. Howat, The Lawrence A. Fleischman Chairman of the Departments of American Art, The Metropolitan Museum of Art; Ella M. Foshay, curator, The New-York Historical Society; Gary Reynolds, curator, Newark Museum; David W. Cassedy, assistant curator, Museum Department, The Historical Society of Pennsylvania; Darrell Sewell, curator of American art, Philadelphia Museum of Art; Jefferson A. Gore, curator of fine arts, Reading Public Museum and Art Gallery; Mark A. Umbach, curator, James H. Ricau collection; Pamela Roach; Meg Perlman, curator, Mrs. John D. Rockefeller III collection;

Martin Peterson, curator of American art, San Diego Museum of Art; Robert D. Schwarz; and Anne Hyland, assistant vice president, Sotheby's.

At the National Gallery, Tam Curry edited, Chris Vogel designed, and Frances Smyth oversaw the production of the catalogue with, respectively, impeccable care, flawless taste, and wise judgment. The exhibition was installed by Gaillard Ravenel, Mark Leithauser, Gordon Anson, Barbara Keyes, and Gloria Randolph of the department of design and installation. It was, of course, done perfectly. Ira Bartfield and Barbara Bernard, in the department of photographic services, obtained and organized the many photographs that the exhibition required. In the department of exhibition programs, Sarah Tanguy and Dodge Thompson arranged and tracked the myriad details of loans, and Mary Suzor, the registrar, saw to it, as always, that the loans arrived safely and on time. Thomas McGill and Ted Dalziel were ingeniously helpful in locating library resources. Exhibition funding was arranged by Elizabeth Weil and Karen Ward in the department of corporate relations. In the department of American art, Rosemary O'Reilly handled the endless details of the exhibition and the catalogue with calm efficiency, and Michael Godfrey did the painstaking work of cleansing the texts and documents of errors.

At the Pennsylvania Academy of the Fine Arts, Robert Harmon, assistant registrar, oversaw the many details involved in bringing the exhibition to Philadelphia. James Voirol coordinated the Academy's grant requests. Inez Wolins, curator of education, prepared the Museum's public programs, and Elaine Lomenzo, director of marketing, organized local promotional efforts with energy and flair. In the office of the director of the Museum, Carolyne Hollenweger brought her usual level-headedness to bear on the entire project. Atkin-Voith Associates provided a skillful and sensitive design for the installation, and Tim Gilfillian, chief preparator, and his staff installed the exhibition with expertise and collegial spirit.

NC, Jr.

LB

4. Detail of fig. 19 (*opposite page*)

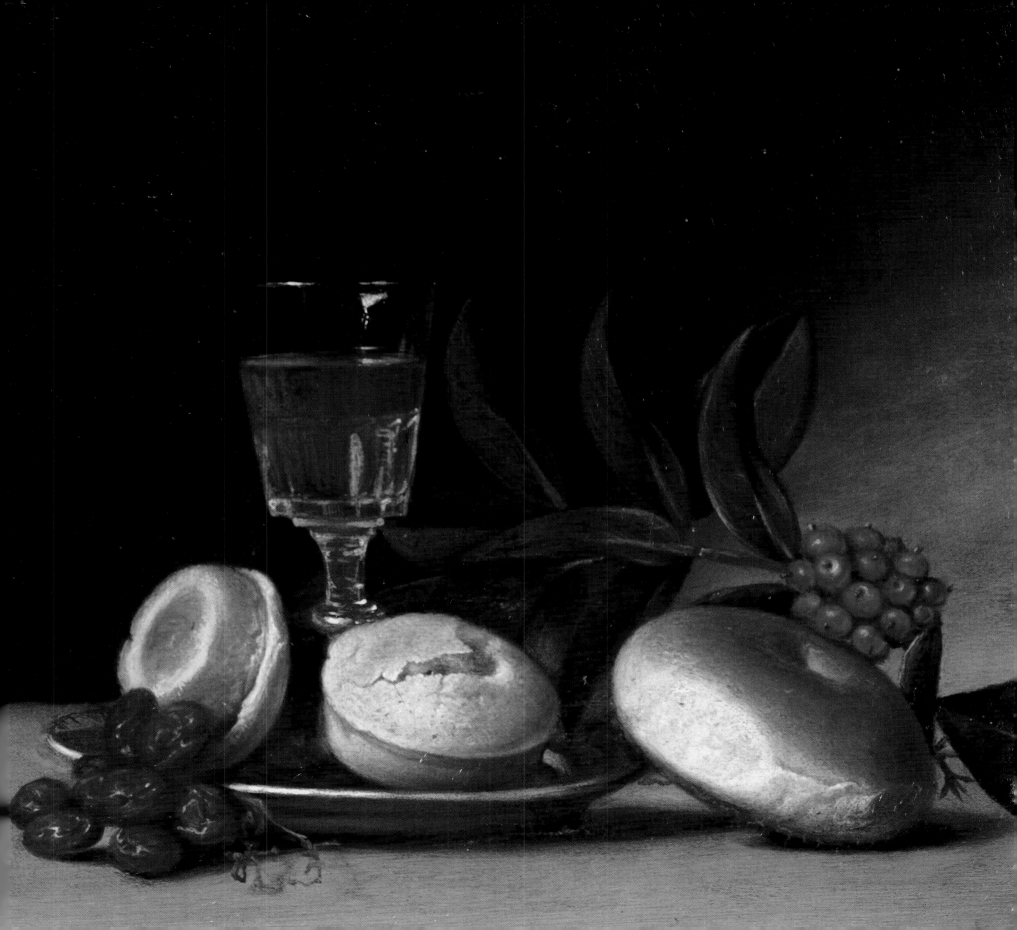

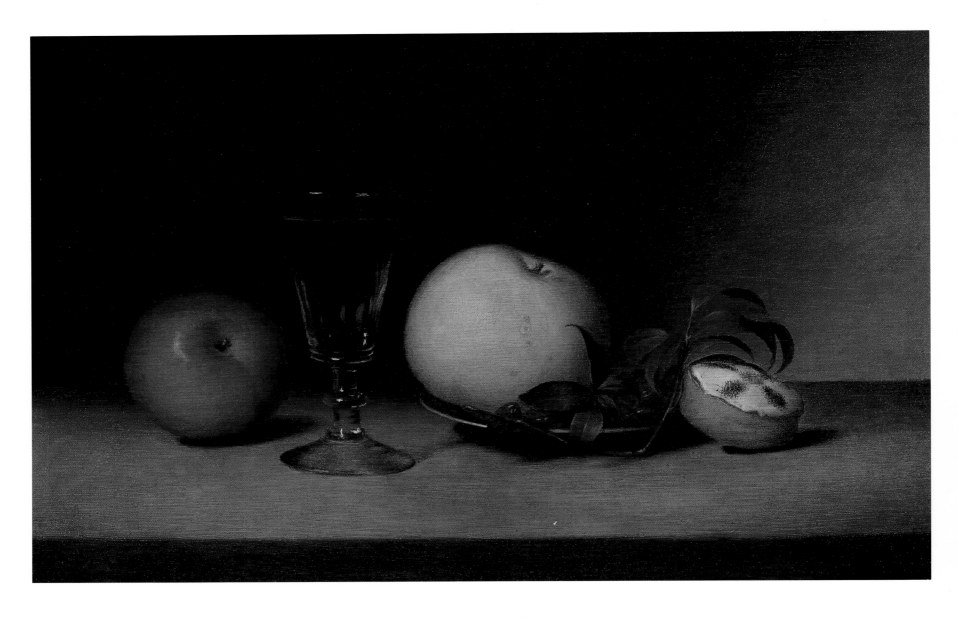

5. Raphaelle Peale, *Still Life with Apples, Sherry, and Tea Cake,* 1822. Collection of Mr. and Mrs. Paul Mellon, Upperville, Virginia

Raphaelle Peale in Philadelphia

LINDA BANTEL

WHY WOULD A PHILADELPHIA ARTIST AT THE turn of the eighteenth century devote himself almost exclusively to still-life painting? There was, after all, little financial incentive. With few exceptions, since the earliest colonial settlements in the seventeenth century, commissioned portraits were the mainstay of artists working in America. Yet Raphaelle Peale, the eldest son of Charles Willson Peale, doggedly and tragically pursued this subject in his professional painting, with no precursors and little financial remuneration. Had he lived in England or Europe, where academic dogma elevated history painting to the top of the hierarchy of subjects and relegated still-life painting to the bottom, he would surely have been scorned and his work rarely shown. But in America he exhibited frequently at the Pennsylvania Academy of the Fine Arts, received encouragement from his family, and won some critical notice.[1] Nevertheless, he was generally overlooked and underpatronized and was soon forgotten. Only within the last quarter century have scholars begun to examine his work and reevaluate his place in the history of American art and still-life painting.

Raphaelle Peale did not keep a journal, nor did he write letters obsessively, as his father and his brother Rembrandt did. Only a few documents from Raphaelle survive, and they are of little help in understanding the deeper motivations and conflicts of this troubled artist. One must therefore rely on letters and other materials written by his family to reconstruct his personal and artistic biography.

It is commonly understood that the history of still-life painting in America is inseparably linked to the history of Philadelphia and to the patriarch of the Peale clan, Charles Willson Peale. With the Enlightenment, Philadelphia experienced the popularization of science. The city had been active in world science since the mid-eighteenth century when Benjamin Franklin achieved international recognition with his discovery of electricity, identification of the electric spark and lightning, and invention of the lightning rod. In that era of professional generalists, Philadelphians excelled in engineering, agriculture, economics, electricity, medicine, and most of all botany. Indeed Philadelphia led the new nation in the study of botany, with a long list of contributions to that field. John Bartram, a talented protégé of the great linguist, classicist, and scientist James Logan, distinguished himself in botanical science. His

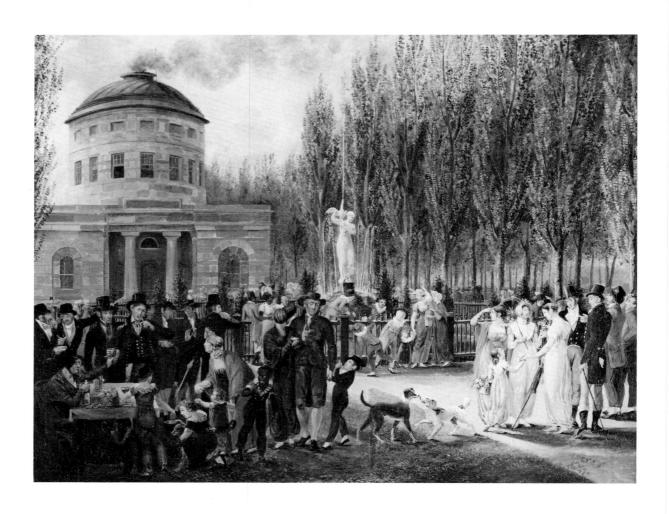

6. John Lewis Krimmel, *Fourth of July in Centre Square,* 1812. Courtesy of the Pennsylvania Academy of the Fine Arts, Philadelphia, Academy Purchase Fund

"Observations on the Inhabitants, Climate, Soil, etc. . . . [based on his] travels from Pennsylvania to Lake Ontario" was called the first scientific exploration by an American.[2] Through Logan, Bartram was introduced to the English naturalists and to Linnaeus, the Swedish botanist whose classification system is considered the foundation of modern botanical nomenclature. Bartram's son William carried on his father's work, becoming a respected botanist in his own right and, perhaps as a necessity or by-product, a creditable painter of flora and fauna. Philadelphia, also the center of publishing in America, provided a flourish-

ing market for artists who could accurately render the latest discoveries in the natural world.

Then as today, Philadelphia was a cultured city that nevertheless managed to retain a feeling of the country and of nature (fig. 6). William Penn had envisioned a "green country town," and Philadelphia was geographically well located to fulfill that ideal. It had a varied but moderate climate, protected from extremes of weather by the Appalachian Mountains. The building lots were large, and it was not uncommon for the wealthier residents to plant gardens and orchards behind their houses (fig. 7).

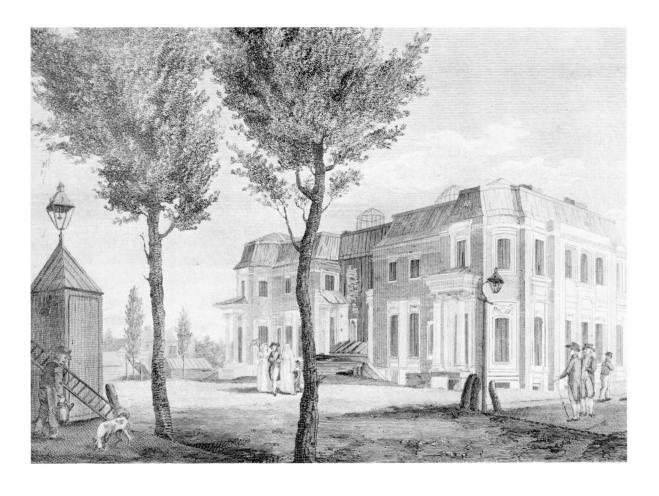

One might even find barns or stables there, with chickens, geese, or the occasional cow. And many middle-class citizens eventually were able to build more spacious homes within an hour of the city. Modeled on the English country house, these residences were also working farms, well stocked with animals and usually incorporating large flower gardens, greenhouses, and fish ponds. This tradition still defines the environs of Philadelphia today. The city's annual spring flower show is one of the largest and most notable of its kind.

This was Raphaelle Peale's milieu. His decision to pursue a career in still-life paint-ing was plausible because art patronage and exhibition possibilities existed in the city. Philadelphia was the focus not only of cul-tural and scientific activity in the newly cre-ated United States but also of politics. By 1794 it had been chosen the interim capital of the Republic, and with so many political leaders in residence, it offered ample op-portunities for accomplished portrait paint-ers. Indeed the demand was great enough to accommodate an influx of European artists as well. With a general taste for paintings thus established, it was also possible to at-tract at least a meager audience for still lifes. The same year, 1794, Charles Willson

7. William Birch, *An Unfinished House, in Chestnut Street Philadelphia*, 1800. Courtesy of the Pennsylvania Academy of the Fine Arts, Philadelphia, John S. Phillips Collection

Peale founded an institution to educate amateur and professional American artists and to sponsor exhibitions of their work. He hoped that this organization, called the Columbianum, would contribute to the cultural life of the city and the nation (Peale was also aware that the city fathers wanted to make Philadelphia as attractive as possible so that it would remain the nation's capital, for obvious political and financial reasons). In spite of Peale's leadership, however, the Columbianum faltered and dissolved after only one exhibition in 1795, principally due to disagreement among the artists over goals.

It was with the diverse Columbianum exhibition that Raphaelle Peale made his artistic debut, showing five portraits and seven still lifes, including *A Bill* and *A Deception*. For Charles Willson Peale, the exhibition provided the opportunity to promote not only Philadelphia but his sons as well. As a showcase work for the Columbianum, and perhaps on the prompting of his sons, he exhibited one of the most famous early deceptions in American art, *The Staircase Group* (see fig. 25), a life-size double portrait of twenty-one-year-old Raphaelle and his brother Titian. Raphaelle is shown ascending a stair, holding a palette in one hand and a maulstick in the other, while Titian peers around the corner from a few steps above. The "deception," or illusion, was completed by placing the painting in a door frame and adding a real step at the bottom. It was not until 1812, seven years after the founding of the Pennsylvania Academy of the Fine Arts, that Raphaelle again exhibited still lifes and attracted attention. In a review of the Academy's second annual exhibition in *The Port Folio*, George Murray particularly mentioned Raphaelle Peale's paintings, noting that whereas the color in

general "is by far too cold," a picture of bread and cheese "is certainly not inferior to many works of the Flemish School."[3]

A predilection for art and nature was imbued in all of Charles Willson Peale's progeny. The children were taught the rudiments of painting and were inculcated with their father's scientific and philosophic enthusiasms as well. After 1786 when Charles Willson opened his Philadelphia museum, the children grew up literally sharing their home with exhibits of animals, plants, and minerals. The commingling of nature and art was the essence of Peale's philosophy: eventually "nature and art" became the motto of the museum. Portraits of key figures in America's recent history—the Revolution and the founding of the nation—were hung above displays of birds, snakes, fish, panthers, opossums, insects, or other specimens acquired through gift or purchase from either the Americas or Europe (see fig. 20). The exhibits were arranged according to the most up-to-date classification system. An anonymous writer reminisced in *Poulson's American Daily Advisor* of 17 July 1828, "He had so contrived everything in his Museum with an eye to economy in space, that there appeared to be a place for everything and everything in its place, decorated and enlivened by appropriate miniature scenery of wood and wild, blended and intermingled with insect, bird and beast, all seemingly alive, but preserving at the same time, the stillness and silence of death."[4]

The influence of the museum and Charles Willson Peale on Raphaelle was considerable. In his youth Raphaelle traveled with his father on painting trips and assisted him in the museum by gathering and preserving specimens and arranging habitats. He painted the background scenes for

8. Raphaelle Peale, *Peaches and Unripe Grapes*, 1815. Kathryn and Robert Steinberg (*opposite page*)

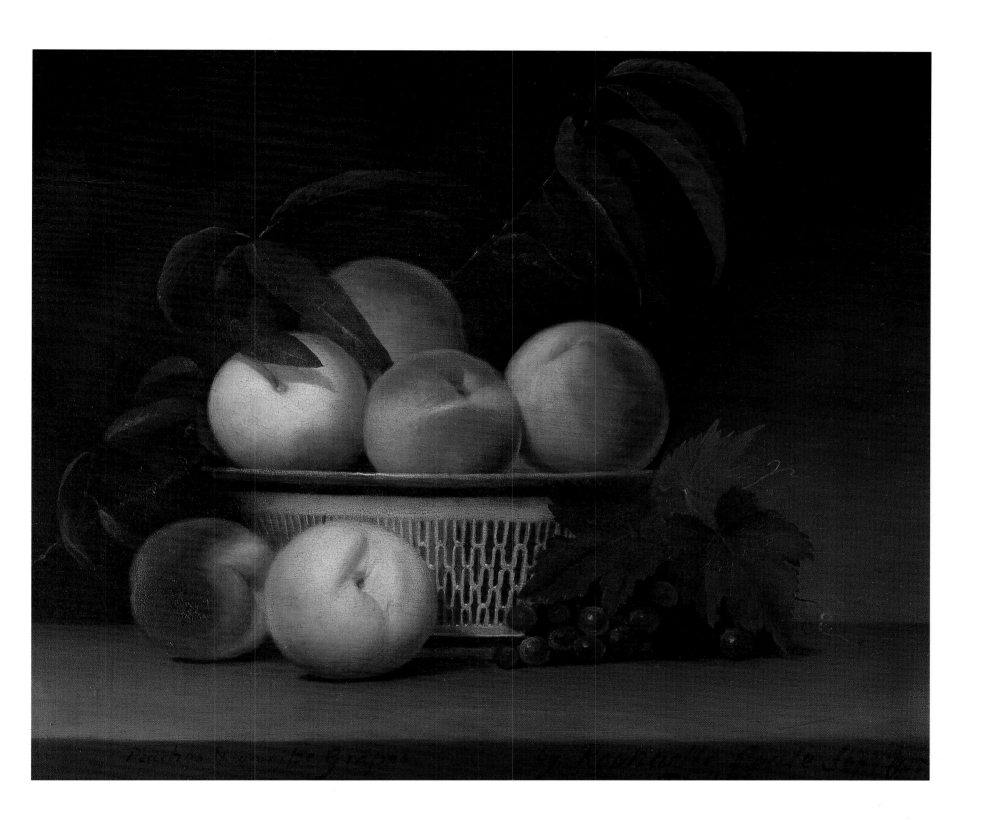

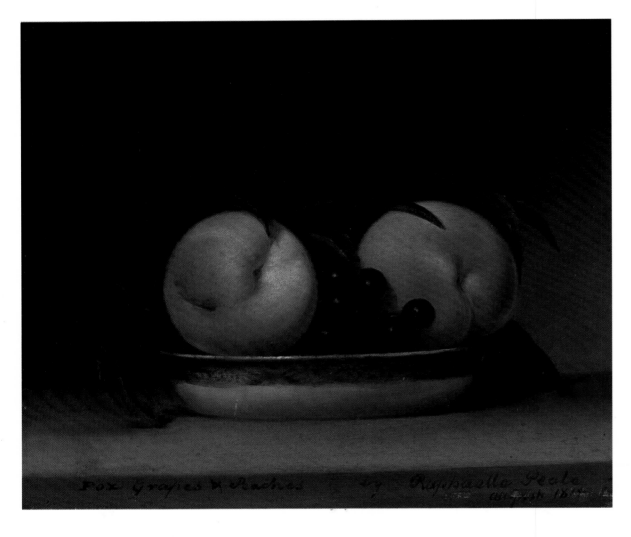

Fox Grapes & Peaches
by Raphaelle Peale

9. Raphaelle Peale, *Fox Grapes and Peaches*, 1815.
Courtesy of the Pennsylvania Academy of the Fine
Arts, Philadelphia

the habitats with leaves, foliage, or insects, reproducing the typical environment in which the animals dwelled.

Such practical experiences may account in part for the relatively large number of still lifes Raphaelle submitted to the Columbianum, particularly curious since at the time he was advertising himself as a portrait and miniature painter. These were clearly the professions Charles Willson sought for his son, not that of an "amateur" still-life painter. In 1794 Raphaelle had formed a

partnership in painting with his brother Rembrandt. At about the same time, Charles Willson Peale announced in the Philadelphia press that he was giving up his successful business of portrait painting and recommending his sons Raphaelle and Rembrandt as his successors.[5] This gesture was typical of Peale's generosity and support: eight years earlier he had turned over his miniature business to his younger brother James. Raphaelle, however, may have been trying to define a personal artistic identity, one better suited to his temperament and talents. For his part, James Peale supported Raphaelle's career in still-life painting by not exhibiting his own still lifes in competition until after Raphaelle's death.

By 1795 Raphaelle surely realized that he was being upstaged by Rembrandt in the field of portraiture. In that year Charles Willson, who recognized early on that Rembrandt would be the artistic success in the family, made great efforts to secure for the favored son the highly desirable opportunity to paint a portrait of George Washington. He was convinced that Rembrandt's future would be secured by the fame and fortune such a distinguished commission would bring in terms of future patronage and income from replicas. Raphaelle, along with his uncle James and brother Titian, joined Rembrandt and Charles Willson for a second sitting with Washington. But Raphaelle sat on the sidelines, executing a watercolor profile on paper, not a major oil. Raphaelle persevered in painting portraits throughout his short life, as any struggling artist had to do to make a living during this era, but perhaps through lack of aptitude or application, he was unable to sustain himself. As Charles Willson Peale observed,

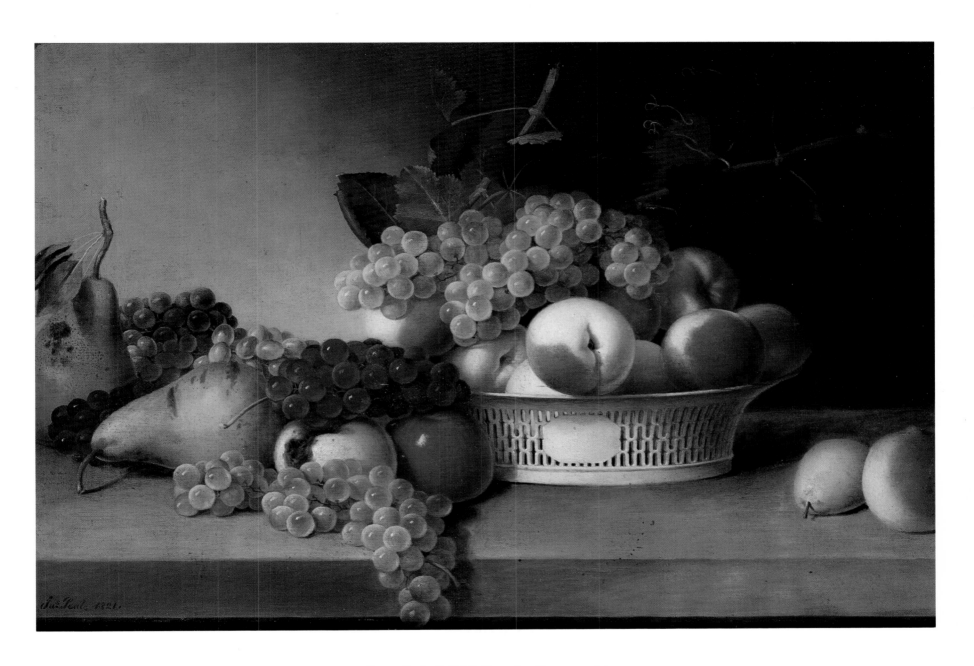

10. James Peale, *Still Life No. 2*, 1821. Courtesy of the
Pennsylvania Academy of the Fine Arts,
Philadelphia, Henry D. Gilpin Fund

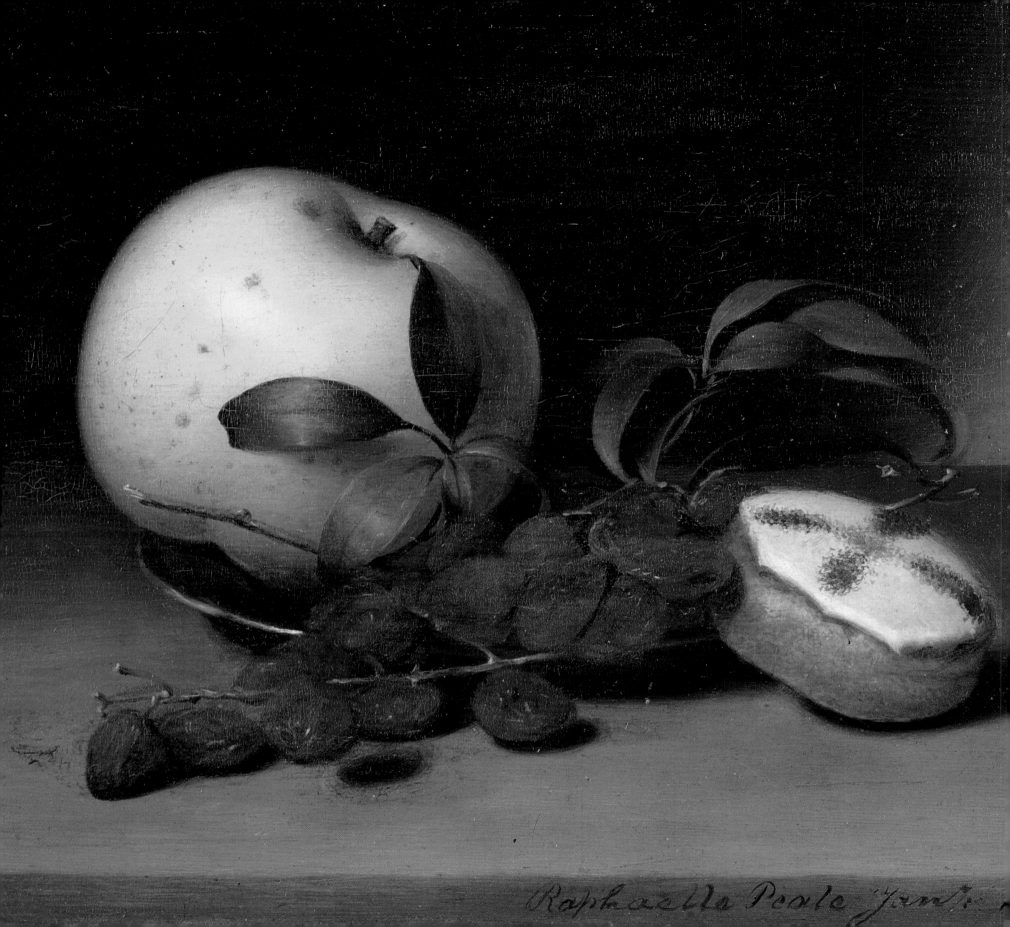

Raphaelle Peale *Janr.*

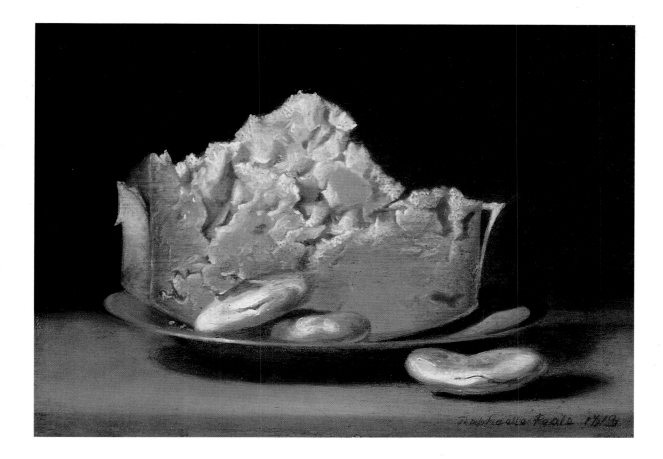

Raphaelle's portraits may have lacked the "dignity and pleasing effects" demanded by fashionable sitters.[6] In this light, it is not surprising that when the Pennsylvania Academy organized its major exhibition of Peale portraits in 1923, only Charles Willson, James, and Rembrandt were included.

During the rest of the decade Raphaelle seems to have been floundering, searching for direction. He went on a painting trip with Rembrandt to South Carolina, and after returning to Philadelphia in 1796, began to work again with his father at the museum and develop patent ideas. Charles Willson had hoped their patented fireplace, employing a damper device with a sliding shutter to conserve heat, would provide his son with some form of stable income. It did not. The following year Raphaelle was in Baltimore with Rembrandt to establish a museum modeled after their father's Philadelphia museum. There, against his father's wishes, Raphaelle married Martha (Patty) McGlathery. Their life together was fraught with anxiety and tension, and Raphaelle would often disappear for months, only occasionally communicating with the family at home. His failure to provide a dependable income was surely the source of much distress, as Patty struggled to support their brood.[7]

Raphaelle and Rembrandt seem to have had a falling out by 1800. The Baltimore venture was closed and their painting partnership dissolved so that each could pursue

12. Raphaelle Peale, *Cheese and Three Crackers*, 1813. Mrs. Frank S. Schwarz

11. Detail of fig. 69 (*opposite page*)

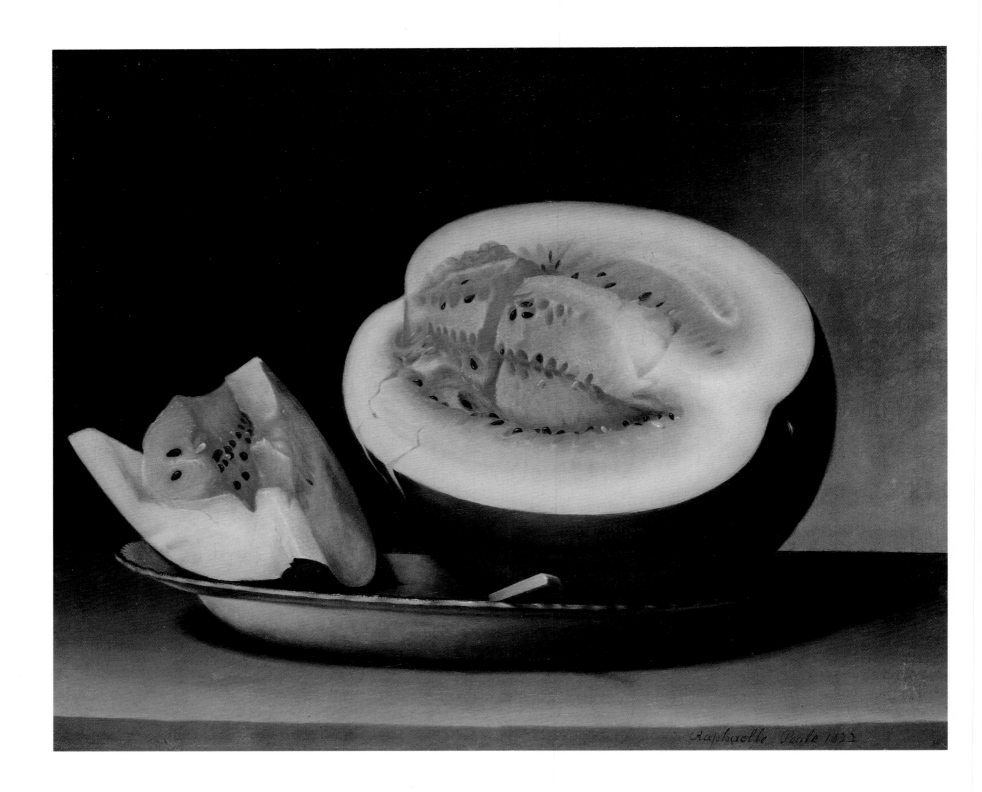

Rapshaelle Peale 1822

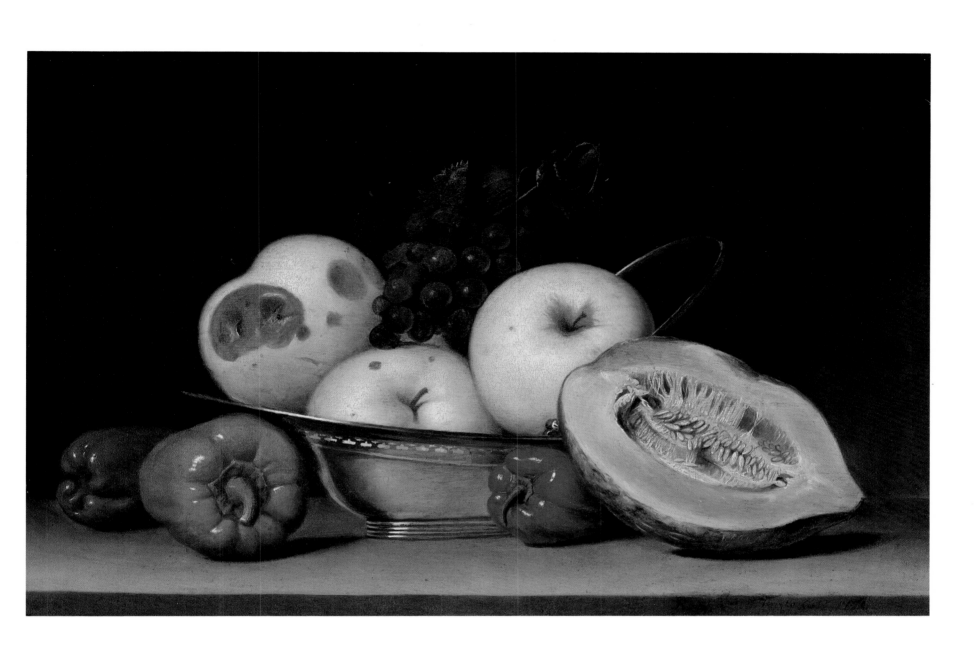

13. Raphaelle Peale, *Still Life with Watermelon*, 1822.
Museum of Fine Arts, Springfield, Massachusetts,
The James Philip Gray Collection (*opposite page*)

14. Raphaelle Peale, *Fruit and Silver Bowl*, 1814.
Private collection

his own independent career. Rembrandt, in a somewhat bitter and self-aggrandizing advertisement, dropped his surname in order to avoid further confusion between himself and his uncle, brother, or father.[8] Raphaelle, on the other hand, highlighted his full name in announcing his new status and thought the best way to gain patrons was to offer discount services:

> A NAME!
> RAPHAELLE PEALE
> To make himself eminent, will paint
> MINIATURES, for a short time, at Ten
> Dollars each—he engages to finish his
> pictures equally as well for this, as his
> former price, and invariably produces
> ASTONISHING LIKENESSES.[9]

Success continued to elude Raphaelle at the turn of the century, even as the financial burdens of a growing family escalated. Whereas Rembrandt was able to further his career and education by going to England and France on business for the Peale museum, Raphaelle never left the country; his art education depended exclusively on his father's or his uncle's instruction and what other art he might have seen in Philadelphia.[10] His career was static. He was getting no commissions. And he was becoming a drain on his father's resources, emotionally and financially. Finally in 1802 his father was able to secure from his good friend John Isaac Hawkins, an English inventor, the exclusive rights for Raphaelle to use his physiognotrace, an instrument based on a French invention of 1786, to produce silhouettes. Hawkins agreed to allow Raphaelle to use the invention in plantations and smaller towns in Virginia, and with paper cutouts in vogue at the time, Raphaelle was able to cut thousands of profiles in the first summer, clearing over $1,600. He had hoped for a

similar success in Boston, but by the time he arrived there several months later, the fad had waned and he again found himself without income. By 1809 Raphaelle's efforts to support his family (he now had six children) were further compromised by his alcoholism and gout. His wife threatened to divorce him. That summer he was committed to Pennsylvania Hospital for "delirium" and released as "cured" two weeks later.

The Pennsylvania Academy of the Fine Arts was established in 1805 (fig. 15) and soon became the preeminent institution in the country for both educating American artists and displaying their work. Rembrandt and Charles Willson Peale were instrumental in the Academy's founding, but Raphaelle was uninvolved, and in light of his peripatetic life-style and lack of self-discipline he was understandably never made an academician. When annual exhibitions were instituted in 1811, Raphaelle did respond, first with miniatures, then principally with still lifes or deceptions and only occasionally a miniature or portrait. Although his works sold poorly, they were critically well received, judging by a reviewer's comments in 1813 in *The Port Folio:*

> This [*Fruit Piece*] is a most exquisite production of art, and we sincerely congratulate the artist on the effects produced on the public mind by viewing his valuable pictures in the present exhibition. Before our annual exhibition this artist was but little known. The last year he exhibited two pictures of still life, that deservedly drew the public attention, and were highly appreciated by the best judges. We are extremely grateful to find that he has directed his talents to a branch of the arts in which he appears to be so well fitted to excel. . . . Raphael Peale has demonstrated talents so transcendant in subjects of still life, that with proper attention and encouragement, he will, in our opinion, rival the first artists, ancient or mod-

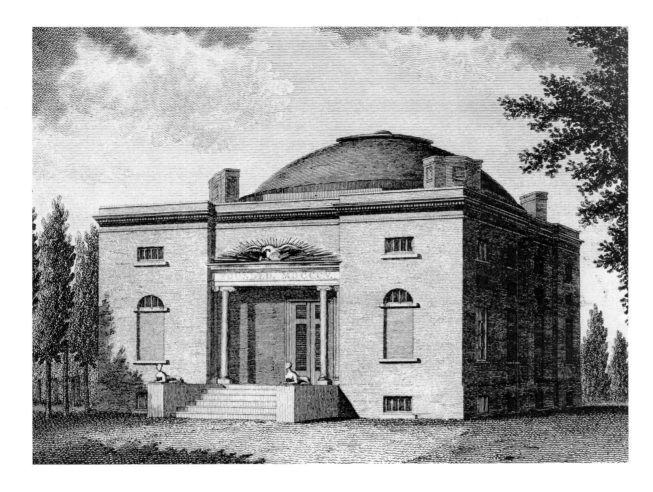

ern, in that department of painting. . . . we have seen fourteen annual exhibitions of the Royal Academy, and one of the Incorporated Society of Artists, in London; and we are bold as well as proud to say, that there were in no one of these celebrated exhibitions, so great a number of pictures on this particular branch of the arts as those now exhibited by Raphael Peale.[11]

Although Raphaelle exhibited still lifes at the Columbianum in 1795, none have been discovered that predate 1813, the second year he submitted still lifes to the Pennsylvania Academy exhibitions. With the exception of 1820 and 1821 (when he was very ill), his paintings were exhibited there every year following 1811 until his death.[12] Since

Raphaelle was unsuccessful in securing portrait commissions, this opportunity to exhibit work done independently of a patron must have encouraged his return to still life. Two other personal factors probably contributed to this choice. With both legs often severely swollen by gout, Raphaelle was not always able to undertake the travel necessary to complete portrait commissions. His excessive drinking must also have made him unreliable. Still-life painting was a more settled and solitary pursuit.

Subject matter for still lifes may also have become more abundant around 1810, for in February of that year Charles Willson Peale, at the age of sixty-nine, purchased a

15. Benjamin Tanner after J. J. Barralet, *Pennsylvania Academy of the Fine Arts* [first building], 1809. Courtesy of the Pennsylvania Academy of the Fine Arts, Philadelphia, John S. Phillips Collection

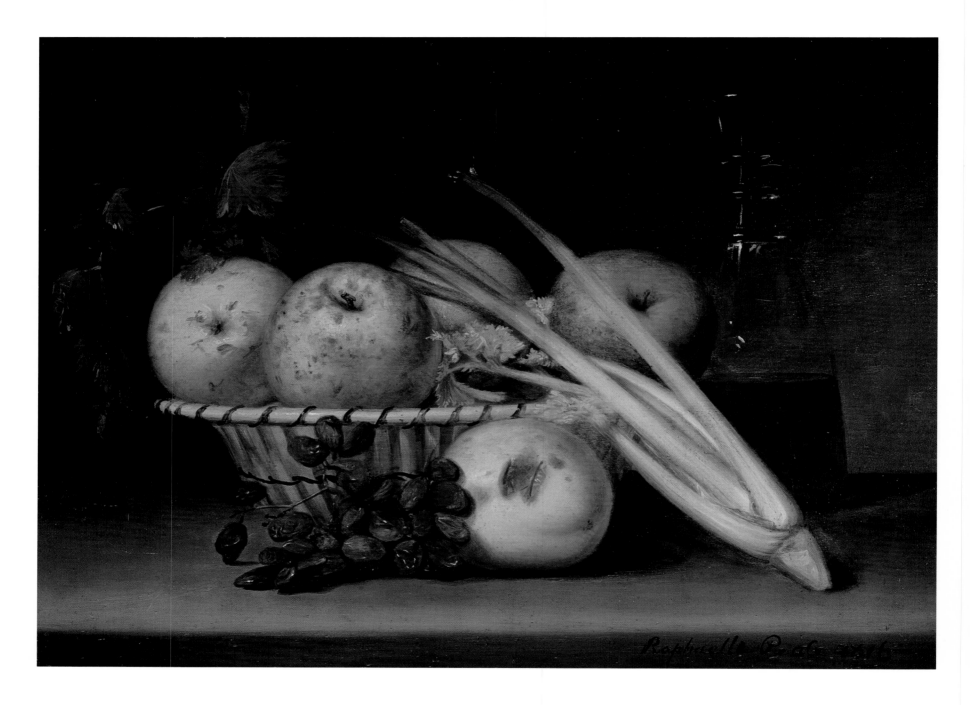

16. Raphaelle Peale, *Still Life with Celery and Wine*,
1816. Munson-Williams-Proctor Institute Museum
of Art

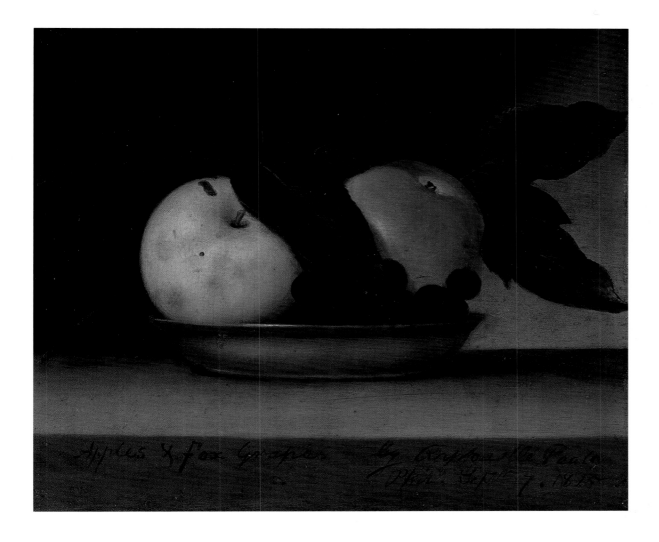

country estate six miles from Philadelphia, just outside of Germantown. Peale lived on these 104.5 acres for eleven years, his children and grandchildren frequently visiting him. He named the farm Belfield, after the estate of the painter John Hesselius, his first teacher. Fruits and vegetables were plentiful—rhubarb, apples, raspberries, strawberries, and currants (which were used to make some of the best wine in the region). Rubens Peale created a botanical garden there, adding herbs and flowers. Pigs and poultry were slaughtered for food. Eventu-

ally a fish pond was built and stocked with catfish from the Schuylkill.

From 1813 to 1821 Raphaelle Peale traveled back and forth between the south and Philadelphia. His wife was forced to take in boarders to make ends meet. His father, steeped in strict academic theory, was concerned about Raphaelle's preference for still-life painting yet recognized his talent and supported him as best he could, buying his paintings or giving him money outright. He tried to promote Raphaelle's work abroad and in September of 1815 sent sev-

17. Raphaelle Peale, *Apples and Fox Grapes,* 1815. Courtesy of the Pennsylvania Academy of the Fine Arts, Philadelphia

eral still lifes to his old teacher in London, Benjamin West, noting that Raphaelle "seem[ed] to possess considerable talent for such paintings."[13] Nothing ever came of this. In 1817, just as in 1795, he painted a portrait of Raphaelle "in the character of an artist" before a still-life painting (see fig. 23), as though to endorse Raphaelle's profession and build up his self-esteem.[14] But Charles Willson was still torn. While praising Raphaelle's still lifes, he continued to admonish his errant son to be less profligate:

> . . . if you applied [yourself] as you ought to do, you would be the first painter in America. . . . Your pictures of still-life are acknowledged to be, even by the Painters here, far exceeding all other works of that kind—and you have often heard me say that I thought with such talents of exact immitation your portraits ought also to be more excellent— My dear Raph. then why will you neglect yourself—? Why not govern every unruly Passion? why not act the *man*, and with a firm determination act according to your best judgement? Wealth, honors and happiness would then be your lot![15]

Charles Willson clearly wanted success and happiness for his son, and he knew that Raphaelle could not support himself by painting still lifes. Demand did not exist, and prices were low. Whereas Rembrandt could charge $100 for a portrait, Raphaelle would take $15 for a still life if he could get it. It was not uncommon for Raphaelle to exchange a painting for services such as carpentry or brick-laying.[16]

Raphaelle Peale died at the age of fifty-one, a young man by the standards of a family in which his father and his brothers Rembrandt and Rubens all lived into their eighties. His wit and sense of humor must have sustained him in the face of chronic illness and continual professional and personal disappointments, especially his inability to establish a lucrative profession independent of his father and attract an audience for his still lifes. Yet, ironically, it is this overindulged, firstborn son who, of all the Peale children, we now view as the significant, independent painter. Paralleling the beliefs of his father and the ordering he knew from his experience as a youth in the Peale museum, Raphaelle assumed the role of architect of nature in his still lifes, by imposing a balance, progression, relationship, symmetry, and design that conformed to his—and his family's—vision of natural harmony.

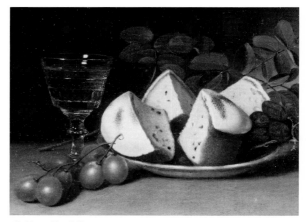

18. Detail of fig. 50

Notes

1. See Texts and Documents, documents 12, 16, and 19.
2. Theodore Thayer, "Town into City: 1746–1765," in *Philadelphia: A 300-Year History,* ed. Russell F. Weigley (New York and London, 1982), 81.
3. See document 12.
4. Quoted in Charles Coleman Sellers, *Charles Willson Peale* (New York, 1969), 263.
5. Raphaelle and Rembrandt Peale distributed a trade card in 1794 advertising their alliance. *The Papers of Charles Willson Peale and His Family,* ed. Lillian B. Miller (Millwood, N.Y., 1980, microfiche edition), series V-A/14. See also *Claypoole's American Daily Advertiser,* 24 April 1794, quoted in Sellers 1969, 262.
6. See document 20.
7. See documents 24, 41, and 48.
8. Sellers 1969, 468.
9. *The Philadelphia Gazette,* 11 September 1800, quoted in Sellers 1969, 291.
10. It is possible that Raphaelle resented Rembrandt's travel to Europe. See document 13, in which Charles Willson Peale seems to be responding to Rembrandt's intuition or suspicion that the other Peale children, especially Raphaelle, may have felt slighted.
11. See document 16.
12. See the Checklist of Contemporary Exhibitions. Since Raphaelle was often not in Philadelphia during many of these years, and was out of touch with his family if not deathly ill, it seems likely that Charles Willson Peale or other members of the Peale family, many of whom bought Raphaelle's work in order to support him, submitted his paintings to the Academy exhibitions. This may account in part for the variety of ways in which his profession was listed in exhibition records.
13. See document 20.
14. See documents 25 and 26.
15. See document 27.
16. See document 45.

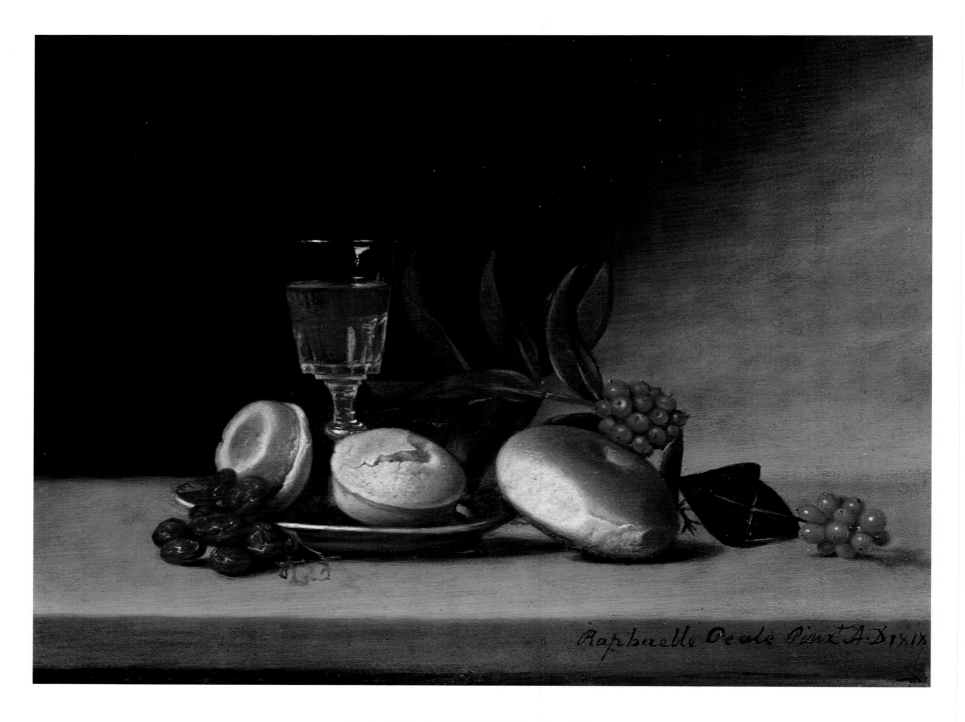

19. Raphaelle Peale, *Still Life with Wine Glass*, 1818.
Detroit Institute of Arts, Founders Society
Purchase, Laura H. Murphy Fund

Democratic Illusions

NICOLAI CIKOVSKY, JR.

THIS IS AN ESSAY—VERY MUCH AN ESSAY, teeming with supposition and suggestion— about what it meant to paint still life, and what still life might have meant, in America about 1800. Its central premise is that Raphaelle Peale's still lifes are not only precious, exquisitely delicate objects, rare and beautiful as they undoubtedly are, but paintings engaged with the artistic as well as the social, political, and economic concerns of their time. Theirs was not an ordinary time, and still life was not an ordinary subject. What in those circumstances allowed, or impelled, Raphaelle Peale to paint still lifes when (as we must remind ourselves today) still life was universally regarded as a lowly subject beneath serious artistic attention? What historical, and not solely art historical, conditions encouraged his undertaking? What theoretical and ideological resources sustained and directed it? What public conditions did it address and what private needs did it satisfy? If questions like these seem to offend the aesthetic purity or to overwhelm the humble charm of Raphaelle Peale's still lifes with excessive responsibilities of meaning and purpose, we should remember that still life, with landscape and genre, was part of that great phalanx of subjects by which, beginning

about 1800, the claims and ambitions of modern painting were carried out.

Raphaelle Peale was born in Annapolis, Maryland, on 17 February 1774, the eldest surviving son of Charles Willson Peale and his first wife, Rachel Brewer Peale. Charles Willson Peale, born in Maryland thirty-three years earlier, was a protean figure who "wished to play every part in life's drama" (as the first historian of American art, William Dunlap, put it with just a touch of amusement), and who said of himself, "like a child of Nature unrestrained, I have strayed a thousand ways, as the impulse led."[1] Raphaelle was so called, Dunlap said, from his father's "whim" of "naming his numerous family after illustrious characters of by-gone ages, particularly painters. A dangerous and sometimes ludicrous experiment. Raphael, Angelica Kauffman, Rembrandt, Rubens, and Titian, and many other great folks, were all his children."[2]

Charles Willson Peale was a man of many interests and boundless curiosity, which he indulged with indefatigable energy to the end of his long and vigorous life (he died in 1827 at the age of eighty-six, outliving Raphaelle by two years). Dunlap summarized his "trades, employments, and professions" this way: "He was a saddler;

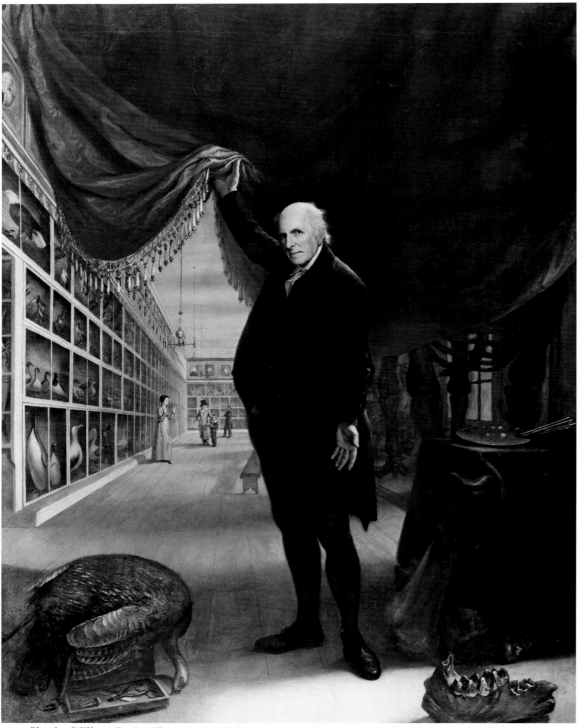

20. Charles Willson Peale, *The Artist in His Museum*, 1822. Courtesy of the Pennsylvania Academy of the Fine Arts, Philadelphia, Gift of Mrs. Sarah Harrison (The Joseph Harrison, Jr., Collection)

harness-maker; clock and watch-maker; silver-smith; painter in oil, crayons, and miniature; modeler in clay, wax, and plaister: he sawed his own ivory for his miniatures, moulded the glasses, and made the shagreen cases; he was a soldier; a legislator; a lecturer; a preserver of animals. . . ."[3] But that does not quite do him justice. As an artist Charles Willson Peale was the best portrait painter in America, particularly during the twenty-odd years between John Singleton Copley's departure for Europe in 1774 and Gilbert Stuart's return to America in 1793. He remained a painter of significant if more sporadic accomplishment virtually until his death. Much more than merely a "preserver of animals," he founded in Philadelphia America's first systematically and scientifically arranged museum of art and natural history. The large self-portrait that Peale painted in 1822 five years before his death, *The Artist in His Museum* (fig. 20), is a visual inventory of his interests and achievements, displayed with characteristically immodest self-esteem.

Charles Willson Peale had an enormous influence on his children, but the most significant and, to judge from its emotional, psychological, and possibly physical results, most damaging on his eldest, Raphaelle. Much of Raphaelle's professional life—the nature of his undertaking and the pattern of his enterprise—was decisively shaped by his father's influence. In his teens Raphaelle began working in the museum, traveling to Georgia and South America to collect specimens, and becoming an accomplished taxidermist in a method developed by his father (Raphaelle was probably correct in attributing his later illnesses to the arsenic and mercury it used as a preservative).[4] By the age of twenty Raphaelle, like his father, was a pro-

fessional painter of portraits. He also shared, sometimes as a collaborator, his father's range of scientific and mechanical interests, writing papers on stoves and fireplaces, carriage wheels, and lightning rods, patenting a process for preserving ships' bottoms and pilings from marine worms, and publishing a theory of the universe.

Raphaelle was pampered as a child,[5] but he did not have a tranquil life. Like everyone born in the last quarter of the eighteenth century, he lived in uncertain and tumultuous times of war and revolution, profound social and political change, rapidly shifting values and changing tastes. Given the name of the greatest artist of modern times, Raphaelle was freighted by his father's "whim" with an impossible standard of perfection. His marriage was unhappy and contracted against his father's wishes. He was irresponsible as a parent and chronically unsuccessful as an artist, unable by his efforts either to support his own family or to please his father—while necessity obliged him to receive his support. By his thirties his hands and legs were crippled by gout. He was so seriously ill from either chemical poisoning or alcoholism that in 1809 he was committed for "delirium." It was from their effects that he died in 1825 at the age of fifty-one.

It has been estimated that Raphaelle Peale painted as many as one hundred and fifty still lifes, of which only about fifty have survived.[6] Even if these estimates are generous, as they probably are, that is not a huge production for an artistic career of more than thirty years, especially given the modest size of his paintings. To be sure, Raphaelle Peale was not exclusively a still-life painter; he was also a portrait painter, a

miniaturist, and a cutter of silhouettes. And in the fashion of other Peales, he had many interests and undertakings outside of art. In view of his professional distractions, his domestic disarray, his physical disability, his dissipation, and his emotional disturbance and sometimes suicidal despondency,[7] however, it is remarkable not that Raphaelle Peale painted so comparatively few still lifes but that he painted as many as he did. It is even more remarkable that his still lifes are paintings of such beauty, so perfected in their form and so untroubled in their subject.

Raphaelle was professionally and personally a disappointment to his father.[8] Yet of all the Peales, he was the truest and the greatest artist. He had the finest artistic sensibility and intelligence, and despite his lack of self-confidence and ambition,[9] he was artistically the most daring. In the end his art had the most lasting influence as well.

What is most remarkable, however, is not how much or how little Raphaelle Peale painted but the kind of paintings he chose to make. In his professional debut (in the Columbianum exhibition of 1795) he already betrayed his artistic inclination. He listed himself in the exhibition catalogue as "portrait painter at the museum," but only five of the thirteen works he exhibited were portraits; the other eight were still lifes. Of the approximately one hundred works Raphaelle Peale exhibited at the Pennsylvania Academy during his lifetime, fewer than fifteen were portraits or miniatures.

We do not know why—with what purpose and by what policy—Raphaelle Peale painted still lifes. Perhaps he found the muteness of still-life objects more agreeable than vain and complaining human sitters. Perhaps he found that the control he could

exert in still life, more than in any other subject—the responsibility he alone had for its selection and arrangement and the order he could achieve by it—provided some psychological compensation for the instability and disorderliness of his real life. Perhaps he simply found painting still lifes a consoling diversion. He cannot have painted still lifes just for private diversion or psychological compensation, however. It was a purposeful, publicly significant undertaking, for it was by still life more than by portraits or any other subject that Peale represented himself, at times copiously, in professional exhibitions during his lifetime.

Raphaelle Peale knew, as did every serious artist at the turn of the century, that painting still lifes professionally rather than as an amateur pastime went against the grain of received artistic belief. It ignored or deliberately flaunted the low regard in which still life was almost universally held. Still life was assigned the lowest place in the academic classification of subject matter first promulgated in the seventeenth century and still binding, at least upon conventional artistic thought, well into the nineteenth. Its "low and confined" subject[10] lacked the human interest, moral force, and intellectual substance that, according to this ordering of subject matter, was contained in the most superior way in the depiction of heroic historical events on the models of classical antiquity.

At issue in this classification was the insignificance and inarticulateness of still-life subjects—the muteness and commonness of vegetables and fruits, fish and flesh, glasses and dishes, bowls and pots. Equally at issue, however, was the *style* of still-life painting, for still-life style was inseparable from its subject matter. In discourses delivered to the students of the English Royal Academy in the late eighteenth century, Sir Joshua Reynolds linked still-life subject and style: the "highest ambition" of the still-life painter, he said, "is to give *a minute representation* [emphasis added] of every part of those low objects which he sets before him. . . ."[11] The painter Benjamin Robert Haydon made the same connection almost forty years later: "To hear terms that would be applicable to the highest beauties of Art applied to a tame, insipid, smooth, flat, mindless imitation of carrots—Good God, is this the end of Art, is this the use of Painting?"[12]

Still life was inferior not just because of the low objects that it depicted but because of the kind and degree of imitation, of deceptive *illusion,* implicit in their depiction. In the theoretical literature that guided artistic thought and practice about 1800 nothing was censured as severely as imitation that faithfully copied particular objects—"the mere imitation of individual ordinary nature," as James Barry put it scornfully—and the kind of artist that pleased by the deceptiveness of his painted illusions—Barry's "mere sordid mechanic, divested of intellectual capacity," or John Opie's "petty kind of imitative, monkey-talent."[13]

To paint still life and to purposely practice deceptive imitation was therefore to disregard, and even openly to defy, the weight of orthodox artistic belief. It is not far-fetched to think that Raphaelle Peale did just that. His father before him had done the same. Charles Willson Peale pursued a policy so deliberately different from established artistic belief, one so specially flavored and so dynastic in its influence upon his family (his brother James, his sons Rembrandt and particularly Raphaelle), that one

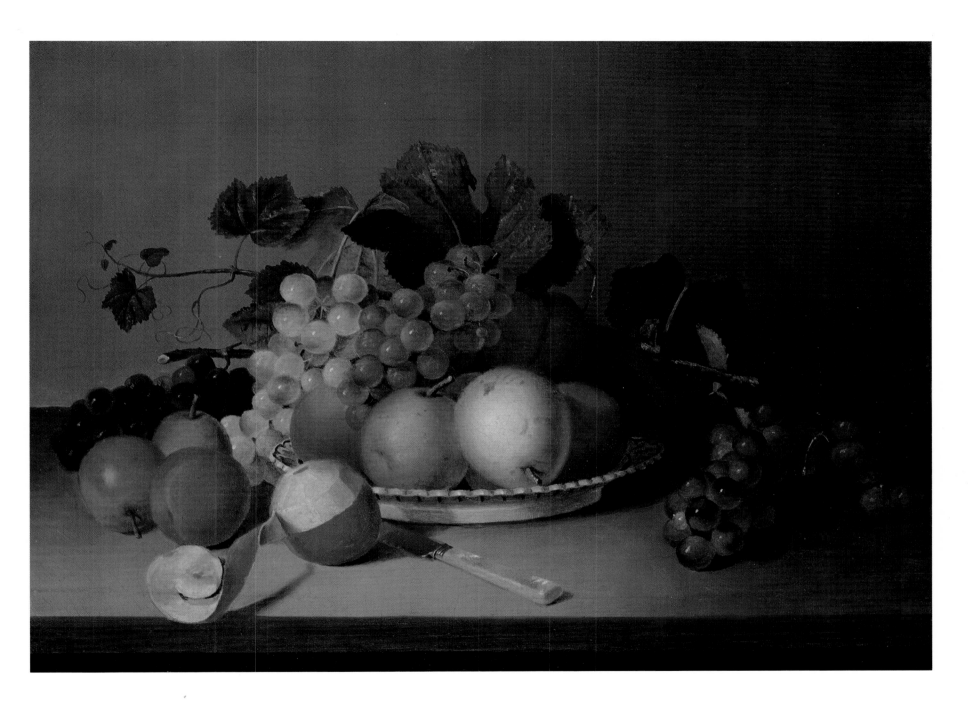

21. James Peale, *Fruit in a Basket*, 1820–1825.
Eric M. Wunsch

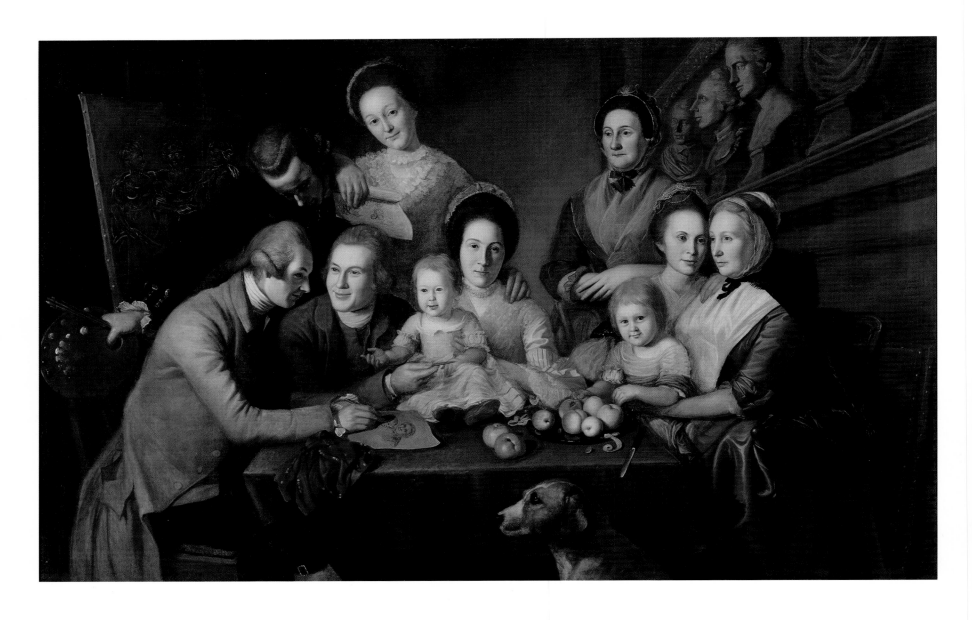

22. Charles Willson Peale, *The Peale Family*, c. 1771–
1773 and 1808. The New-York Historical Society,
New York, Bryan Collection

might almost call it Pealism. It was in his father's example, and more readily there than in any other place, that Raphaelle would have found precedents and permission for the subject of still life, and more especially for his still-life style.

In about 1772, shortly after he returned from three years of study in London with the American-born artist Benjamin West—that is, at the commencement of his professional life—Charles Willson Peale painted a group portrait of his family that included the artist himself, his two brothers, two sisters, wife and two children, mother, and the children's nurse (fig. 22).[14] Although its subject was private, it was not a private painting; on the contrary, it was executed on a public scale (on the order of five by seven feet), and during the artist's life it hung in the public space of his painting room as a specimen of his ability and as an exemplum of his ideal of artistic and domestic felicity. Prominently and almost centrally placed in this exemplary image is a still life of fruit on a plate. Fruit is a conventional symbol of fertility and fecundity, and the still life therefore pertains directly to the painting's domestic meaning.[15] But to locate still life with such prominence in a painting that systematically represents the principal mediums of art (painting, drawing, and sculpture) and its principal subjects (allegory, history, and portraiture) was to allow still life an uncustomary status in the hierarchy of art. Perhaps Peale gave it that position because, if the twisted peel can be read as a pun on the artist's name and the still life, consequently, as the painting's signature motif,[16] it had for the artist himself some special appeal.

No still lifes by Charles Willson Peale survive, unless the still life in the back-

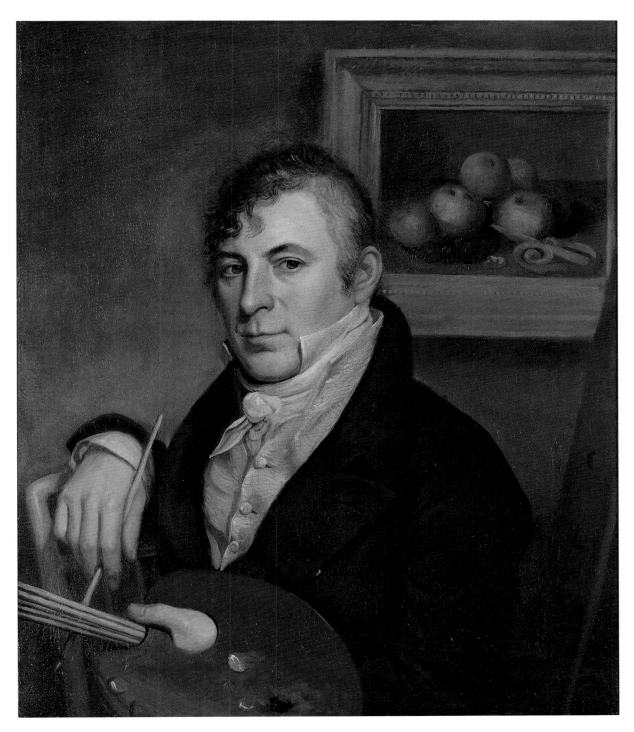

23. Charles Willson Peale, *Portrait of Raphaelle Peale*, c. 1817. Private collection

24. Charles Willson Peale, *William Smith and His Grandson*, 1788. The Virginia Museum of Fine Arts, The Robert G. Cabell III and Maude Morgan Cabell Foundation and the Glasgow Fund

ground of his portrait of Raphaelle (fig. 23) is a replica of one of his own compositions instead of one by the sitter, as is usual by the conventions of this type of portrait.[17] We do know that he painted, or thought of painting, still lifes. He remarked in letters to his daughter Angelica that in 1808 he "contemplated" painting "some pieces of deceptions of still life" for the museum and in 1815 he "painted a piece of still life, a basket of apples & pears on a round stand."[18] Whether or not he actually painted pure still lifes, the still-life elements in his portraits are never perfunctory but consistently executed with care, conspicuousness, and frequency that suggest an affection for the subject that he did not more openly indulge (see figs. 22, 24, and 57). Charles Willson's interest in still life licensed Raphaelle Peale to paint still life more tolerantly than contemporary artistic practice or theory allowed.[19] More important, his example also afforded Raphaelle a clear directive of style.

In most respects Charles Willson Peale was a creature of his time, a man who in virtually every aspect of his being and act of his life—in his moral principles, religious belief, faith in reason, and devotion to science—embodied the principles of Enlightenment thought. Yet no other artist of his generation as willfully disobeyed its ruling artistic beliefs. This was not a matter of ignorance or provincial isolation. As a pupil of Benjamin West, the one living artist who most completely translated theoretical principles into practice, Peale knew perfectly well what those beliefs were and what they required of an artist of high calling. But in 1772, a few years after his return and about the time he painted *The Peale Family*, Peale wrote his friend and patron John Beale Bordley to this effect:

What little I do is by mear immitation of what is before me. . . . A good painter of either portrait or History, must be well acquainted with the Greesian and Roman statues to be able to draw them at pleasure by memory, and to account for every beauty, must know the original cause of beauty— in all he sees—these are some of the requisites of a good painter, these are more than I shall ever have time or opportunity to know, but as I have a variety of Characters to paint I must as Rambrandt did make these my Anticks and improve myself as well as I can while I am provideing for my support.[20]

Here, at the beginning of his career, Peale dissented boldly from artistic authority. Authority held as one of its principal canons that knowledge of the sculpture of antiquity "shortened the road," as Reynolds put it, to a perception of "perfect form."[21] Peale, however, followed the example of Rembrandt in the "immitation" of more ordinary models. In doing so, he took as his artistic paradigm the chief example of artistic error. If an artist "takes individual nature just as he finds it," Reynolds said, "he is like Rembrandt," or as James Barry expressed it more pointedly, "a mere vulgar and uninteresting Dutch copyist."[22] But Peale perversely saw nothing wrong in copying ("mear immitation") or in finding his subjects in individual nature. He confided to Bordley a year or two earlier, "nature is the best Picture to Coppy, and I do not regrett the loss of the Anticks. . . ."[23]

About a decade later he proclaimed his regard for imitation emblematically, as a publicly avowed artistic principle. In the elaborate scheme of historical and allegorical subjects that Peale made as illuminated transparencies for the public celebration of the arrival of George Washington in Philadelphia in 1781 there were figurations of the arts. Painting was described this way: "Paint-

ing has a pallet and pencils in one hand, and the other supporting a picture; she has a golden chain hanging from her neck, with a medal, on which is [inscribed] IMITATION. . . ."[24] For Peale imitation was quite literally painting's defining attribute.

Imitation meant several things and took several forms for Charles Willson Peale. It meant representing the "characters" he had before him instead of modeling them on "Greesian and Roman statues." It meant a precise and finished style ("Nature is very perfect, and a Juditious Painter cannot finish too high," he noted in his copy of Pilkington's *Dictionary of Painters*[25]). But in its highest form it meant an illusion so convincingly complete that it was capable of deceiving the eye.

Peale pursued deceptive illusionism in different ways. In 1785 he held an exhibition of moving pictures inspired by the Eidophusikon ("image of nature") that Philip James de Loutherbourg staged at the Drury Lane Theater in London in the early 1780s. By using moving pictures, colored light, and sound, Peale depicted—"with *changeable* effects, imitating nature in various *movements*," as he advertised it[26]—such transient conditions and effects as dawn and nightfall, a rain storm with thunder and lightning and rainbow, fire, and rushing and falling water. A couple of years later a visitor to Peale's museum described another form of illusionism that he experienced there with startling effect: a waxwork imitation of Peale himself "so perfectly a like" that it appeared to him to be "*absolutely* alive" and indistinguishable from the original.[27]

In a more orthodox medium than moving pictures or waxwork, Charles Willson Peale made painted illusions that enacted his conviction that "illusive likeness [was

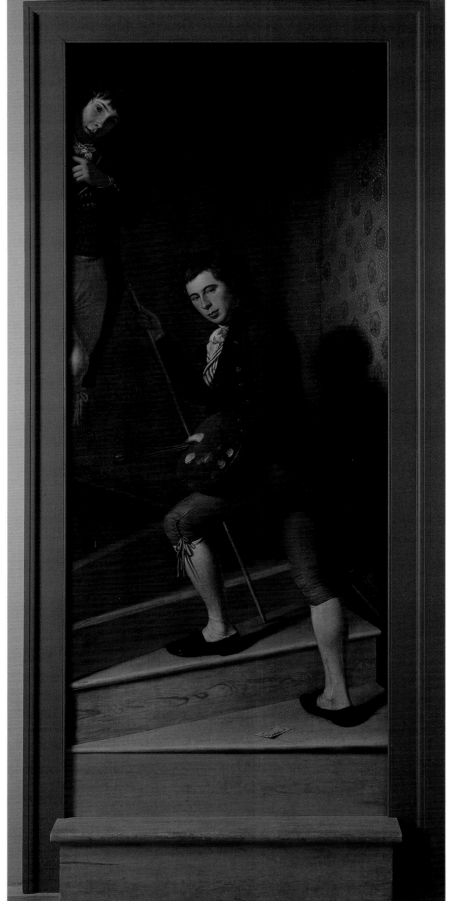

25. Charles Willson Peale, *The Staircase Group*, 1795. Philadelphia Museum of Art, The George W. Elkins Collection

the] perfection of art."[28] The most important and most convincing of these was *The Staircase Group* of 1795 (fig. 25). It depicts the full-size figures of his sons Raphaelle, climbing a flight of curving stairs and looking back into the room he has just left, and Titian, peering back at the viewer around the door frame. To make the illusion more compelling, Peale extended the painted space into literal space by setting the canvas into an actual door frame and adding a real step at the bottom.

The Staircase Group was first exhibited in the one and only exhibition of the Columbianum, or American Academy of Painting, Sculpture, Architecture, and Engraving, which opened 22 May 1795. Largely the creation of Charles Willson Peale, the Columbianum was the first serious attempt in America to establish an academy of art based on prototypes like the English Royal Academy, but with a distinctly American character, as its name declared. Its 1795 exhibition was the first public art exhibition in America, and *The Staircase Group* was painted specifically for that occasion. It served several purposes. One was to show that Peale, having devoted himself for many years to natural history, had not lost his artistic skill, his "remarkable faculty of depicting visible objects faithfully on canvas," as it was put apropos of *The Staircase Group.*[29] Another was to launch the artistic career of his son, the twenty-one-year-old Raphaelle, who was represented bodily in *The Staircase Group* and by the second largest number of paintings in the exhibition. Its higher, less self-interested purpose was to be a demonstration of the power and purpose of painting, in the first exhibition of the first American academy of art, for the benefit of the academy's clientele of students, professional

artists, discerning amateurs, and prospective patrons.

Peale may have avowed his conception of painting in such an ambitious and unambiguous way not only to offer an academic demonstration of his theory of painting but to give that theory the force of argument as well, in the public forum of the Columbianum exhibition for which his *Staircase Group* was expressly made. The theory of artistic imitation promulgated in *The Staircase Group* was, as he knew, diametrically opposed to the theory of imitation that ruled eighteenth- and early nineteenth-century artistic thought. Sir Joshua Reynolds gave the standard view of the matter with unusual eloquence:

> There are excellencies in the art of painting beyond what is commonly called the imitation of nature. . . . A mere copier of nature can never produce any thing great; can never raise and enlarge the conceptions, or warm the heart of the spectator.
>
> The wish of the genuine painter must be more extensive: instead of endeavouring to amuse mankind with the minute neatness of his imitations, he must endeavour to improve them by the grandeur of his ideas; instead of seeking praise, by deceiving the superficial sense of the spectator, he must strive for fame, by captivating the imagination.
>
> The principle now laid down, that the perfection of this art does not consist in mere imitation, is far from being new or singular. It is, indeed, supported by the general opinion of the enlightened part of mankind. The poets, orators, and rhetoricians of antiquity, are continually enforcing this position; that all the arts receive their perfection from an ideal beauty, superior to what is to be found in individual nature.[30]

Against this theory of intellectual or conceptual imitation—the imitation, that is, of an ideal and general beauty formed in the mind of the artist and addressed in turn to the ideas and imagination of the spectator—Peale argued by the fittingly visual example of *The Staircase Group* for an art of perception that convincingly described individual things and appealed directly to the perception of the beholder by the persuasiveness of their description.

The Staircase Group represented Charles Willson Peale's dissension from artistic orthodoxy in another way. "Intellectual dignity," Reynolds said, "ennobles the painter's art [and] lays the line between him and the mere mechanic."[31] The distinction between manual and intellectual effort lay strategically at the heart of painting's claim "to the name of a Liberal Art . . . ," for as Reynolds and many others believed, "the value and rank of every art is in proportion to the mental labour employed in it, or the mental pleasure produced by it. As this principle is observed or neglected, our profession becomes either a liberal art, or a mechanical trade."[32] All paintings, of course, are made "mechanically," that is, by actual manual work. But it was crucial to the argument for the nobility and liberality of painting that the stress be placed not on the sordid fact of its mechanical execution but on the ennobling "mental labour" and "intellectual dignity" of its conception. This was argued verbally in theory. It was also argued visually. Reynolds only once depicted himself in the act of painting, preferring instead to represent himself in academic, that is, intellectual, dress (fig. 26). And in John Trumbull's early self-portrait the palette and brushes that rest, untouched by the artist, on William Hogarth's *Analysis of Beauty* symbolize Trumbull's belief in the dependence of practice on theory (fig. 27). Charles Willson Peale's view of the matter was very different. In *The Staircase Group* the chief

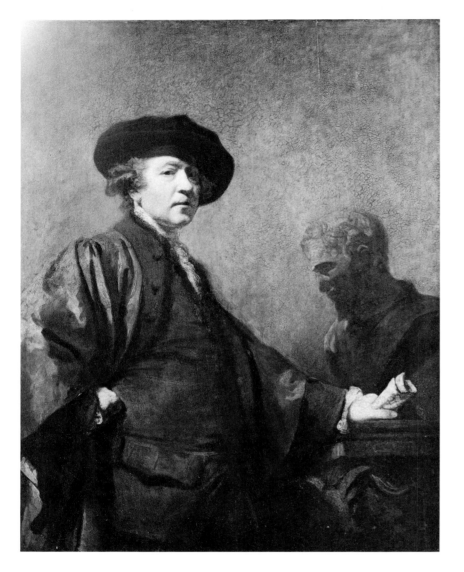

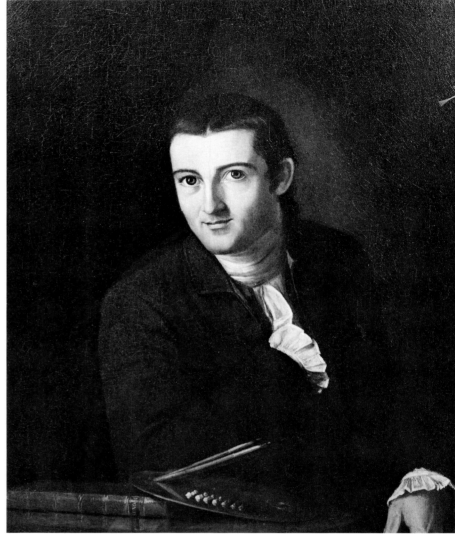

26. Sir Joshua Reynolds, *Self Portrait*, c. 1780. The Royal Academy of Arts (*left*)

27. John Trumbull, *Self Portrait*, 1777. Museum of Fine Arts, Boston, Bequest of George Nixon Black (*right*)

figure (Raphaelle Peale), equipped with palette, brushes, and maulstick, is undisguisedly a practicing ("mechanical") artist. In other artist portraits by Peale, as in his later portrait of Raphaelle (fig. 23) and his own great self-portrait (fig. 20, in which there is also an illusionistic disregard for the boundary separating real and pictorial space), the stress again is on practice.

In Charles Willson Peale's professional life, as summarized in his self-portrait, art and science were mixed.[33] Painting, zoology, and paleontology were all represented in his museum, seen in the painting's distance, and his scientific (taxidermic) instruments and painting tools are given equal symbolic weight in its foreground. But perhaps the relationship between art and science in Peale's enterprise is to be found not only in the fact that Peale

practiced both in something like equal measure, or that both occasionally intersected in such projects as the backgrounds that he painted for the habitat groups of the zoological specimens in the museum. It may also be that modern scientific method was the truest model of Peale's (modern) artistic method. The major disciplines of modern science—astronomy, physics, mechanics, chemistry, geology, geography, biology—had been wrested from textual (theoretical) authority descended from antiquity by direct, inductive knowledge and empirical observation. Peale's artistic discipline was similarly grounded, not, as he put it, in the authority of "Greesian and Roman statues," but on the "variety of Characters" he knew from his own immediate experience. Perhaps Peale dissented from classical art theory because it, like premodern science, depended largely on authority based in antiquity; and because it could not accommodate empirical observation and disdained exact description. Peale's disengagement from ruling theory—from what such theory held to be true, and even from formal theory itself—was, in other words, very like the disengagement from authority that was crucial in the development of modern scientific method, just as his own artistic method shared in its essential premise the empiricism of modern science.

Peale said of his artistic method, "what little I do is by mear immitation of what is before me," as if he practiced the exact description of experience instead of something better. But just as empirical observation and the exact description of its results were fundamental procedures of modern scientific method (particularly in the natural sciences, which most interested Peale), so too they were part of modern ar-

tistic method. What the most openly revisionary and innovatory—that is to say, most modern—critiques of classical theory, such as those by William Blake and William Hazlitt, condemned in the strongest language was its devaluation of imitation. They focused on Reynolds' *Discourses*—"considered as a text-book on the subject of art," Hazlitt said in 1814[34]—and in particular, on Reynolds' theory of imitation. Reynolds believed that art should imitate general nature, "the idea of that central [ideal] form . . . from which every deviation is deformity."[35] About 1808, in his annotations to the *Discourses*, Blake wrote without mincing words, "To Generalize is to be an Idiot. To Particularize is the Alone Distinction of Merit. General Knowledges are those Knowledges that Idiots possess."[36] Hazlitt also took issue with what he considered Reynolds' belief "that the whole of art consists in *not* imitating individual nature." For Hazlitt, "The concrete, not the abstract, is the object of painting," because "it is not very conceivable how, without the power of copying nature as it is, there should be the power of copying it as it ought to be."[37] That Reynolds' notion of General Nature today seems as chimerical and unworkably theoretical (Hazlitt called it "metaphysical") as it seemed to Blake and Hazlitt at the beginning of the nineteenth century is a measure of how much their belief in the representation of the particular and concrete came to shape modern artistic thought.

It was Charles Willson Peale's method, too, and the chief artistic legacy to his children.

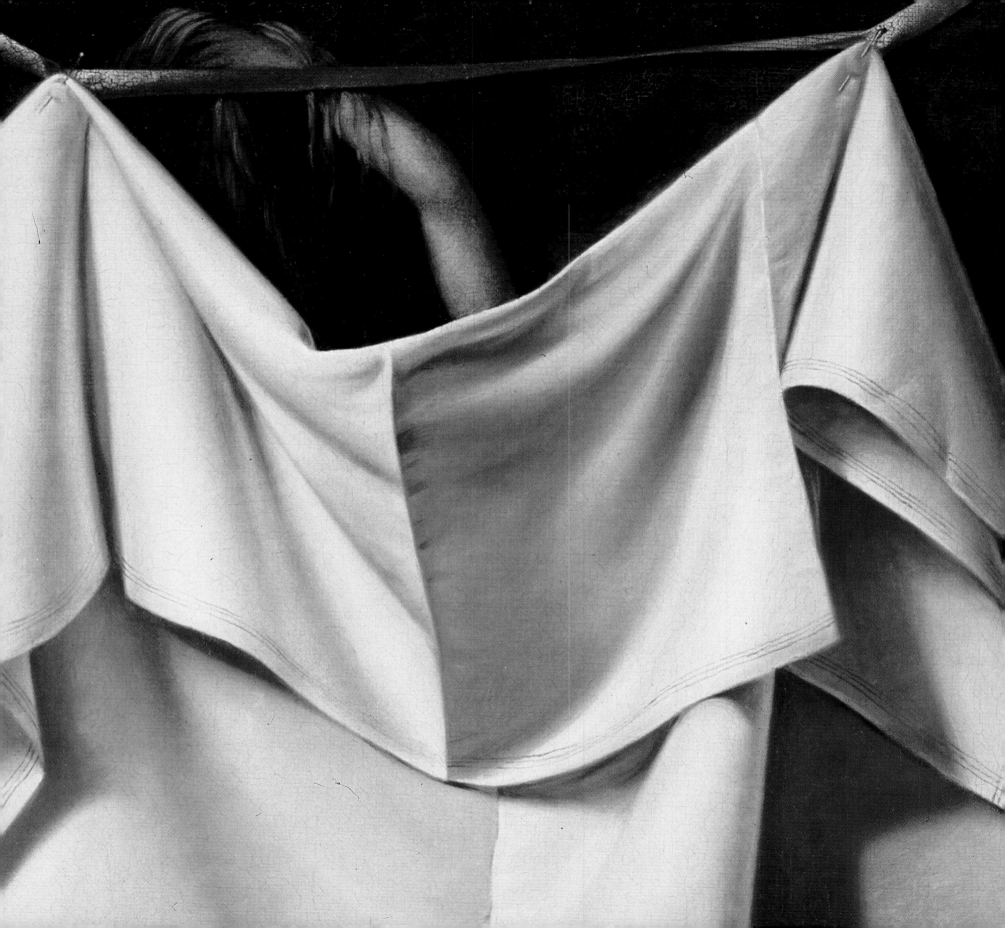

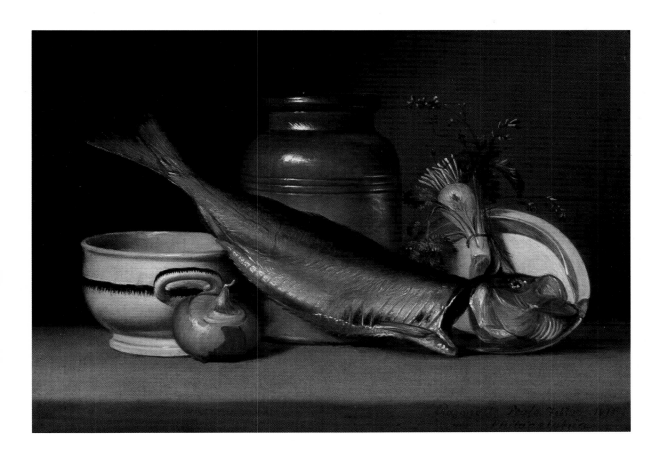

THE ONLY NOTICE TAKEN OF RAPHAELLE
Peale in the first history of American art,
William Dunlap's *History of the Rise and
Progress of the Arts of Design in the United
States,* published in 1834, was a short com-
ment by his brother Rembrandt: "Raphael
was a painter of portraits in oil and minia-
ture, but excelled more in compositions of
still life. He may perhaps be considered the
first in point of time who adopted this
branch of painting in America. . . ."[38] De-

spite its brevity, it makes the very consid-
erable claim that Raphaelle Peale was
America's first still-life painter. As far as we
can tell, that was true; Raphaelle Peale *was*
the first professionally committed still-life
painter in America. What is more, as Rem-
brandt could not see in the 1830s, Raphaelle
was not an isolated phenomenon but the fa-
ther of a long tradition of still-life painting
in America. It was from him, though it is not
certain by exactly what genealogical path,

29. Raphaelle Peale, *Still Life with Dried Fish
[A Herring]*, 1815. The Historical Society of
Pennsylvania

28. Detail of fig. 37 (*opposite page*)

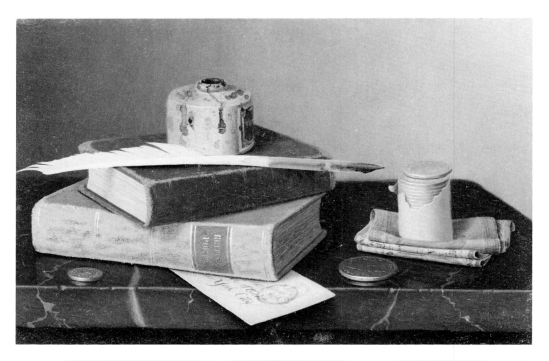

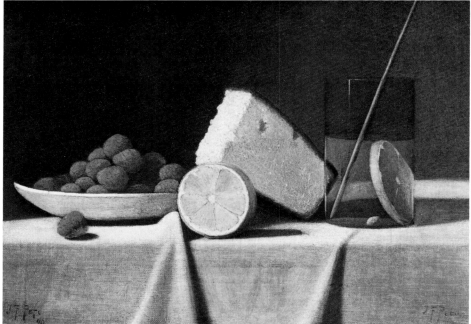

30. William Michael Harnett, *The Banker's Table*, 1877. The Metropolitan Museum of Art, Elihu Root, Jr., Gift, 1956 (*top*)

31. John F. Peto, *Cake, Lemon, Strawberries, and Glass*, 1890. Collection of Mr. and Mrs. Paul Mellon, Upperville, Virginia (*bottom*)

that such later nineteenth-century American still-life painters as William Michael Harnett and John F. Peto (figs. 30, 31) surely descended.[39] What made this remarkable innovation possible? What precedents of example or inheritance inspired it? What conception of purpose guided it? What historical conditions made it opportune?

One method—the ordinary art historical method—of explaining Raphaelle Peale's accomplishment would be to attempt to locate its sources. Unfortunately, it is not possible to do that with any precision, because we do not know what Raphaelle Peale saw of other art. Still-life paintings could be seen in Philadelphia, of course. Many were shown in the exhibitions of the Pennsylvania Academy of the Fine Arts beginning in 1811 when Raphaelle Peale was a regular exhibitor, and judging from their titles and artists, some could have been germane in style and subject to Peale's still lifes. The fruit still lifes by the Dutch painters de Heem and Kalf would have been; so would the still lifes by the Spanish painter Juan Sánchez Cotán shown in the 1818 Academy exhibition (fig. 32),[40] and the *Fruit* shown in 1811 that was said to be by Caravaggio but was more likely of a type at one time often attributed to him (fig. 33, for example). Whatever Peale might have seen at the Academy, however, it could not have been seminally formative. The completely practiced compositional refinement and illusionistic sophistication of his own still lifes painted at the time of these exhibitions indicates an established, wholly confident maturity that no experiences of other art could by then seriously affect.

There are nevertheless echoes of other art in Raphaelle Peale's. The still lifes he exhibited in Academy exhibitions were invari-

ably compared to Dutch and Flemish still lifes.[41] Netherlandish still lifes were, if only because of their abundance, by far the most available, authoritative, indeed virtually inescapable instructional example for a still-life painter. Even without knowing what in particular Raphaelle Peale could have seen of Netherlandish still life, it was surely within that tradition, probably at some time in the 1790s, that he found the stylistic models that influenced him (perhaps through the agency of his father, who invoked Rembrandt as his own artistic exemplar[42]). Apart from whatever influence it had on his style, Dutch still life would also have held an aptness of meaning for an American painter like Raphaelle Peale—working at a time of high national consciousness and democratic feeling—because of the political and social pertinence of its associations with republican government and middle-class culture.

If the syntactics, the formal order, of Peale's still lifes was in some manner shaped by the influence of things he saw, like Dutch still lifes, their grammar, the deeper theoretical rules of their artistic language and the principles of their artistic purpose, had a more direct source in the work of his father, Charles Willson Peale. There, more than in any outside influence, Raphaelle Peale found ratification in practice and in principle for still-life painting and for illusionistic imitation. The subject of still life and its matching style, therefore, were both for Raphaelle Peale more hereditary than acquired.

Illusionism was to some extent the inheritance of all of Charles Willson Peale's artistic progeny: it was the essential element in Rembrandt's "port-hole" portraits of George Washington, with their painted illu-

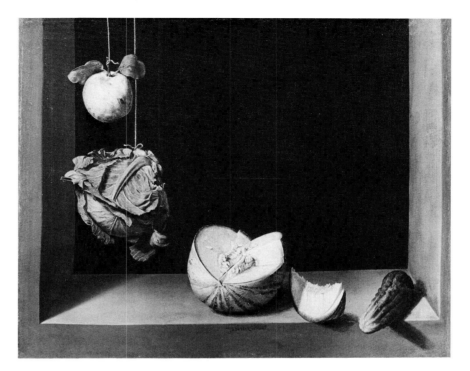

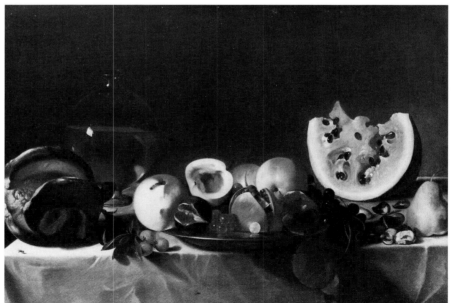

32. Juan Sánchez Cotán, *Quince, Cabbage, Melon, and Cucumber,* c. 1602. San Diego Museum of Art, Purchased for the Museum by the Misses Anne R. and Amy Putnam, 1945 (*top*)

33. Follower of Caravaggio, *Still Life,* 1573–1610. National Gallery of Art, Washington, Samuel H. Kress Collection (*bottom*)

34. Rembrandt Peale, *George Washington, Patriae Pater,* c. 1824. Courtesy of the Pennsylvania Academy of the Fine Arts, Philadelphia, Bequest of Mrs. Sarah Harrison (The Joseph Harrison, Jr., Collection)

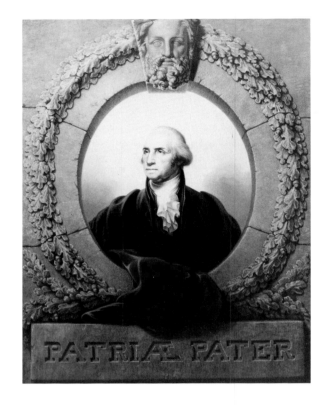

35. Margaretta Angelica Peale, *Catalogue of the Peale Museum,* 1813. James Ogelsby Peale Collection (from *American Art Journal* 18, no. 2 [1986]: 9)

sions of internal masonry frames (fig. 34).[43] But Raphaelle Peale was almost literally implicated in illusionism as the chief actor in one of the most ambitious trompe l'oeil deceptions, his father's *Staircase Group* (fig. 25), and the belief that illusionism constituted the highest form of painting pervaded all of Raphaelle's own work. In the 1812 Academy exhibition he showed a *Catalogue for the Use of the Room. A Deception,* which probably resembled his cousin Margaretta Angelica Peale's *Catalogue of the Peale Museum* (fig. 35). His *Still Life—A Catalogue and Papers Filed,* painted in 1813, was exhibited at the Academy a number of times. And his only surviving deception, *Venus Rising from the Sea—A Deception,* was exhibited at the Academy in 1822 and probably corresponds to the painting long known as *After the Bath* (fig. 37).[44]

(*Venus Rising from the Sea,* in which an engraving of Venus after a painting by James Barry is covered by a cloth, may also indicate what the 1795 *Covered Painting* looked like.[45]) In fact, Raphaelle Peale's work comprises the full spectrum of imitation, from physiognotrace silhouettes made by mechanically tracing the sitter's features (reenacting by mechanical means the myth of the mimetic origin of art [fig. 36]) to three-dimensional waxwork figures.

Raphaelle Peale's still lifes are overwhelmingly food still lifes (rather than flowers or dead animals), and they depict such things as temptingly opened watermelons, berries, peeled fruit, raisins, cakes, glasses of wine, or crumbled cheese. Like most still lifes, they have sensuous appeal. They are not, however, about actual eating, or the sheer, unabashed enjoyment of food and drink; on that plane their allure is very much less than Dutch still lifes that depict the remnants of meals already consumed, for example, or freshly opened oysters,

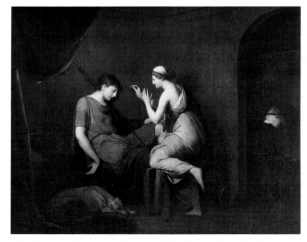

36. Joseph Wright of Derby, *The Corinthian Maid,* 1783–1784. National Gallery of Art, Washington, Paul Mellon Collection

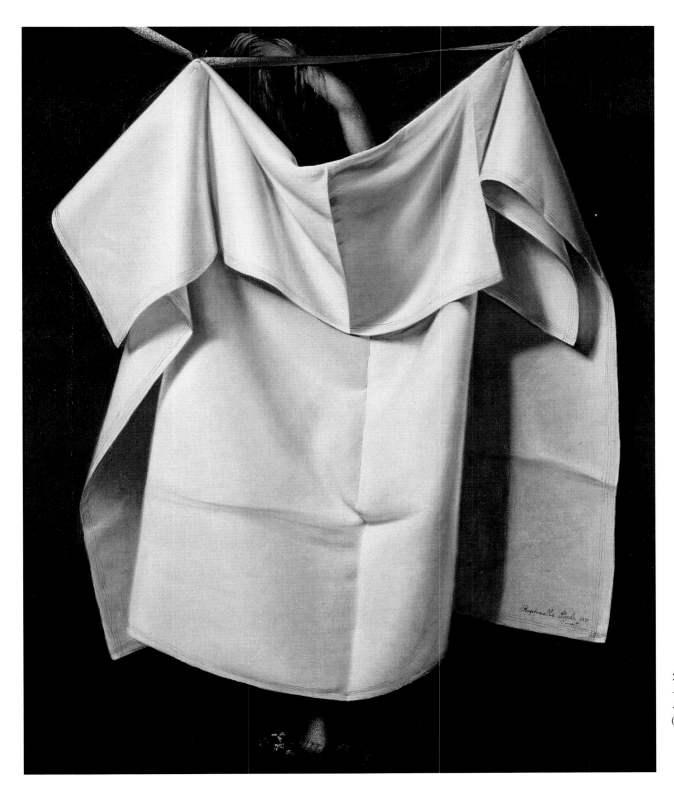

37. Raphaelle Peale, *Venus Rising from the Sea—*
A Deception [After the Bath], 1822? The Nelson-
Atkins Museum of Art, Kansas City, Missouri
(Nelson Fund)

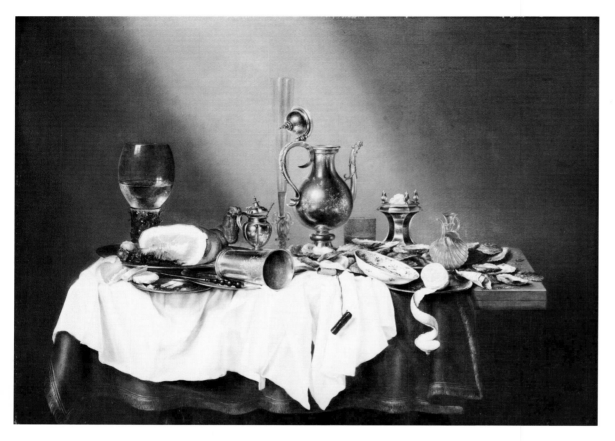

38. Willem Claesz. Heda, *Still Life,* 1656. The Museum of Fine Arts, Houston, Gift of Mr. and Mrs. Raymond H. Goodrich

may also have something to do with an essential property of still life as it was understood in the seventeenth century. At that time the Dutch word *stilleven,* from which the English word derives, apparently meant not only "still life" but "still model," that is, a fixed arrangement of objects made for the artificial purposes of art.[46] In other words, an inherently formal attitude toward the subject was present in the original meaning of still life, one in which the value of the objects depicted lay in their function as models—in their visual properties of shape, color, and texture—as much as it did in their appeal as things—their sensuousness or edibility. Raphaelle Peale's attentiveness to formal arrangement, therefore, is to some extent historically intrinsic to modern still life and not the result wholly of his innate aesthetic sensibility. In this sense, Rembrandt Peale's observation that Raphaelle excelled in "*compositions* [emphasis added] of still lifes" perhaps receives more exact meaning.

Still life is in many ways a private subject. Still lifes depict ordinary objects of personal use and private occasions like meals; they were made for an artist's own pleasure and diversion more often than were public subjects such as portraits, landscape, or history; and they were intended most often, too, for private rather than public places. Raphaelle Peale's still lifes were in all of these respects thoroughly private: he obviously found more gratification in still lifes than in any other subject; his paintings are all scaled to domestic space; and objects that recur in them—decanters and wine glasses, cream pitcher, handled pot (figs. 2, 39, 40, 41, and 53)—were clearly, by the very fact of their recurrence, parts of his or his family's domestic life.

sliced hams, and cut pies, that, sometimes with almost erotic seductiveness, await to be eaten (fig. 38). Raphaelle Peale's still lifes— in the impeccably careful, sensitively balanced, and measured placement of their objects and the geometric purity of their form—are almost more metaphysical than physical. In that respect they have something of the stringency and austerity of seventeenth-century Spanish still lifes such as those particularly by Zurbarán, van der Hamen, and Sánchez Cotán, two of which (see fig. 32) we know were exhibited at the Pennsylvania Academy in 1818.

A refined abstract or formal sensibility is unquestionably at work in Raphaelle Peale's still lifes. That makes them especially attractive to twentieth-century viewers. It

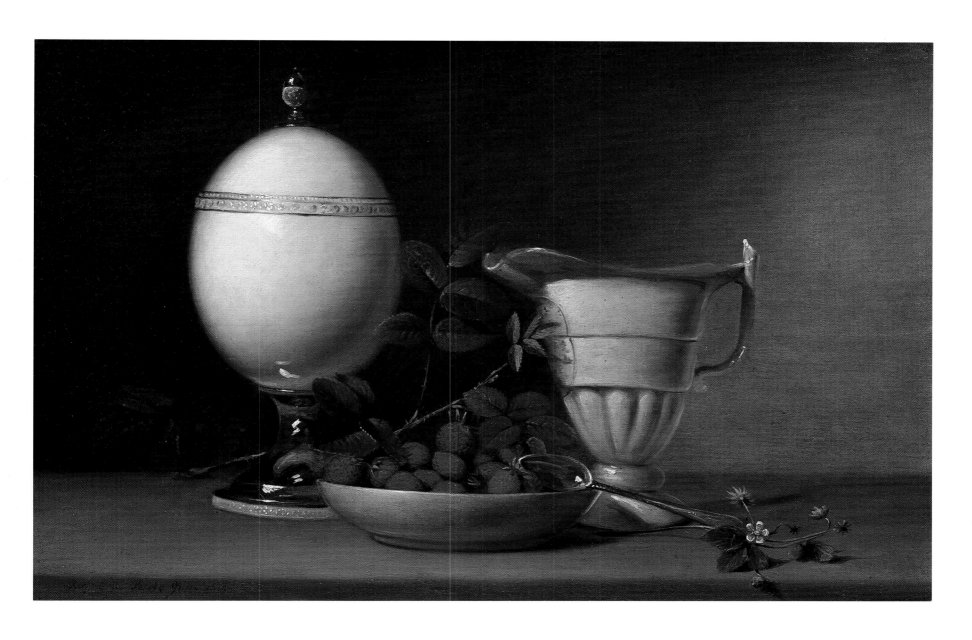

39. Raphaelle Peale, *Still Life with Strawberries and Ostrich Egg Cup*, 1814. Private collection

40. Raphaelle Peale, *Lemons and Sugar*, c. 1822.
Courtesy of the Reading Public Museum and Art
Gallery

41. Raphaelle Peale, *Still Life with Wild Strawberries*,
1822. The Art Institute of Chicago, Lent by Jamee
and Marshall Field

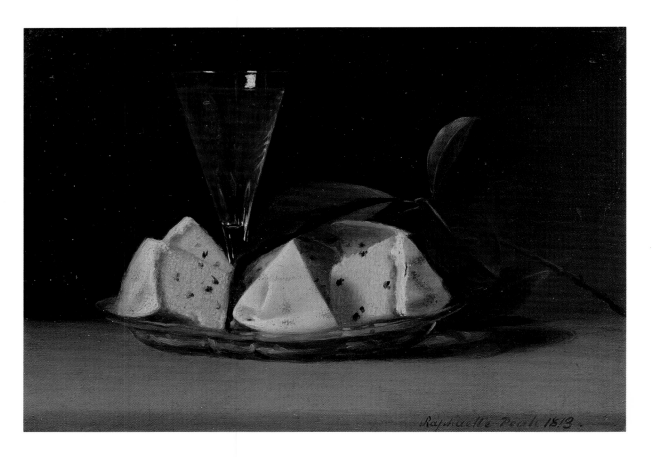

42. Raphaelle Peale, *Still Life with Raisin Cake,* 1813. Private collection

That said, Raphaelle Peale's still lifes were not private paintings made only for his own use and pleasure. He painted them for public exhibition, and he sold and traded them when he could. More important, as difficult as it might be to believe it of paintings of such delicacy and reticence or of an artist of such apparently modest ambition, they seem to have addressed the artistic issues of their time more intelligently, subtly, and—certainly in terms of their quality—more successfully than did the work of any of his contemporaries.

The most vexing issue that every serious American artist faced in the fifty years surrounding the turn of the eighteenth century was, generally speaking, nationality. Few historical precedents gave guidance to what kind of art it was possible for, or incumbent upon, an American artist to make in the circumstances of republican government and democratic society. What subjects were most appropriate? What audience should art address, and by what language or on what plane of style ought that address to be made? What class or form of patronage should support it? As the persistent disappointment of American artists in this period attests, there were few easy answers to the questions posed by American nationality and the social and economic consequences of political democracy. The major artists of the early republic (those, at any rate, who were not content to paint portraits)—John Trumbull, John Vanderlyn, Washington Allston, and Samuel F. B.

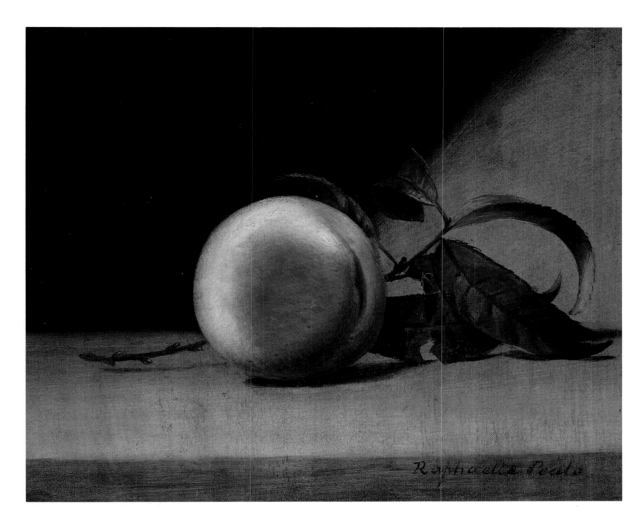

43. Raphaelle Peale, *Still Life with Peach*, c. 1816. San Diego Museum of Art, Purchased through funds provided by the Earle W. Grant Acquisition Fund

Morse—were all thwarted in their artistic ambitions and embittered by failure to an extent that is singular to this period.

They tried in various ways to adjust. Trumbull and Vanderlyn painted national subjects: Trumbull's revolutionary war series and *Declaration of Independence,* Vanderlyn's *Death of Jane McCrea,* and the Niagaras that they both did. Trumbull, Vanderlyn, and Morse painted purposely popular pictures: Trumbull's projected panorama of Niagara, Vanderlyn's panorama of Versailles (fig. 49), Morse's *Old House of Representatives* and *Gallery of the Louvre* (figs. 47, 48). And they all tried their hands at landscape, a subject newly invested, as they rightly sensed, with both national and popular meaning. Yet deeply implanted in their collective artistic understanding were ideas about nobility of subject matter, ideality of style, and expectations of patronage fundamentally incompatible with, if not actually hostile to, the political, social, and economic order of a middle-class, democratic republic. As late as 1835 Morse could write, "The truth is, the Fine Arts are addressed not to the great mass of the community, but to the majority of the well educated and refined in Soci-

ety."[47] Theirs was an aristocratically ordered program of belief transmitted by a theory of art formulated and promulgated in the seventeenth and eighteenth centuries by the royal academies of France and England. Raphaelle Peale's understanding, on the other hand, the mentality and artistic policy he inherited from the political radicalism, social egalitarianism, and artistic revisionism of his father, was very different. And it was above all the nature of that ideological inheritance, not any artistic source, that seems to have influenced and inspired Raphaelle's enterprise as a still-life painter.

Choosing to paint still life around 1800 with the seriousness and sense of calling—the degree of professional consciousness and standard of painterly aptitude—that Raphaelle Peale quite evidently brought to the subject had the quality and effect of a revolutionary act. It was a deliberate, relatively sudden, radical inversion of artistic order in which a subject long relegated to the bottom of the artistic scale was raised to its top. It was part also of a larger revolutionary process by which other once lowly subjects like landscape and genre (depictions of ordinary life) were similarly raised to higher station, and part of the even more profound and pervasive remaking of political, social, economic, and intellectual order that was the central condition of Raphaelle Peale's age. His egalitarian revaluation of still life belonged to the shift in hierarchies that can also be measured in such paintings as his brother Rembrandt's *Rubens Peale with a Geranium* of 1801 or Ralph Earl's *Daniel Boardman* of 1789 (see figs. 56, 59). In them, the human figure, which had for centuries been regarded without question as the object of highest artistic value, is displaced from the center of pictorial attention it had

so long commanded and is compelled to share it on an equal footing with still life and landscape.

To speak of this artistic change as revolutionary is, of course, to speak figuratively. But the change was revolutionary in certain real social and political senses, too. The artistic reclassification that gave new significance to subjects like landscape, genre, and still life was a function (and not merely a reflection) of the social reclassification that the revolutionarily transformative events of the late eighteenth century set in motion. These subjects were available to the experience of new aesthetically enfranchised social classes in ways that "noble" subjects based on ancient history were not (as those artists who persisted in producing them discovered). Derived from ordinary, direct, and shared experience rather than from privileged and educated experience, each of these subjects was democratically accessible—popular—in a way that historical subject matter was not and, on the whole, did not attempt to be.

In certain respects Raphaelle Peale's still lifes are the clearest case among these new subjects of what seems to be purposeful social and political relevance. The very fact that professional still-life painting in America had its beginning in Raphaelle Peale's work about 1790, as though it were a deliberated invention possible only in that historical moment, suggests a conscious response to its special social and political circumstances. Certainly the everyday commonness of still-life subjects and the depiction in still life of simple and humble things ("any common objects grouped together," as Charles Willson Peale put it[48]) had an intrinsic, socially classifiable diction. But the social and political address of Raphaelle

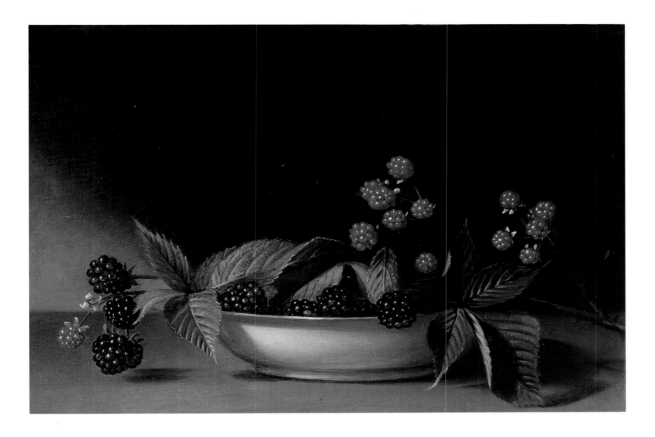

Peale's still lifes was clearest of all, and most deliberately pursued, in their language of style.

Imitative illusion was the visual language of Raphaelle Peale's still lifes. Its extreme form was the trompe l'oeil illusionism of his deceptions (fig. 37), but all of his still lifes solicited consent to the reality of their illusions, the believability of their painted imitations of reflected and refracted light, texture and tactility, volume and substance. Raphaelle Peale surely derived a great deal of satisfaction from the technical achievement of successful illusion; a number of his still-life arrangements seem clearly to have been made to maximize the opportunities for illusionistic effect (figs. 2, 14, 39, 44, 45,

46). But he also surely knew that the public appeal of still life rested very largely upon the convincing accomplishment of illusion.

The English painter Benjamin Robert Haydon, passionately devoted to high art, was deeply distressed by the power of illusionistic painting to command the kind of widespread admiration that he believed only history painting deserved. He confided to his diary in 1808 (on the eve, it is worth noting, of the period when Raphaelle Peale produced and exhibited still lifes most prolifically), "With the People of England, all their ambition and all their delight, and all their ideas of art go not beyond [the] immediate object of their senses; the exact copy

44. Raphaelle Peale, *Blackberries,* c. 1813. Private collection

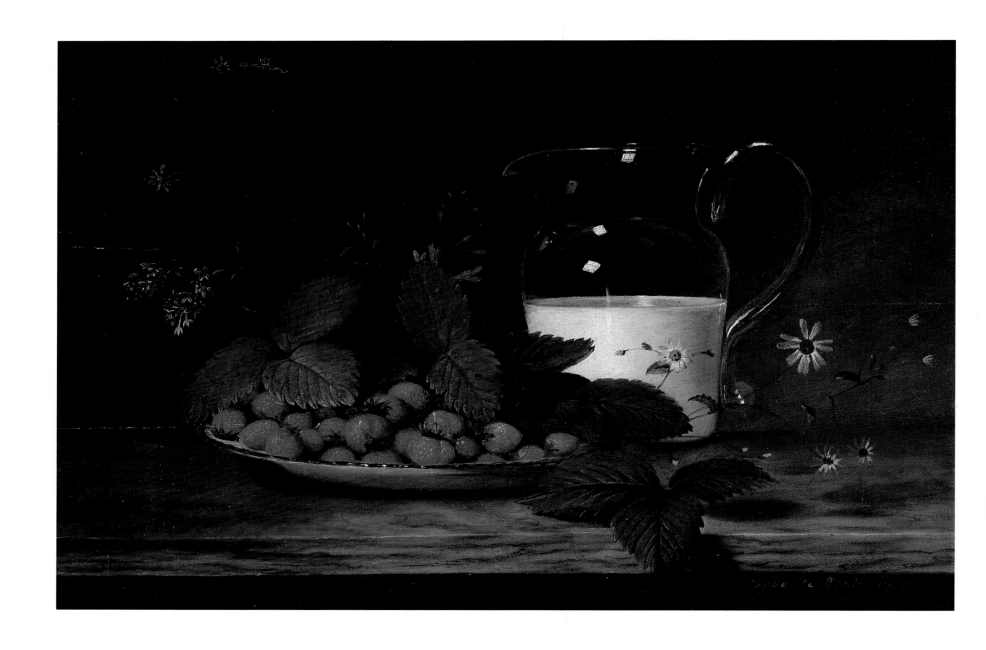

45. Raphaelle Peale, *Strawberries and Cream*, 1818.
Collection of Mr. and Mrs. Paul Mellon,
Upperville, Virginia

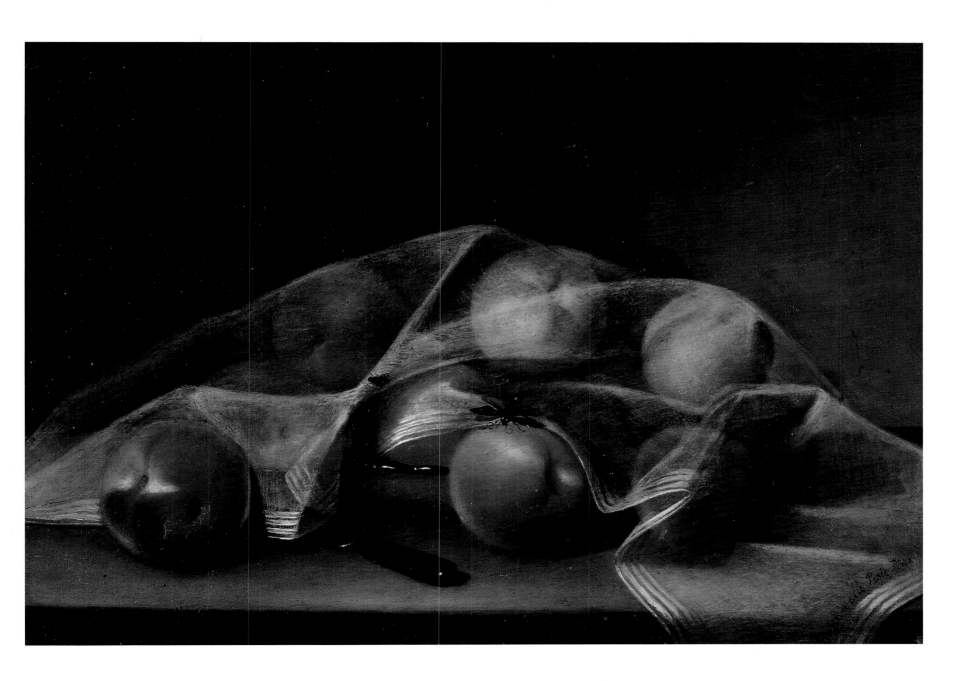

46. Raphaelle Peale, *Fruit Piece with Peaches Covered by a Handkerchief* [*Covered Peaches*], c. 1819. Private collection

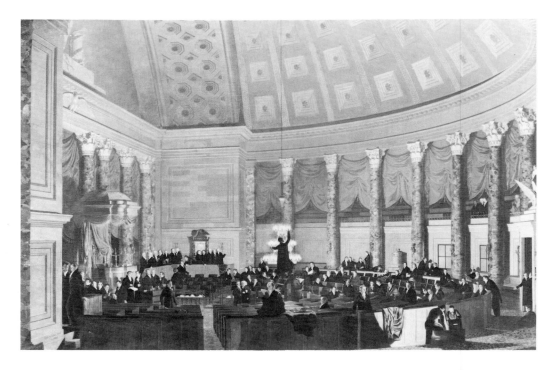

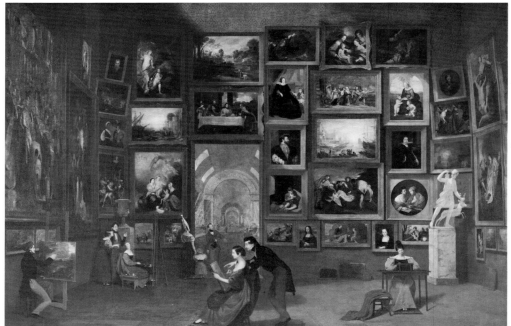

47. Samuel F. B. Morse, *The Old House of Representatives*, 1822. The Corcoran Gallery of Art, Museum Purchase, Gallery Fund, 1911 (*top*)

48. Samuel F. B. Morse, *Gallery of the Louvre*, 1831–1833. Courtesy of the Daniel J. Terra Collection, Terra Museum of American Art, Chicago (*bottom*)

of a pound of butter or china cup—." What troubled Haydon most acutely was that illusionism appealed to those who should know better: "People . . . see only the individual likeness to the thing and there their delight ends and there their notions of art are confined . . . uneducated People might be forgiven—but Noblemen, the ministers of the Country, the government of England, . . . instead of being ambitious of having their Souls elevated, and their minds expanded . . . [utter] exclamations of ravishment and rapture, at a smutty crock, or a brass candlestick."[49]

The social classification of illusionism (and in the bargain still-life subject matter like crocks and candlesticks) is here unmistakable: illusionism appeals, as Haydon put it, to "uneducated people," people, that is, of inferior social class. Haydon was far from alone in this understanding. Reynolds, for example, speaking as candidly as had Haydon, said, "When the arts were in their infancy, the power of merely drawing the likeness of any object, was considered as one of its greatest efforts. The common people, ignorant of the principles of art, talk the same language, even to this day."[50] More often this prejudice was conveyed by the terms "servile" and "mechanical" by which illusionistic imitation was usually described—thus Haydon's "Mere mechanic deception"[51]—for these were terms of social value, ones that still bore in their usage meanings traceable to the belief that art, like any other manual work, was to be assigned to a laboring class of slaves, servants, and mechanics.[52] Lower forms of painting, Reynolds said, were a "mechanical trade," an association that survived in America well into the nineteenth century. "The painter who copies such things [as brass kettles

and dead game]," wrote a reviewer of the 1831 Boston Athenaeum exhibition catalogue, is only "somewhat more refined than the tinker or cook who handles the originals. . . ."[53]

By about the time of Raphaelle Peale's death in 1825 the social stigmatization of illusionism was losing force both as a doctrine of criticism and as a prejudice of practice. Reynolds admonished the students of the Royal Academy in the late eighteenth century that a serious artist "will disdain the humbler walks of painting, which however profitable, can never assure him a permanent reputation. He will leave the meaner artist servilely to suppose that those are the best pictures, which are most likely to deceive the spectator."[54] In America in the early nineteenth century, however, serious artists began to suppose precisely that. Two of Morse's most ambitious public painting projects, for example, *The Old House of Representatives* (fig. 47) and *Gallery of the Louvre* (fig. 48), staked their success largely on overt illusionism—the contrived effects of light in one, the replicated paintings in the other—even though Morse believed that "deception or accurate likeness of objects" held a subordinate artistic station.[55] In 1808 John Trumbull planned a panorama of Niagara that was never carried out, while in 1814 John Vanderlyn began a panorama of the gardens of Versailles that he finally exhibited in New York in 1819 (fig. 49). Invented in the 1790s, panoramas were large paintings on the walls of circular rooms that, by wholly filling the beholder's field of vision, produced illusions of the most convincingly complete reality. They were frankly made for a popular audience, and their popular success depended in large measure on deceptive imitation. The writer

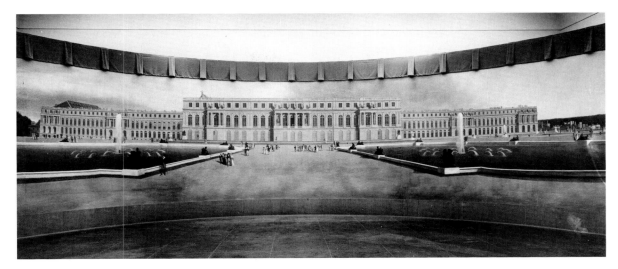

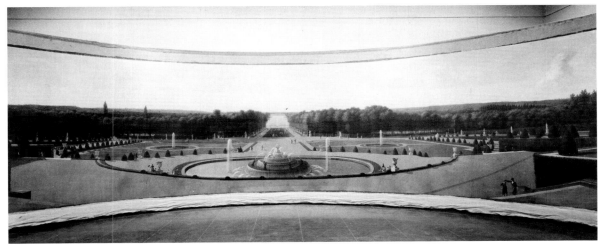

of a biographical memoir of Vanderlyn described their popular character very precisely: "panoramic exhibitions possess so much of the magic deceptions of the art, as irresistibly to captivate all classes of spectators, which gives them a decided advantage over every other description of pictures; for no study or cultivated taste is required fully to appreciate the merits of such representations."[56]

49. John Vanderlyn, *The Palace and Garden of Versailles,* panorama, 1816–1819. The Metropolitan Museum of Art, Gift of the Senate House Association, Kingston, New York, 1952

This passage on panoramas parallels in its strategy of explanation the nearly contemporary discussion of the still lifes in the second National Academy of Design exhibition in 1827:

> The peculiar merit of this class of pictures consists in the *exactness of the imitation.* A single glance proves their success in this excellence; it is one that is always so striking, that most persons think it to be the great end and most difficult attainment of painting. . . . The department we are considering, although it ranks thus low in the scale of works of art, has always been popular, and for the very obvious reason, that its chief merit is intelligible to all.[57]

Just as the "exactness of the imitation" of still lifes made them "intelligible to all," panoramas were available to "all classes of spectators" because "no study or cultivated taste" was needed to appreciate them.

During roughly the first quarter of the nineteenth century it is almost as if both a consensual understanding of the nature and function of popular style and, under the pressure of democratized social and political reality, a policy of its upward revaluation were being formed, however provisionally and pragmatically. The compact clarity of the discussion of still-life style and its social meaning in the review of the National Academy of Design exhibition is a symptom of this revaluation. Although the review's low ranking of still life is entirely conventional, what is not, in this first serious consideration of the subject in American criticism, is its identification (with something close to the precision of a theoretical formulation) of still life with imitation, and imitation with popular (democratic) intelligibility. Another comment on Vanderlyn's panorama, although it speaks of subject matter rather than style, describes this revaluation and its social justification more exactly:

> Although it was not to have been expected that Mr. Vanderlyn would have left the higher department of historical painting, in which he is so eminent, to devote his time to the more humble, though more profitable, pursuit of painting cities and landscapes—yet, in a new country, taste must be graduated according to the scale of intellect and education, and where only the scientific connoisseur would admire his [history paintings] Marius and Ariadne, hundreds will flock to his panorama to visit Paris, Rome and Naples. This is to "catch the manners living as they rise," and with them catch the means to promote a taste for the fine arts.[58]

Here, in 1818, the readjustment from high subjects to humble popular ones is described not as an opportunistic descent or degenerate decline (as Reynolds might have described it) but as a matter of positively desirable democratic sociocultural policy.[59]

Some such policy, as we have been arguing, guided Raphaelle Peale's artistic purpose as a still-life painter. What necessarily also concerned him was not only the popular intelligibility of his paintings but their actual *popularity*, not only how or by whom they might be understood but who might buy them. "It is no doubt extremely gratifying to the painter to have his works viewed and praised by the public," the artist and critic George Murray said in addressing this issue in his notice of the fourth annual exhibition of the Pennsylvania Academy in 1814. "He cannot, however, live by praise alone; the sale of a single picture would be of more solid advantage to him than empty eulogiums on a thousand." Human vanity assured that portraits would always find encouragement. But what of subjects of more general public interest, "historical,

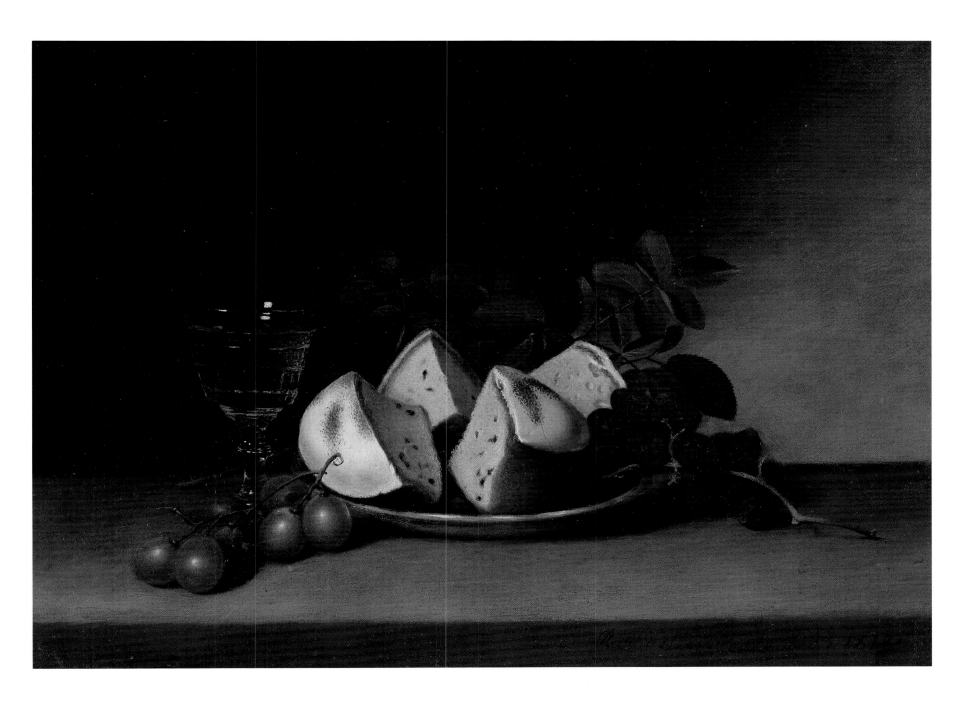

landscape, marine, and flower painting [that is, still life]," as Murray enumerated them, which "are universally pleasing to all"? In a middling, democratic society like America's in which there were no popes or

princes and great wealth was rare, who had the means or the disinterested responsibility to encourage that sort—Raphaelle Peale's sort—of painting? There was one prototypical example of democratic patron-

50. Raphaelle Peale, *Still Life with Cake*, 1818. Lent by The Metropolitan Museum of Art, Maria DeWitt Jesup Fund, 1959

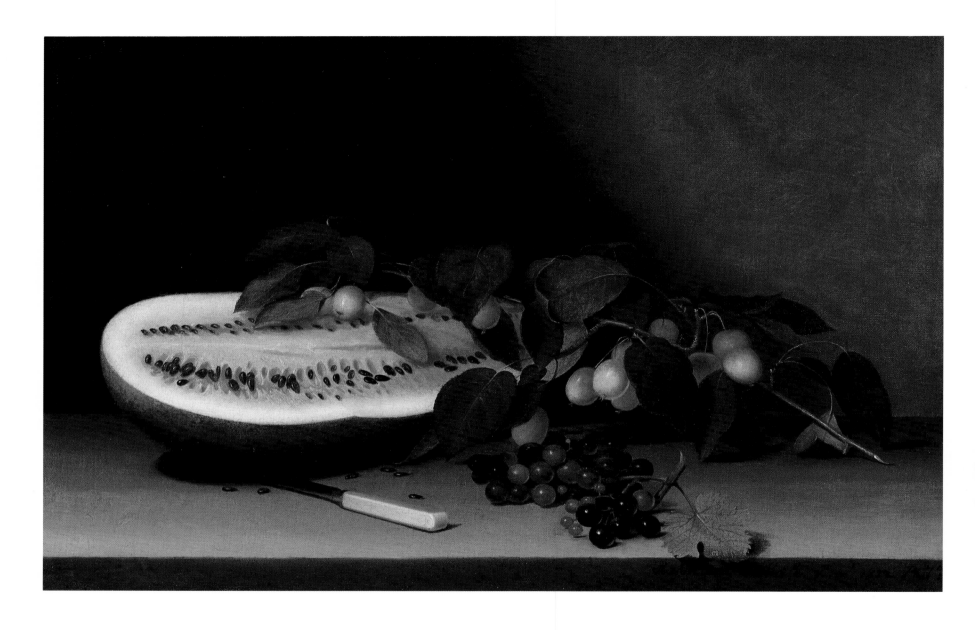

51. Raphaelle Peale, *Still Life with Watermelon*, 1822.
Berry-Hill Galleries, New York

age and republican connoisseurship: "The Dutch and Flemish schools, for faithful representations of nature, have never been excelled. Who were here the connoisseurs? Who the patrons of the artists?—Merchants and other wealthy citizens—men of plain and simple manners, possessing taste without affectation."[60] The "plain and simple" members of the middle class, the wealthy bourgeoisie that admired "faithful representations of nature," could be America's patrons as they had been Holland's. Just as "the pictures of Dutch and Flemish artists were generally of a small size and well calculated to ornament rooms," so too, the suggestion is, American artists should similarly

tailor their products for middle-class, domestic consumption. As if by design, Raphaelle Peale's art was suited in subject, size, and style to bourgeois patronage. It was in fact exactly that kind of patron—like Robert and William Gilmor of Baltimore, Charles Graff of Philadelphia, James Fullerton of Boston, and John Ashe Alston of South Carolina—who bought Raphaelle Peale's still lifes, and to whose taste and understanding their "faithful representations of nature" were directed.[61]

Raphaelle Peale had some of the most distinguished patrons of his time.[62] Nevertheless, he seemed to sense that a system of patronage in which the artist depended upon the beneficence of wealthy and cultivated individuals—although it was the system that every program for the improvement of public taste, and everyone seriously concerned with the encouragement of the fine arts in America, attempted to develop—was fundamentally conventional and conservative.

We know of the existence of Raphaelle Peale's still lifes only through those occasions when he exhibited them; if he painted still lifes at other times, no visible or written trace of them remains. It can be argued, of course, that exhibitions were simply windows through which segments of a continuous but otherwise unknown development happened to be visible. It is also possible, however, as William Gerdts has argued, that we have not lost almost twenty years of Raphaelle Peale's work in still life but that he painted still lifes only at those times when they could be exhibited—at the Columbianum in 1795 and the Pennsylvania Academy beginning in 1812.[63] The reviewer of the third annual Pennsylvania Academy exhibition (probably George Murray) sug-

gested just that when he said of Raphaelle Peale, "Before our annual exhibitions this artist was but little known."[64] It is probably not a coincidence that Peale's most prolific production of still lifes occurred only when public exhibitions became routinely part of professional artistic life in Philadelphia with the establishment of annual Academy exhibitions in the second decade of the nineteenth century.

Raphaelle Peale seems to have had a perception, different from calculations of opportunism, that the exhibition system was peculiarly well suited to still life and other modern subjects like it, painted essentially on speculation. By making still lifes chiefly for exhibitions rather than on commission from individual patrons, Raphaelle Peale would anticipate what later in the century became the essential economic condition of artistic production and distribution, and the chief mechanism of patronage. Of course, he tried to sell or trade his paintings in whatever way and by whatever system he could. As modest and moderately ambitious as Raphaelle Peale seems by all accounts to have been in person, he had a quite surprising sense of commercial competitiveness and an aptitude for aggressive advertising—both verbal and typographical—that suggests a keen sense of the operations of the marketplace, as in figure 52, or the following from *The Philadelphia Gazette* (11 September 1800):

A NAME!
RAPHAELLE PEALE
To make himself eminent, will paint MINIATURES, for a short time, at Ten Dollars Each—he engages to finish his pictures equally as well for this, as his former price, and invariably produces ASTONISHING LIKENESSES.[65]

52. Advertisement, *Poulson's American Daily Advertiser*, 10 October 1801

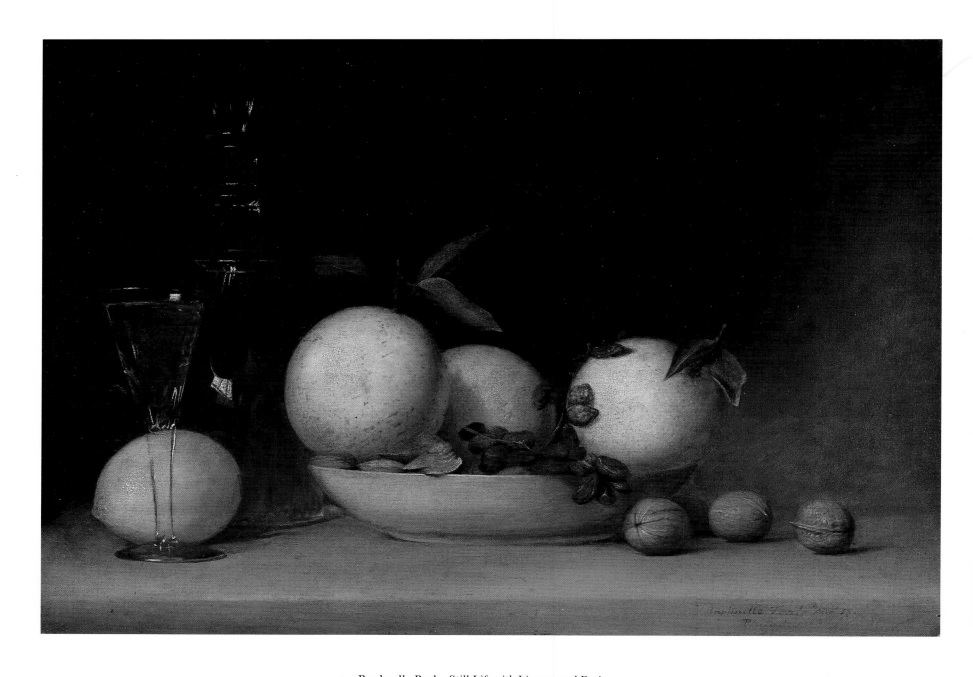

53. Raphaelle Peale, *Still Life with Liqueur and Fruit,*
c. 1814. Eleanor Searle Whitney McCollum,
Houston, Texas

Exhibitions were a method of appealing directly to the public for commercial purposes. But in the sense of seeking a new hearing and a reversal of judgment, the appeal of public exhibitions was more legal than commercial. In Raphaelle Peale's case, the judgment to be appealed was the long-standing artistic ranking of the subject and style of still life. The point would be decided not by Reynolds' "enlightened part of mankind" or Morse's "well educated and refined in Society," but by the new tribunal of popular opinion that the public exhibition made possible. If its appellate function was indeed a factor in Raphaelle Peale's choice of the public exhibition to present his still lifes, he anticipated what would become by the 1860s and 1870s the practice of more consciously and aggressively advanced artists—Courbet, Manet, the impressionists—who used the exhibition to appeal the judgments of the artistic establishment.

Today still lifes can seem to be comfortingly irrelevant—serene experiences of pure beauty and perfect order in an aesthetically discordant and emotionally harsh world (fig. 54). That is what we have admired in the pristine classicism of Raphaelle Peale's still lifes, and during Peale's own trying time and troubled life he must have found a similar comfort in the making and contemplation of these still lifes. But Raphaelle Peale was close enough to the origins of modern still life in the seventeenth century to know that the relationship of still life to real life was far from irrelevant. Palomino Velasco's account of Velasquez reminds us how close, in terms both of optical and sociological descriptiveness, that relationship once was: "He took to representing, with the most singular fancy and notable genius, beasts, birds, fishes,

fish-markets and tippling-houses, with a perfect imitation of nature, . . . differences of meats and drinks, fruits of every sort and kind; all manner of furniture, household-goods, or any other necessaries which poor beggarly people, and others in low life, make use of; with so much strength of expression, and such colouring, that it seemed to be nature itself."[66] It reminds us, too, of how much of that relationship survived in Raphaelle Peale's endeavor as a still-life painter.

54. Cover drawing by Sempé, © 1988, The New Yorker Magazine, Inc.

Notes

1. William Dunlap, *History of the Rise and Progress of the Arts of Design in the United States*, 2 vols. (New York, 1834), 1:138; and Charles Willson Peale to Edmund Jennings, Philadelphia, 28 December 1800, in *The Selected Papers of Charles Willson Peale and His Family*, ed. Lillian B. Miller, 2 vols. (New Haven, 1988), 2:295.

2. Dunlap 1834, 1:140.

3. Dunlap 1834, 1:140–141.

4. See document 54, under Texts and Documents.

5. See document 1.

6. William H. Gerdts, essay on *A Covered Painting* in Robert Devlin Schwarz, *A Gallery Collects Peales* (Philadelphia, 1987), 20.

7. Charles Willson Peale mentions Raphaelle's thought of suicide in a letter to Raphaelle Peale, Belfield, 26 June 1818. See document 31.

8. Charles Willson Peale's letters are filled with praise for Rembrandt, and although his father would not admit it, Raphaelle was understandably resentful of his favoritism. See document 13.

9. Raphaelle's insecurities were compounded, his father believed, by damagingly impolitic behavior. See document 4.

10. The phrase is Sir Joshua Reynolds', applied by him to what was almost as bad as still life, the "low and vulgar" characters of Hogarth. See his *Discourses on Art*, ed. Robert R. Wark (San Marino, Calif., 1959), 51.

11. Reynolds 1959, 52.

12. *The Diary of Benjamin Robert Haydon*, ed. Willard Bissell Pope, 2 vols. (Cambridge, Mass., 1960), 1:7.

13. James Barry and John Opie, in *Lectures on Painting by the Royal Academicians*, ed. Ralph N. Wornum (London, 1848), 93, 97, 248. Goethe expressed the same belief more gently: "If a naturally gifted artist . . . turns to subjects in nature and copies her forms and colours exactly and conscientiously, truly and diligently, and always beginning and ending in front of her, that artist will always be worthwhile, for it follows absolutely that his works will be assured, powerful and rich in variety. . . . Such subjects must be easily procured, studied at leisure, and copied calmly; the mind that occupies itself with such work must be quiet, self-contained and satisfied with moderate enjoyments. This sort of imitation will hence be practised by quiet, honest, limited artists on so-called still-lives. But that does not preclude a high degree of perfection. But

more often than not the artist finds this way of working too timid and inadequate. . . ." See Goethe's "Simple Imitation of Nature, Manner, Style," *Der Teutsche Merkur*, February 1789, in *Goethe on Art*, ed. John Gage (Berkeley and Los Angeles, 1980), 21.

14. Peale said he painted the family portrait in 1773, but it was more plausibly done a year or two earlier; according to its inscription, it was not finished until 1809, when, among other changes, the dog was added. See Charles Coleman Sellers, *Portraits and Miniatures by Charles Willson Peale*, Transactions of the American Philosophical Society, vol. 42, pt. 1 (Philadelphia, 1952), 157–158.

15. Whether the knife that projects over the table's edge has some phallic significance one cannot confidently say, for it was a commonplace illusionistic *topos* in still-life painting. Peale was capable of that sort of allusion, however, as at least one painting strongly suggests—a painting, what is more, with a prominent still-life component. In the double portrait of Benjamin and Eleanor Laming of 1788 (see fig. 57) the expandable telescope directed by Mr. Laming at Mrs. Laming's lap, in which she holds two pieces of fruit, is, particularly given Mr. Laming's more lustful than merely affectionate gaze, something more than an image of "conjugal felicity"—or at any rate, a special condition of it. See Sellers 1952, 119–120.

16. Peale's family portrait is signed and inscribed in the more usual manner at right center.

17. The portrait was painted at Charles Willson Peale's country home, Belfield. See documents 25 and 26. The possibility that the still life hanging on the wall behind Raphaelle reproduces one of Charles Willson Peale's is enhanced by its resemblance to the still life in *The Peale Family* (fig. 22), to which it is closer than to any generally accepted still lifes by Raphaelle. A few months after he painted Raphaelle's portrait with a still life in the background, Charles Willson Peale exhibited a *Still Life—Apples, &c.* at the Pennsylvania Academy of the Fine Arts. Its title describes the still life in the portrait, and it was the only time he exhibited a still life. See Sellers 1952, 167; and William H. Gerdts, *Painters of the Humble Truth; Masterpieces of American Still Life* (Columbia, Mo., 1981), 48. But traces of what seems to be the beginning of a similarly constructed portrait with a similar still life in the background can be seen beneath Raphaelle Peale's *Venus*

Rising From the Sea (fig. 37), which, unless Raphaelle painted over one of his father's unfinished canvases, complicates the question of whether it is the father's or the son's still lifes that are represented in these cases. See Dorinda Evans, "Raphaelle Peale's *Venus Rising From the Sea:* Further Support for a Change in Interpretation," *American Art Journal* 14 (1982): 72.

18. Charles Willson Peale to Angelica Peale Robinson, Philadelphia, 16 June 1808, in *Selected Papers* 2:1,087; and Belfield, 22 November 1815, in *The Collected Papers of Charles Willson Peale and His Family,* ed. Lillian B. Miller (Millwood, N.Y., 1980, microfiche edition), series II–A/59.

19. Nevertheless, Charles Willson Peale had reservations about still life. He repeatedly urged Raphaelle to apply the powers of imitation he displayed in his still lifes to the more lucrative field of portraiture, which he believed was inherently more difficult than and hence superior to still life: "It is not like the painting of still life; the painting of objects that have no motion, which any person of tolerable genius with some application may acquire." See Peale's "Autobiography" (typescript by Horace Wells Sellers, American Philosophical Society), 337.

20. Charles Willson Peale to John Beale Bordley, Philadelphia, November 1772, in *Selected Papers* 1:127. Peale's source for Rembrandt's practice was the article on Rembrandt in Matthew Pilkington, *The Gentleman's and Connoisseur's Dictionary of Painters* (London, 1770): "It appears as if he had more solid delight in contemplating his own repository of old draperies, armor, weapons, and turbans, which he jocularly called his antiques, than he ever felt from surveying the works of the Grecian artists, or the compositions of Raphael." That this was not a method generally to be encouraged is suggested by the article on painting in the first American edition of the *Encyclopedia Brittanica* (Philadelphia, 1798), which warned that a painter needs more than "what Rembrandt used to call his *antiques,* being nothing more than coats of mail, turbans . . . and all manner of old household trumpery. . . ." See Brandon Brame Fortune, "Portraits of Virtue and Genius: Pantheons of Worthies and Public Portraiture in the Early American Republic, 1780–1820" (Ph.D. diss., University of North Carolina, Chapel Hill, 1987), 180.

21. Reynolds 1959, 45.

22. Reynolds 1959, 103; Barry in Wornum 1848, 100.

23. Charles Willson Peale to John Beale Bordley, Annapolis, 1770–1771, in *Selected Papers* 1:86.

24. Notice published in the *Pennsylvania Packet,* 4 December 1781, in *Selected Papers* 1:366.

25. *Collected Papers,* series II-E/1.

26. *Pennsylvania Packet,* 19 May 1785, in *Selected Papers* 1:431.

27. Manasseh Cutler, journal of a trip to New York and Philadelphia, 13 July 1787, in *Selected Papers* 1:483. Cutler was a Congregational minister in Ipswich Hamlet, Massachusetts.

28. Charles Willson Peale, "Autobiography," 338. Phoebe Lloyd locates Peale's belief in eye-fooling illusionism in Palomino Velasco, *Account of the Lives and Works of the Most Eminent Spanish Painters, Sculptors and Architects* (London, 1739), a copy of which "the [Peale] family owned and cherished." See "A Death in the Family," *Philadelphia Museum of Art Bulletin* 78 (spring 1982): 8, 13 n. 16.

29. In Sellers 1952, 167.

30. Reynolds 1959, 41–42.

31. Reynolds 1959, 43.

32. Reynolds 1959, 50, 57.

33. For Peale's scientific undertakings, see Brooke Hindle, "Charles Willson Peale's Science and Technology," in Edgar P. Richardson, et al., *Charles Willson Peale and His World* (New York, 1982), 106–169.

34. "Introduction to an Account of Sir Joshua Reynolds's Discourses: I," in *The Complete Works of William Hazlitt,* ed. P. P. Howe, 21 vols. (London, 1933), 18:62.

35. Reynolds 1959, 73, 45.

36. *Blake: Complete Writings,* ed. Geoffrey Keynes (London, 1972), 451.

37. "Introduction to an Account of Sir Joshua Reynolds's Discourses. III: On the Imitation of Nature," and "Mr. West's Picture of Christ Rejected," in Hazlitt 1933, 18:70, 78, 31.

38. Dunlap 1834, 2:51.

39. See Alfred V. Frankenstein, *After the Hunt: William Harnett and Other American Still Life Painters 1870–1900,* rev. ed. (Berkeley and Los Angeles, 1969), 31–33.

40. See William B. Jordan, *Spanish Still Life in the Golden Age* (Fort Worth, 1985), 58–60.

41. See documents 12, 16, 19.

42. For Netherlandish influence in general, see H. Nichols B. Clark, "A Taste for the Netherlands: The

Impact of Seventeenth-Century Dutch and Flemish Genre Painting on American Art 1800–1860," *American Art Journal* 14 (spring 1982): 24, 32–33. For Dutch influence on Raphaelle Peale, see John I. H. Baur, "The Peales and the Development of American Still Life," *Art Quarterly* 3 (winter 1940): 82–84. See also Roger B. Stein, "Charles Willson Peale's Expressive Design: The Artist in His Museum," *Prospects* 6 (1981): 168–170.

43. The oval internal frame was not Rembrandt Peale's invention but a common device in seventeenth- and eighteenth-century painted and engraved portraits. Deceptive illusionism is seldom as extensive and explicit as here, however.

44. For a discussion of problems in the dating and replicas of *Venus Rising from the Sea,* see Evans 1982, 63–72.

45. It may possibly have resembled *Fruit Piece with Peaches Covered by a Handkerchief* [*Covered Peaches*] (fig. 46). See Gerdts 1987, 21. Raphaelle Peale's plans briefly included another form of deception, waxwork, which his father said "will far exceed in natural appearance any that has been shown in this City [Philadelphia] heretofore." See document 5.

46. Charles Sterling, *Still Life Painting from Antiquity to the Present Day* (New York, 1959), 43; Titia van Leeuwen, "Still-life Painting in the Netherlands: Historical Facts and Facets," *Still-Life in the Age of Rembrandt* [exh. cat., Auckland City Art Gallery] (Auckland, 1982), 39.

47. Samuel F. B. Morse, *Lectures on the Affinity of Painting with the Other Fine Arts,* ed. Nicolai Cikovsky, Jr. (Columbia, Mo., 1983), 28–29 n. 63.

48. Document 34.

49. Haydon 1960, 1:5.

50. Reynolds 1959, 96. He also said, "the Vulgar will always be pleased with what is natural, in the confined and misunderstood sense of the word" (p. 89).

51. Haydon 1960, 1:7.

52. John Barrell, *The Political Theory of Painting from Reynolds to Hazlitt* (New Haven, 1986), introduction, 13. The social valuation of imitation had the authority of Plato, who believed that as painting imitated mere appearances, not truth, it was unworthy of a free citizen.

53. Review, "Exhibition of Pictures at the Athenaeum Gallery. Remarks upon the Athenaeum Gallery of Paintings for 1831," *The North American Review* 33 (October 1831): 512.

54. Reynolds 1959, 50.

55. Morse 1983, 109.

56. Dunlap 1834, 2:39.

57. D. Fanshaw, "Review. The Exhibition of the National Academy of Design," *The United States Review and Literary Gazette* 2 (July 1827): 258.

58. *The National Advocate* (21 April 1818), in John W. McCoubrey, *American Art 1700–1960: Sources and Documents* (Englewood Cliffs, N.J., 1965), 43–44. Also William T. Oedel, "John Vanderlyn: French Neoclassicism and the Search for an American Art" (Ph.D. diss., University of Delaware, 1981), 432. The quotation is from Pope's *An Essay on Man:*

> Eye Nature's walks, shoot folly as it flies,
> And catch the manners living as they rise.
> Laugh where we must, be candid where we can;
> But vindicate the ways of God to man.
> Say first, of God above or man below,
> What can be reason but from what we know?

59. By the late nineteenth century still life continued to be considered a popular but a low subject. "There are many who stop and look with delight at Mr. W. M. Harnett's *The Social Club,*" the critic of the *New York Times* wrote in a review of the 1879 National Academy of Design exhibition. It "attracted the attention that is always given to curiosities, to works in which the skill of the human hand is ostentatiously displayed working in deceptive imitation of Nature." It was, however, a low form of art to which "few artists of merit have ever condescended to apply their skill." But when another of Harnett's paintings was seen in a more popular setting, I. N. Reed's drugstore in Toledo, Ohio, a writer said the artist made the subject "so perfect—so like the real—that in looking upon it you are likely to forget that it is a picture. . . . The higher triumph of artistic genius is in approaching the actual—in the perfect reproduction of the subject presented." See Frankenstein 1969, 7, 50.

60. George Murray, "Notice of the Fourth Annual Exhibition in the Academy of the Fine Arts," *The Port Folio* 3, ser. 3 (June 1814): 568–569.

61. Nearly half of Robert Gilmor's collection consisted of Netherlandish paintings. Clark 1982, 26. Raphaelle's *Still Life with Oranges,* fig. 1 is inscribed: "Painted for the Collection of John A Alston Esq.ʳ / The Patron of living American Artists." *Blackberries* ("A branch of red and black blackberries, lying across

a saucer"), fig. 44 and *Peaches and Unripe Grapes* ("Basket of yellow peaches with a bunch of unripe grapes. An extraordinary imitation"), fig. 8, were both owned by Charles Graff, and sold in the 1856 executor's sale in Philadelphia. Graff also owned three other still lifes by Raphaelle Peale: one described as "China basket of oranges, glass of wine, a cake, bunch of raisins. Frame with the engraved head of a boy"; another described as "Orange, apples, prunes, almonds and filberts"; and a third, "China basket of peaches, bunch of blue grapes on the table on the left, and four peaches on the table on the right." None of these are now known.

62. Gerdts 1987, 20–21.

63. Gerdts 1981, 50–51.

64. See document 16.

65. See Charles Coleman Sellers, *Charles Willson Peale*, vol. 2, *Later Life* (Philadelphia, 1947), 123.

66. Palomino 1739, 50. For Palomino and the Peales, see n. 28 above.

55. Detail of fig. 8

America's Young Masters
Raphaelle, Rembrandt, and Rubens

JOHN WILMERDING

THE TRADITIONAL HIERARCHY OF SUBJECTS IN European painting ranked mythology, religion, and history as highest in importance, followed by portraiture and landscape, with still life occupying the lowest line of significance. Although early America inherited this tradition, by the time it had declared its political independence at the end of the eighteenth century, it was also ready to assert a new artistic vision for itself. Arguably, part of this cultural originality was the elevation of still-life painting to a place of prime importance both as a major form of expression for painters and as an index of national self-definition. Almost by exclusive spontaneous generation the Peale family perfected the first great body of American still-life subjects in the decades just before and after 1800. Expressing a new sense of American practicality and informality, the founding father of this remarkable clan, Charles Willson Peale (1741–1827), had created inventive syntheses of the former subject categories. His various family portraits were not just likenesses of individuals but fusions of biography and autobiography. The famous double portrait of his two sons Raphaelle and Titian pausing at the bottom of a staircase (fig. 25) is at once an obvious figure painting and as much a human-scale

still life in its formal order and illusionism. For his part, Raphaelle, the eldest son, crafted within a career of attractive but ordinary portraits a supreme group of several dozen still-life compositions. Perhaps his work as a miniaturist had turned his hand and eye to condensations and clarities. Whatever the impulse, his tabletop arrangements, though relatively conventional in the tradition of northern European baroque precedents, managed to evoke and embody the fresh American aspirations for order and union.[1] Peale's second son, Rembrandt, in turn created one great masterwork for himself and for all American art when he painted the unusual, even startling, portrait of *Rubens Peale with a Geranium* (fig. 56).

This singular work would be an unsurpassed achievement for Rembrandt and has remained one of the most original images in the history of American art. Though it shares with Raphaelle's pictures a love of balance, coherence, and clear finish, it poses an inventiveness all its own. Attempting to understand that originality for its time may help to explain why it has remained so compelling for us ever since in its articulation of an American sensibility.[2]

To begin with, what is depicted? In our very description of the subject, and our no-

56. Rembrandt Peale, *Rubens Peale with a Geranium*, 1801. National Gallery of Art, Patrons' Permanent Fund (*opposite page*)

73

tation of its author and date, there is a confluence of associations and timing that speaks to the Peale family's aspirations. The painting is of course first of all a portrait, but one equally of an individual and of a flowering plant. The sitter was Rubens Peale (1784–1865), Charles Willson's fourth son, and he was seventeen at the time of the painting in 1801. He poses beside what has often been called the first geranium brought to America. That it probably was not absolutely the first such imported speciman has been subsumed by the continuing wishful speculation. The artist was Rubens' older brother, Rembrandt (1778–1860), himself only twenty-three and born on George Washington's birthday in the middle of the Revolution. As is well known, Charles Willson Peale and his first wife named their children after famous old master artists; the offspring of his second marriage were given the names of illustrious scientists like Linnaeus and Franklin. By such gestures and acts the elder Peale's life would continually assert a panoramic ambition for achievements as much in the arts as in the sciences. Certainly the two fields were aligned in one son's tribute to another, seated before him as both would-be artist and scientist. Thus by names and dates alone, this work is partially about beginnings—of young lives, a new nation, an American artistic tradition, a new century. It is a multiple record of newness and originality, a statement of belief in growth, promise, and regeneration, whether in sense of family or of nature.

Surely with this painting Rembrandt Peale began his own artistic maturity. He had been born in Bucks County, Pennsylvania, while his father was away serving in Washington's army. After the Revolution, Charles Willson Peale's professional practice accelerated, as he continued to paint portraits of prominent Americans, pursued his scientific enterprises, and realized ambitious plans for art exhibitions, an academy, and a museum. In this atmosphere young Rembrandt began to draw at the age of eight, produced his first self-portrait at thirteen, and undertook professional work at sixteen.[3] The elder Peale was familiar with the old master tradition, having studied with Benjamin West in London. But unlike West and John Singleton Copley, who had felt it imperative to conclude their artistic successes abroad, Peale returned to Philadelphia with a personal mission of making contemporary history paintings in America.

Peale's Philadelphia was itself an enlightened environment, for it was foremost Benjamin Franklin's city, but in the last decade of the eighteenth century it also hosted Benjamin Latrobe and William Strickland in architecture, view painters like Francis Guy and William Groombridge, the landscapists William and Thomas Birch, and the preeminent portraitists of the Federal period, Gilbert Stuart and Thomas Sully. During this same decade the city served as the first seat of the new American government, focused on the central embodiment of national paternity in George Washington. Civilized equally in politics and the arts, Philadelphia was in the forefront of defining the nation intellectually and culturally.[4] The Constitution was signed there in 1787, followed by a year of intensive debate over national governance in *The Federalist Papers*. In Latrobe's and Strickland's hands American architecture took on a powerful new classicism. The former built his first two major banks in Philadelphia in the 1790s, as well as his precocious Greek revival Centre Square Waterworks to meet the city's growing population

needs. In addition, fine cabinetmakers and silversmiths were producing high-style decorative arts under prospering local patronage.[5]

By the time Rembrandt Peale was twenty, Philadelphia was home to a number of influential painters. The Birches had arrived from England in 1794, Adolph-Ulric Wertmuller and Gilbert Stuart came the next year, while the English portraitist and history painter Robert Edge Pine had been settled for a number of years. Peale's father Charles Willson reached a high point in his own professional activities: in 1794 he opened his first art academy and the next year held his first public art exhibition, the Columbianum, followed in 1796 by the opening of his museum of "natural curiosities." His major artistic achievement was his painting of *The Staircase Group* in 1795 (fig. 25), a visual tour-de-force that depicted his sons Raphaelle and Titian and provided an indelible and immediate family precedent when Rembrandt chose to paint his other brother Rubens. Also in 1795 father and son shared another artistic project: the painting of Washington's portrait. Stuart had already painted his first famous likeness earlier that spring, which possibly prodded the aspiring Rembrandt to undertake his own version. With recent training in life drawing, study of classical casts, and the completion of a few youthful portraits, he nervously readied himself for this first great professional challenge. To proceed confidently, he urged his father to join him with a matching canvas and easel, which "had the effect to calm my nerves, and I enjoyed the desired countenance whilst in familiar conversation with my father."[6] The result was a Washington portrait (Historical Society of Pennsylvania) of great sympathy and immediacy, rich and descriptive in its textures, direct and unequivocal in its realism, setting a mark of understanding and ability that forecast the near magical sensitivity of *Rubens Peale with a Geranium* six years later.

In such circumstances Rembrandt prepared to invent and execute his new painting. Historians of this period have correctly argued that artists felt a certain ambivalence about pure portraiture. On the one hand, Stuart and Sully exemplified the "rage for portraits" in Federal Philadelphia; on the other hand, Peale was one who felt the calling somehow inadequate, especially as he saw artists like Allston, Vanderlyn, Trumbull, and Morse attempt with mixed success to meet the shifting tastes of time.[7] Peale aspired to his own form of history painting, as evident in his eventually making ten copies of his 1795 Washington portrait and, after 1824, some seventy-nine versions of the so-called Patriae Pater or "port-hole" portrait of the president. These he intended to be "the standard National Likeness" of Washington, certainly embodiments of a grand nationalist iconography.[8] Arguably, Peale's best early portraits were either those of preeminent national figures like Washington and Jefferson or of family members, foremost being his father and brother.[9] All of these captured a combination of realism, grace, and psychological immediacy, elements that would be perfectly distilled in the 1801 image of Rubens occupying the left half of that canvas.

And what of its right side? The geranium plant is of course a still life in artistic convention and an exemplum of botanical science. As a subject of concentrated attention, still life was already very much established in the artistic lexicon of the elder Peale painters. A still-life composition—a plate of

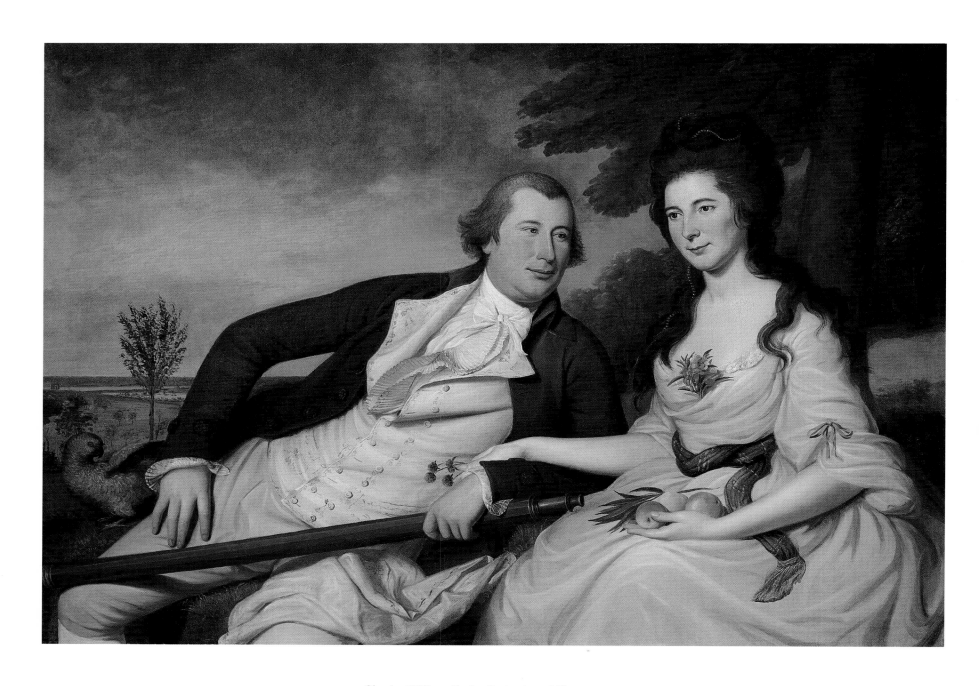

57. Charles Willson Peale, *Benjamin and Eleanor
Ridgely Laming*, 1788. National Gallery of Art,
Washington, Gift of Morris Schapiro

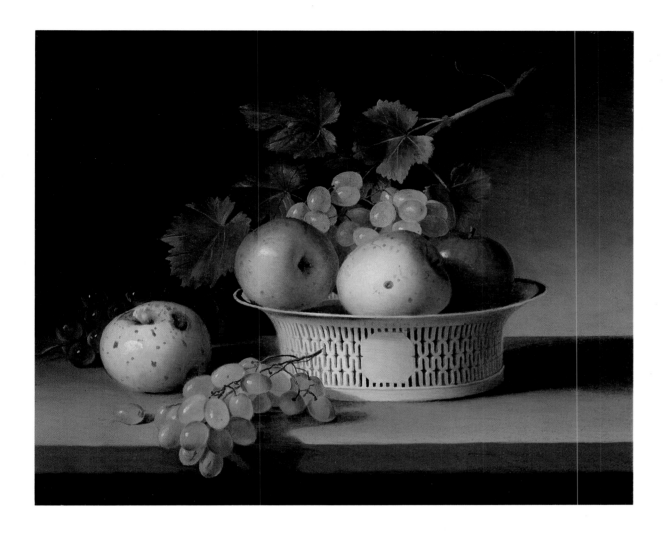

peaches with a knife and playful "peel" of fruit skin—literally occupied the center of Charles Willson's first major canvas, his large group portrait of *The Peale Family*, c. 1770–1773 and 1808 (fig. 22). Fruit and flowers together were significant emblems of domestic fruition and felicity in his double portrait of *Benjamin and Eleanor Ridgely Laming* (fig. 57). Not only is the couple at ease in the landscape setting but the central details of flowers at the wife's bosom, ripe peaches in one of her hands,

clover in the other, convey a sense of organic harmony joining Man with Nature. Charles Willson also taught his younger brother James the rudiments of painting, and by the 1790s this second Peale was an accomplished painter of portraits, miniatures, and still lifes. Stimulated both by his brother and by his nephew Raphaelle, James produced some of the family's most sensuous and elegant fruit arrangements, which culminated in his *Fruit Still Life with Chinese Export Basket* (fig. 58).

58. James Peale, *Fruit Still Life with Chinese Export Basket,* 1824. Jeanne Rowe Mathison Family in Memory of Robert Vincent Mathison

Even more, the treatment of ripe fruit and fresh flowers by the Peales presented the still life as a microcosm of nature, with specimens drawn from the common garden and from scientific investigation. In part, Rembrandt's depiction of his brother is a tribute to Rubens' early interest in botany. As a boy, the latter had studied botany as well as mineralogy, and he had assisted his father in the selection and installation of specimens in the Peale museum. The two brothers worked together for a number of years in their father's scientific excavations and museum projects.[10] Both sitter and painter were immersed in the shared universe of nature and art. Rubens' interest in exotic plants and rare seeds apparently arose as a counter to the frustrations he felt pursuing art with imperfect eyesight. As a boy he was active in cultivating exotic seedlings for his father, and he had early success in growing tomatoes and the geranium. Thomas Jefferson in particular had difficulty raising the latter but was captivated by its color and presumed medicinal properties.[11]

Almost at the same time Rembrandt was painting Rubens' portrait, Jefferson entered the White House, where he proudly displayed this bright and unusual plant in the East Room: "Around the walls were maps, globes, charts, books, &c. In the window recesses were stands for the flowers and plants which it was his delight to attend and among his roses and geraniums was suspended the cage of his favorite mockingbird."[12] But in addition to the president's noted interest in this specimen and his wider concern with nature's cosmos, there was a more immediate and influential tradition of botanical and natural science in the Peales' native Philadelphia. Alexander Wilson, author of *American Ornithology,* was a fellow naturalist and a colleague of Charles Willson Peale's. (The artist also knew Charles-Alexandre Lesueur, the French artist-naturalist who came to the United States in 1816.) Wilson worked for a time in Peale's museum and had a school on land owned by William Bartram (1739–1823), one of the foremost naturalists of the day. Bartram was born near Philadelphia, the son of John Bartram, America's first great botanist. The son traveled and sketched extensively, having been trained as a young man by his father, for whom he collected and drew specimens during their journeys through the southeastern colonies in the mid-1770s. Peale and William Bartram were certainly familiar with the beautiful and exacting bird sketches by Mark Catesby, whose *Natural History of Carolina, Florida, and the Bahama Islands* had been published in 1754. Bartram kept a journal on his travels and made dozens of watercolors and drawings from life (now in the British Museum), which were described by his sponsor, Dr. John Fothergill, as "elegant performances." Two of his early watercolors of birds were published in George Edwards' *Gleanings from Natural History* (London, 1758), and another large group of drawings illustrated Benjamin Smith Barton's *Elements of Botany* in 1803.[13] Peale honored his friend by including him in his panoramic group painting, *The Exhumation of the Mastodon,* 1806–1808 (The Peale Museum, Baltimore), and by a sensitive portrait in 1808 (Independence National Historical Park Collection, Philadelphia) showing Bartram with a sprig of white jasmine in his lapel.

In 1798 Jefferson, then president of the American Philosophical Society, appointed Charles Willson Peale to a committee

charged with collecting information about the country's natural and archeological antiquities. This led to the society's partial sponsorship of Peale's 1801 excavations in upstate New York. Not long after, as president of the United States, Jefferson also initiated the ambitious Lewis and Clark Expedition to explore and chart the western interior of the American continent. In a sense these were national ventures determined to claim an ancient natural history for the new nation. Certainly, all these scientific activities linked to Philadelphia and to the Peales provided fertile ground for young Rembrandt's conception.

Other biographical events in the years just preceding his painting of Rubens' portrait may have made Rembrandt further conscious of family generation and regeneration. His younger brother Titian died in 1798 at the age of eighteen, but the next year a new half brother was born and given the same name, and Rembrandt's own first child Rosalba was born. A year later a second daughter Angelica followed. We can only imagine that such family growth and change would provide at least one layer of meaning in the tender depiction of a youth and his flowering plant. Simultaneously the family was joined in the adventure of nature's history at work: in the summer of 1801 Rembrandt accompanied his father up the Hudson River to the site of the mastodon excavations, sketching the landscape en route. The elder Peale later recalled that "my son and Doctor Woodhouse was astonished with the sublimity of the Sciene, we were called to Dinner, and although the hunger pressed yet the attraction of the View of the mountains were more forcible. The storm increased, it rained very hard, and thundered—Rembrandt exclaimed the

scene was awfully grand he wished to be able [to] paint the affect and staid as long as was prudent."[14]

In fact, Rembrandt had painted at least two strong portraits in 1797 of sitters posed against a landscape background, his Baltimore cousin *Anne Odle Marbury* and *William Raborg.* A little over a decade later he was inspired by Jefferson's *Notes on Virginia* to paint a view of Harper's Ferry.[15] Thus, nature in full or in detail was very much in his mind as he turned to the geranium portrait. Of course, there were existing artistic conventions in both European and early American painting for sitters posed with ancillary still-life details or placed beside a landscape view. John Singleton Copley's mature American portraits most readily come to mind. Aside from those depicting flowered patterns on dresses, curtains, and rugs, or others of women with flowers in their hair or pinned to their bosom, there are more than a dozen well-known female portraits painted by Copley during the 1760s and early 1770s containing prominent still-life elements. Sitters variously hold bouquets or baskets of mixed flowers, branches of cherries or lilies, bunches of grapes, fruit in the folds of their dresses, flowers picked from a nearby bush, a vase of roses, or a glass with a mixed spray.[16] Perhaps most relevant to the Peale legacy are examples like *Mrs. Ezekiel Goldthwait,* 1770–1771 (Museum of Fine Arts, Boston), who reaches out to rest her hand on a bowl of ripe peaches and apples; and *Mrs. Moses Gill,* c. 1773 (Rhode Island School of Design Museum, Providence), who stands beside a pot of tall lilies.[17]

In addition, there is the curious but improbable precedent of Copley's English portrait of *Mrs. Clark Gayton,* 1779 (Detroit Institute of Art), which must be the first

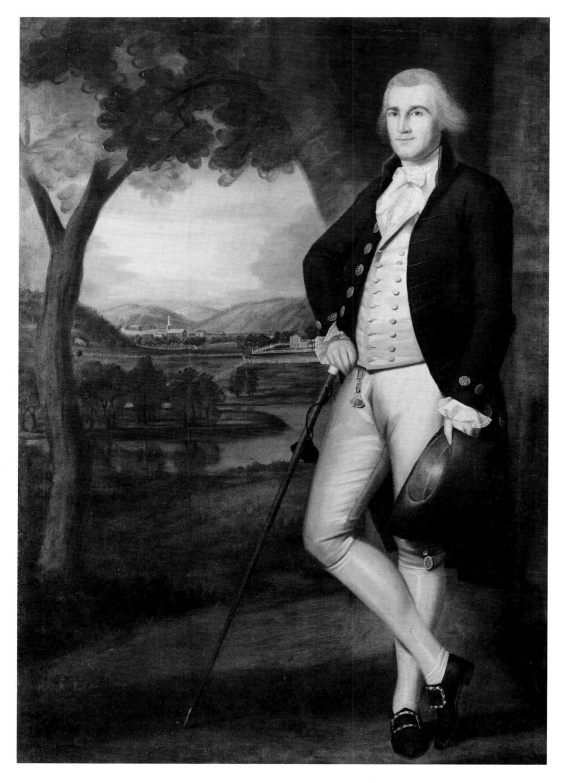

American depiction of a sitter posing before a potted geranium. As the provenance indicates that the canvas descended in the family of the original English owner and did not come to the United States until a sale in the early twentieth century,[18] it is doubtful that Peale knew this image firsthand. The subject confirms the interest in this uncommon plant in England as well as America during the last quarter of the eighteenth century. A French artist, Henri-Horace Roland de la Porte, also painted a striking still life of a flowering plant in a terra-cotta pot, *Une Justicia* (The National Swedish Art Museums), about the same time, again suggesting a similar vision of increasing scientific realism in this age of Enlightenment.

When we look again at *Rubens Peale with a Geranium* (fig. 56), it is clear that Rembrandt Peale has transcended Copley's conventions in at least two ways: in the utter directness and informality of pose and in the fluid, textured rendering of details. This freshness of presentation in both conception and technique was the perfect reflection of a youthful artist with a bold vision. At the same time, a new sense of immediacy and unpretentiousness was beginning to appear in American painting after the Revolution, as artists sought to adapt European styles to the young republic's democratic character, its celebration of the individual and the landscape. Indicative of this emerging sensibility is Ralph Earl's full-length portrait of *Daniel Boardman*, painted in 1789 (fig. 59). Now the figure not only poses comfortably before an expansive New England panorama, he literally stands to one side with the landscape fully occupying its own half of the portrait. Although the stance and the view derive from eighteenth-century English compositions, the relaxed air of the

subject and the conscious prominence of American nature establish the very formula for the iconography and design of Peale's portrait just over a decade later. Peale was to go one slight but decisive step further: his emblem of nature not only occupies an equal half of his canvas, the potted geranium actually stands forward of the figure in a narrow plane just in front of Rubens' torso. Yet the two parts of the portrait are naturally intertwined as some of the upper leaves and stems start to reach across Rubens' head, while his hands and eyeglasses rest comfortably near or on the clay pot.

This casual pose and gesture of hands sensitively linked to the sitter's work again call to mind some of Copley's more observant and clever depictions. For example, *Paul Revere,* 1768–1770 (Museum of Fine Arts, Boston), visually balances the rounded form of the silversmith's head with that of the teapot below; moreover, each hand echoes the other, as one serves as prop under Revere's chin while the other cradles the silver pot.[19] The artist links intelligence with action by such subtle contrasts, at once describing and interpreting his subject's professional creativity. Rubens Peale, by holding his spectacles in one hand and the rim of the pot in the other, connects for us his acts of seeing and doing.

A more immediate influence probably existed in the work of Gilbert Stuart, who had just settled in Philadelphia in the formative years of Rembrandt Peale's life. At the height of his powers, Stuart had completed one of his masterworks in *Mrs. Richard Yates* (fig. 60) only a year before his arrival in 1795. Here was a lightness of touch and texture, musical harmonies of tone, and a delicacy of line and accent that would inform his best portraits of Washington and

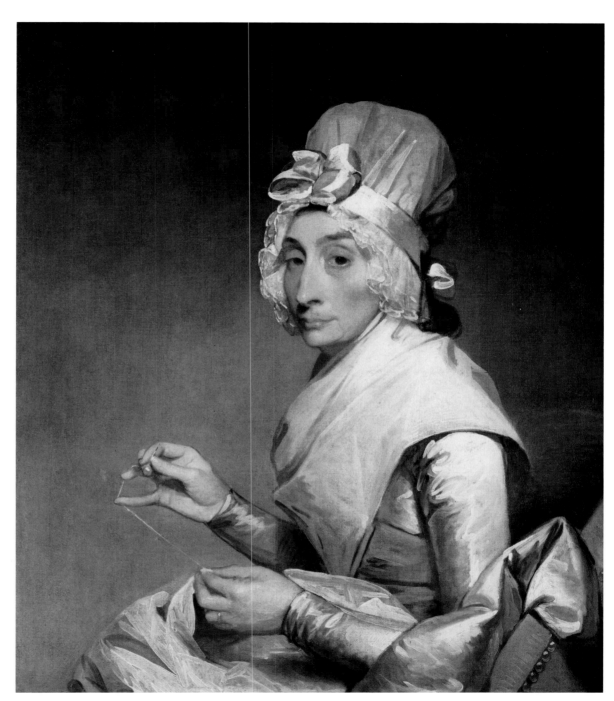

60. Gilbert Stuart, *Mrs. Richard Yates,* 1793–1794. National Gallery of Art, Washington, Andrew W. Mellon Collection

59. Ralph Earl, *Daniel Boardman,* 1789. National Gallery of Art, Washington, Gift of Mrs. W. Murray Crane (*opposite page*)

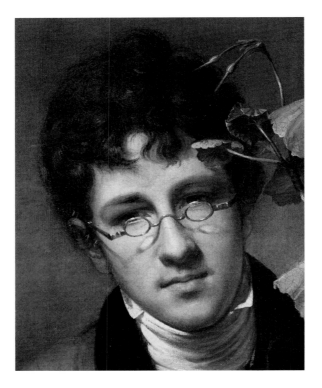

Closer inspection of some of its details suggests an even more idiosyncratic touch: the wilting leaves of the plant and the presence of two pairs of spectacles, for example (figs. 61–63). In fact, each gives further insight into Rubens Peale's life and work. The long-standing myth that Rubens' geranium was the first imported to America, a claim that variously appears in some early listings of the pictures, goes back to his daughter Mary Jane Peale's will in 1883, which referred to "*The Portrait* of Father with the Geranium, the first brought to this country, and painted on account of the plant which shows that it was in the studio being a little withered."[21] Several subsequent exhibition catalogues repeated this assumption, one in 1923 quoting an old typed label on the reverse of the canvas to the effect that this was "said to have been the first specimen brought to America."[22] But recent historians now believe that geranium seeds were imported and cultivated prior to Rubens' effort in 1801. By this time there was a craze for the plant in England and Europe. Jefferson's example was introduced from South Africa, and one index of the plant's popularity in America was the publication in 1806 of the *American Gardener's Calendar* with instructions for raising geranium seedlings.[23]

other individuals at this time. What particularly enlivens the three-quarter pose, along with the glance that we feel has just momentarily turned from concentration on work, are Mrs. Yates' two hands caught lifted in the action of sewing. Stuart's sense of the momentary and the personal helps to make his sitter more accessible, an attitude that carries over to the Peale work. But Stuart's influence was also to be felt in transforming Rembrandt's early delicate and linear style into a more painterly and fluid one.[20] The result was an image of his younger brother that at once suggests shyness, modesty, and pride: presenting his remarkable success in cultivating his plant and ready to take his father's mastodon bones on tour to Europe. The painting thus memorializes both accomplishment and expectation.

Doubtless Rubens' scarlet flower was among the first to blossom from seed, and by all accounts he cared passionately and worried much about his specimens. The geranium that Rembrandt depicted here has but a couple of new blooms, and the wilting leaves hint of the struggle to bring the plant to flower (fig. 62). When the brothers departed for England the year after the painting's completion, Rubens feared that no one would care properly for his beloved rari-

ties.[24] Surely one of the most eloquent details recorded by Rembrandt is that of his brother's right hand reaching across to rest on the lip of the geranium pot. It is a dual gesture, as Rubens both checks the moisture in the soil and claims possession of his creation. In contrast to the bright new flowers above, the middle leaves sag, a lower one has started to decay, and a dead one has fallen off at the lower right. This intimate cycle both illustrates and symbolizes nature's process of regeneration. It is also a process with human involvement, for as Rubens' two fingers lightly touch the soil (fig. 63), there is above the echoing gesture of the two bare stems arching over to the top of his head (fig. 61). Although contained in the pot, the growing plant in its dirt represents a piece of the larger landscape and a wider natural world.

If Rubens' dedication to his project bore flower, it was as a result of his overcoming handicaps of health and particularly of eyesight, which had inhibited his ability to pursue the family profession of painting. In

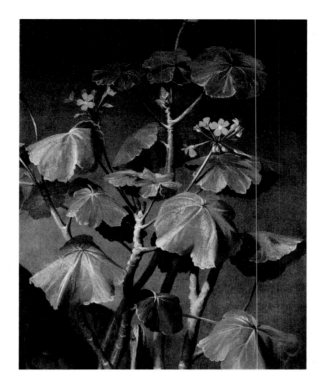

61. Detail of fig. 56 (*opposite page*)

62. Detail of fig. 56 (*above*)

63. Detail of fig. 56 (*below*)

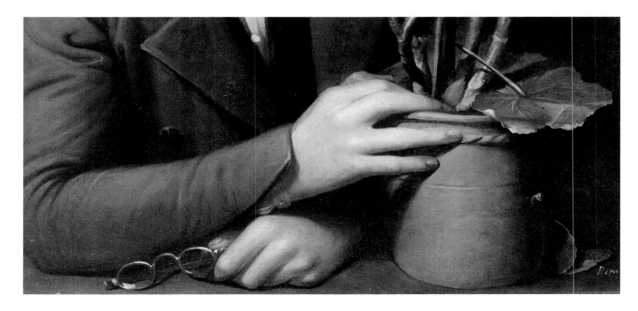

older age he wrote about his childhood frailties in the third person, with occasional hyperbole:

> It is said he was so small when 3 or 4 days old, that he was put into a silver mug & the lid shut down over him. . . . I was very delicate in health and our family physician Dr. Hutchins required that I should be kept out of the sun as much as possible. . . . I made little progress at school for my sight was so imperfect. . . . One day . . . I went into the garden and took the watering pot and watered my flowers which I was forbidden to do, and after that time I gradually increased in strength and health.[25]

Poor eyesight also plagued his brother Rembrandt, who wrote about their respective afflictions in his own "Reminiscences" in 1856:

> Perhaps there is no recollection of the events of my life of greater value, than my experience in regard to the preservation of sight, which can be duly appreciated by no class of human beings, more than by artists. That I, in my 79th year, am now able to paint all day and read half the night, is owing to the care I have taken of my eyes, after having greatly injured them. . . .
>
> I was forty years of age, before I began the use of spectacles. Finding that I was obliged to hold the newspaper close to the lamp, I was induced to get glasses of forty inches focus. I painted with them, and in a little time by judiciously, but not constantly, wearing them, could see with them at all distances. After a few years, it was necessary to employ a shorter focus—thirty-six inches, for reading at night, and occasionally in the day. Another lapse of time demanded a third pair of glasses—twenty-four inches. All these I carried in my pocket, and never minded the trouble of changing them, according to varying circumstances.[26]

No wonder two pairs of glasses should appear as critical details (figs. 61 and 63) in the portrait of his brother, who evidently had even greater trouble seeing. By Rembrandt's account, Rubens:

was so near-sighted, that I have seen him drawing . . . looking sometimes with his left eye, and then turning to look with his right eye, the end of his nose was blackened with his greasy charcoal. He was slow in his progress at school. . . . At ten years of age he only knew two letters, *o* and *i*, never having distinctly seen any others. . . . No *concave* glasses afforded him relief; but at Mr. M'Allister's, the optician, my father being in consultation on his case, there lay on the counter several pairs of spectacles. . . . Taking up one of these and putting it on, he exclaimed in wild ecstasy, that he could see across the street. . . . In London in 1802, he was present at a lecture on optics, by Professor Walker, who declared he had never known another instance of a short-sighted person requiring strong magnifying glasses.[27]

In fact, what Rembrandt described in 1856 as "short-sighted" vision is what we know today as classic farsightedness, in which images come into focus behind the retina of the eye, making distant objects much easier to see than those close up. The true nature of this condition of hyperopia was not fully elucidated until several years later.[28] Before that time other early nineteenth-century accounts confirm Rubens' poor eyesight and the efforts to correct it. In 1802 John Isaac Hawkins, a scientific associate of Charles Willson Peale's, gave the Peale museum his physiognotrace, a device for tracing small silhouette profiles (once again marrying artistic and scientific functions). It was then that he learned about the artist's son, whom he later recalled:

> I knew twenty-five years ago a very extraordinary exception to the use of concave glasses for near sighted eyes, in a young man in Philadelphia; he tried concaves without any benefit, but accidently taking up a pair of strong magnifiers, he found that he could see well through them, and continued the use of strong magnifiers with great advantage.
>
> I now allude to Mr. Rubens Peale. . . .[29]

Yet another family reminiscence tells of Rubens as a boy coming upon a "burning glass" in the upper rooms of his father's museum, headquartered in Philosophical Hall. Accidently discovering its capacity for improving his sight, he rushed to tell his father but, disoriented, tripped on the stairs and fell into the older man's arms. This incident in 1796 led Charles Willson to order corrective lenses for his son. Five years later Rubens would pose comfortably in them for this portrait, though at first he evidently suffered the taunts of school friends and simply remarked that "since I find them useful, I do not regard anything they may say about my use of spectacles."[30]

Rembrandt's reference to their father's consultation with John McAllister about making spectacles brings up an active correspondence between these men and between McAllister and Thomas Jefferson as well. In a letter of 1806 the optician wrote to the president regarding the details of a pair of spectacles he had ordered; in passing he noted, "I have done a number of spects with near & distance focus in each eye. I fitted two pair lately for Mssr. Jas. and Charles Peale for painting miniatures that answer extremely well." He went on to say that careful calculations could make possible limiting the number of glasses to various seeing distances: "By knowing this I may suit your needs with 2 or 3 pairs of glasses than otherwise by a great many."[31] Used sequentially or even in combination, such pairs provided the benefits of today's bifocals and trifocals.

Bifocals were known originally as an invention of Benjamin Franklin sometime before 1784. In France at the time, he is believed to have corresponded with Jefferson on the subject. During the 1790s William Richardson, a Philadelphia hardware merchant, was already supplying imported spectacles to Washington and Jefferson. In 1799 he sold the business to McAllister, who continued to do business with Jefferson. McAllister's first shipment of new glasses reached Philadelphia in early 1800, and almost certainly the ones shown with Rubens Peale in his portrait the next year are from that group.[32]

What now requires some examination is how the two pairs of glasses in the painting relate to one another. An absolute answer is not easy, because the sitter's daughter, Mary Jane Peale, in her last will and testament unambiguously stated that the portrait "was at first painted without the spectacles and afterwards put on."[33] Speculating further on this record, a recent biographer has argued that "he was originally painted holding his spectacles but it was later decided that he would look more like himself with them on. When the second pair was added, the first was never deleted."[34] Here it may be argued that a familial recollection late in life of an event that occurred over three-quarter's of a century before was devoted but faulty.

First of all, there is no physical or conceptual evidence to support such an alteration. Conservation study of the surface and x-ray examination of the passage give no hint of measurable pentimenti, local changes in paint thickness, or any reworking of the key area. Nor does a later addition of the upper eyeglasses make any sense imaginatively. To the contrary, these spectacles seem so integral and central to the entire effect and meaning of the painting that they must have been part of the intention and composition from the start. For an individual so dependent on spectacles for the very act of his scientific vision, and here so absorbed in distant thought, yet immedi-

ately alert, it is inconceivable that Rubens' portrait could show him without his wearing glasses. Removed, his eyes would read as uninteresting shadowy recesses, and the cheeks below as soft, bland surfaces. The face is too critical to the design and would not have compelling visual character otherwise. As a positive argument, we can only marvel at the harmony of ovals these glasses make, echoing the eyes just above and their balanced shadows below, with the larger oval curves of the head itself, the white shirt collar, and even the foreshortened rim of the clay pot. In a final conceit that could hardly have been an afterthought, the glasses delicately curve across the eyes behind, with the highlights on the rims coinciding exactly with the pinpoint reflections in the pupils. With the eye surfaces so divided they pun on the very idea of bifocal vision.

Assuming both pairs of glasses were indeed intentional, let us then consider whether these were meant to be identical or interchangeable. As McAllister's correspondence with Jefferson and Charles Willson Peale indicates, it was commonplace for the optician to prescribe several lenses of different powers for varying levels of focus. Rubens Peale unquestionably needed some magnification for his scientific scrutiny of specimens at hand and another type of lens for intermediate and distant vision. With his plant close by and the world before him, two pairs of glasses would have been natural. This does not necessarily argue that the spectacles in his hand were used on occasion to replace those he is wearing. Some careful observers have noticed the very fine horizontal line intersecting the right-hand lens closest to Rubens' thumb and forefinger (fig. 63). This has led to the suggestion

that this pair might be an actual example of true bifocal glasses. In fact, this is most probably another of the artist's visual puns, for the left lens does not bear a comparable division line, and what we are seeing is the frame support (that extends from the spectacles back over the ear) folded up behind the lens.[35]

One other aspect of this lower pair of glasses is intriguing: the ovals are decidedly larger and the bridge wider than in the set Rubens is wearing. The two frames are clearly different, most obviously in the bridge configuration, again suggesting that Rembrandt did not begin by painting his brother with a generic pair and then, dissatisfied, decide to place the same pair on his face. Recent scientific thinking has offered the most logical explanation: "Perhaps the reason for the wider bridge was so that the spectacles could be worn further down the nose, for reading or close work purposes, while at the same time wearing the 'distance' glasses (thus providing a 'two-focal' system)."[36] Optometry aside, this intricate imagery serves to reinforce on a deeper level the links between hands and eyes, between observation and intelligence. That we have concentrated so much attention on this critical element of the portrait profoundly reinforces the thesis that the work is about such abstractions as seeing and vision, perception and art itself.

Up to this point Jefferson's name has been invoked often enough to indicate his pervasive importance as an intellectual presence at times directly linked to the Peales' world, and as a shaper of the part of American culture pictured in this one focused image. He grew geraniums both at the White House in Washington and at Monticello, and he cared about their nourishment

by the human hand, seeing an affinity between the organic life of man and nature: "If plants have sensibility, as the analogy of their organization with ours seems to indicate. . . ."[37] At Monticello his greenhouse was located on the south piazza, where his geraniums and other most delicate specimens might receive the best daylight and warmth. Significantly, this room was also adjacent to his cabinet and library, integrating his entire world of learning, much as man and plant stand in balance next to one another in Peale's painting.

Jefferson had already made, in the words of one historian, "natural history the queen of sciences," when he wrote his one comprehensive book, *Notes on the State of Virginia,* in 1785.[38] Itself an original creation in American literature at this time, it sought to summarize the universe of facts concerning Jefferson's native soil in a matter-of-fact language. His chapters were in effect inquiries into Virginia's boundaries, rivers, mountains, birds, animals, and minerals. A section of "Query VI" was devoted to the principal vegetables, which Jefferson logically subdivided in several ways. He drew distinctions among trees, plants, and fruits, between imported versus native plants, and between gardens versus orchards. Typically he pursued accuracy over pedantry:

> A complete catalogue of trees, plants, fruits, &c. is probably not desired. I will sketch out those which will principally attract notice, as being 1. Medicinal, 2. Esculent, 3. Ornamental, or 4. Useful for fabrication; adding the Linnaean to the popular names, as the latter might not precisely convey precise information to a foreigner. I shall confine myself too to native plants.[39]

In this context the geranium both as image and as specimen was but one notable item in the varied inventory of meats, vegetables, fruits, flowers, plants, and berries depicted in the Peale family's still-life paintings.

Jefferson further contributed to an American vision of newness identified with nature and geography in many of his other great pronouncements, for example: "The Creator has made the earth for the living, not the dead," an assertion of the sovereignty of the present and the future.[40] Most prominently, he announced the political equivalents in the Declaration of Independence: "It is the right of the people . . . to institute new government"; and ten years later in the Bill for Religious Freedom, 1786, he drafted for Virginia, the country's first statements of separation between church and state and freedom of thought.[41] Throughout this period, of course, he was designing and building in phases his house at Monticello, a fresh and creative statement in American architecture, full of practicality, ingenuity, idealism, and humanity. But Jefferson's sense of America as a revolutionary experiment had an even closer chronological parallel to Peale's portrait in his first inaugural address as president, 4 March 1801. The election the year before was not only the first of the new century, it was the first between two organized political parties after the national union under George Washington. In the following year as young Rubens was posing for his brother, Jefferson stood to proclaim "a rising nation, spread over a wide and fruitful land. . . ."[42] What he said then led two years later to the Louisiana Purchase and, immediately after, to the Lewis and Clark Expedition into the northwest wilderness, in which America's grandest ideas of continent and destiny were charged into action. Such imagery and attitudes would dominate American life for more than the next quarter century, echoing pas-

sionately in the expressions of Thomas Cole, Ralph Waldo Emerson, and Daniel Webster, who could assert in 1825, "American glory begins at the dawn."[43]

Jefferson's powerful documents stimulated an entire generation to envision the interchangeable ideas of freedom and newness. Following the signing of the Constitution in Philadelphia on 17 September 1787, Alexander Hamilton, James Madison, and John Jay publicly deliberated in a sequence of eighty-five lengthy essays, known as *The Federalist Papers,* the meaning and implementation of the republic's originating documents. Between October 1787 and May 1788 they discussed the separation and interdependence of powers, the balancing of forces within the structure of government, and above all the desire for unity and stability in order "to form a more perfect Union." Repeatedly the authors turned to a phraseology of invention and originality, as Hamilton in no. 1: "You are called upon to deliberate on a new Constitution"; or no. 14: "the form of government recommended for your adoption is a novelty in the political world." In the same paper Hamilton went on to conclude: "They accomplished a revolution which has no parallel in the annals of human society. They reared the fabrics of governments which have no model on the face of the globe. They formed the design of a great Confederacy. . . ."[44] Subsequently, Madison paid a deserved tribute to Jefferson and his role: "The plan, like everything from the same pen, marks a turn of thinking, original, comprehensive, and accurate."[45]

In addition to these political figures, two other intellects of the period are worth citing for their concurrent contributions to this new American age: Benjamin Franklin

and Noah Webster. The former held a special place of reverence in Philadelphia as a personification of the Enlightenment, who harmonized (not least because of his ingenious bifocals) farsightedness and clearsightedness. He exemplified the self-made individual, prudent yet inventive, thrifty yet revolutionary, plain yet forceful. Although he died in 1790, a decade before Rembrandt Peale undertook his portrait, Franklin's life and achievements immediately begot a powerful mythology. Actually, his life became a two-fold accomplishment, the one he lived and the one he recorded. It is the latter, *The Autobiography of Benjamin Franklin,* first published in part in 1791 and 1793 and reprinted nearly complete in 1818, that made a contribution to American culture and history as original as Jefferson's *Notes,* Hamilton's *Federalist Papers,* or Rembrandt Peale's portrait of *Rubens Peale with a Geranium.*

Although autobiography as a form of literature already existed in Europe and elsewhere, what historians have seen in Franklin's work as being uniquely American and fresh is its unpretentiousness. He used colloquial expressions, clear images, and an informal manner, which speaks to us with a directness comparable to Peale's painting. Like Jefferson, he believed in the glory of the living, active present. As a friend of Franklin's wrote in 1783, he was "connected with the detail of the manners and situation of a *rising* people."[46] While Jefferson and Peale might turn to the example of nature for their metaphors of growth and promise, all shared an outlook in common. Woodrow Wilson wrote of Franklin in an introduction to a 1901 edition of the *Autobiography:* "Such a career bespeaks a country in which all things are making and to be made. . . . [the autobiography] is letters in business garb,

literature with its apron on . . . setting free the processes of growth."[47]

For all of Franklin's stature in Philadelphia as a diplomat, inventor, and writer, we may readily come back to the subject of *Rubens Peale with a Geranium*, for Franklin also exemplified that city's reputation as America's horticultural capital. Along with the Peales, Wilson, and the Bartrams, Franklin was equally honored as a natural scientist. In fact, Philadelphia could claim several individuals who as professional or amateur naturalists identified or cultivated rare new species of flowering plants, among them the Franklinia, a shrub with showy white flowers; the wisteria bush named after the anatomist Caspar Wistar; and the poinsettia plant discovered in Mexico by America's first ambassador to that country, Joel R. Poinsett.[48] Proudly the young Rubens Peale could take his place in this lineage, for he had himself been the first to introduce the tomato plant to his native city and was now ready to take credit for his early success in growing his scarlet geranium to full maturity.

In the broadest sense, what we have been talking about thus far are the definitions and rhetoric of American character and will. Fittingly enough, the young republic was able to summon up not just a language of independence and new governance, along with original literary and pictorial forms of self-expression, but also a new language itself. Taking on this task at the very same time was the New Englander Noah Webster (1758–1843), who was descended from colonial governors of Connecticut and Massachusetts. After graduating from Yale in 1778, he tutored in law with Oliver Ellsworth and was admitted to practice in Connecticut a few years later. The law had

stimulated him to think about the precision of meanings and definitions, the logic and process of explication. He soon began teaching and wrote his first primer on spelling. In 1783 he published *A Grammatical Institute of the English Language, Comprising an Easy, Concise, and Systematic Method of Education, Designed for the Use of English Schools in America.* This appeared in repeated later editions and was followed in 1806 by *An American Dictionary of the English Language,* whose stated purpose was "organizing and clarifying the language."[49] Like other aspects of American culture, design, and customs, these titles imply the nation's gestures in acknowledging its inheritance while declaring its separation. Although Americans still speak English, Webster began the process of claiming new spellings, pronunciations, meanings, and even new words. He was at one with his age in wanting to nurture young seedlings in an American soil.

That optimistic vision in large part held the national imagination through the country's first century, even with the interrupting crisis of civil strife and self-questioning in the 1860s. By the centennial of 1876 a colonial revival in architectural and design styles was underway, and the cult of American youth was never more possessing, as citizens celebrated their origins and the course of destiny. Mark Twain's novels and Winslow Homer's paintings conspicuously placed youth in the center of the American landscape. In particular, the latter's *Breezing Up, A Fair Wind,* 1876 (National Gallery of Art), set a group of boys beside an old man in the catboat's cockpit, a reminder of history's passage, but also a dream in maturity of renewable freshness.

Another picture completed that same year in Peale's native Philadelphia was *Baby*

64. Thomas Eakins, *Baby at Play*, 1876. National Gallery of Art, Washington, John Hay Whitney Collection

at Play by Thomas Eakins (fig. 64). Since Peale's day, that city had remained a center of American scientific studies. Mindful of the upcoming centennial, Eakins began work on his monumental composition of *The Gross Clinic*, 1875 (The Jefferson Medical College of Thomas Jefferson University, Philadelphia), a tribute to modern Philadel-

phia medicine and the foremost surgeon of the day, Dr. Samuel Gross. At the same time Eakins also conceived a pictorial homage to Philadelphia's first important sculptor, *William Rush Carving His Allegorical Figure of the Schuylkill River*, 1876–1877 (Philadelphia Museum of Art). *Baby at Play* was a portrait of Eakins' niece Ella, the first child of his sister,

at play in the family's back courtyard. Like the dramatic clinic picture of the preceding year, this focused on a central figure engaged in connecting the concentration of mind with the action of the hand. But instead of depicting the fulfillment of experience, this showed the beginnings of learning.[50] Aside from its personal meanings for Eakins, could it also have been a companion salute to another early Philadelphia artist? Among its most noteworthy details is a large potted plant on the ground to the right. Although vague and without flowers, its bare stems and large leaves could well characterize a geranium. Having acknowledged the history of local medicine and sculpture, Eakins could have equally intended here a private recognition of his city's first family of painters and explicitly Rubens Peale's geranium plant, for Eakins similarly cared about the creative role of the artist and about the joining of art and science. Whether tribute or tradition, it certainly recalls Rembrandt Peale's earlier meditation on human intellect and perseverance. Rembrandt's fraternal portrait of *Rubens Peale with a Geranium* is testimony as much to their father's "Great School of Nature" as to Jefferson's "rising nation, spread over a wide and fruitful land."

Notes

1. For a discussion of Raphaelle Peale's still-life painting as an exemplum of American ideas and culture in the Federal period, see my "The American Object: Still-Life Paintings," in *An American Perspective: Nineteenth-Century Art from the Collection of Jo Ann & Julian Ganz, Jr.* [exh. cat., National Gallery of Art] (Washington, D.C., 1981), 85–111; and "Important Information Inside: The Idea of Still-Life Painting in Nineteenth-Century America," in *Important Information Inside: The Art of John F. Peto and the Idea of Still-Life Painting in Nineteenth-Century America* [exh. cat., National Gallery of Art] (Washington, D.C., 1983), 36–55.

2. In 1986 one historian took note that "this portrait of *Rubens Peale with a Geranium*, 1801, has recently been acquired at auction by the National Gallery of Art in Washington, D.C., from the collection of Mrs. Norman Woolworth. The fact that it brought the record price for an American painting signals the growing interest in Rembrandt Peale's too long neglected art." Carol Eaton Hevner, "Rembrandt Peale's Life in Art," *The Pennsylvania Magazine of History and Biography* 110, no. 1 (January 1986): 3. Rather, it may be argued, that while fresh attention to Peale is part of a larger reexamination of historical American art, the record price reflected more the long recognized importance of this picture alone and the belief that it, quite apart from Peale's career, somehow held the power of a profound national icon.

3. Biographical information from Carol Eaton Hevner and Lillian B. Miller, *Rembrandt Peale, 1778–1860, A Life in the Arts* [exh. cat., The Historical Society of Pennsylvania] (Philadelphia, 1985).

4. For a summary of the artistic state of Philadelphia at this time, see Beatrice B. Garvan, *Federal Philadelphia, 1785–1825, The Athens of the Western World* [exh. cat., Philadelphia Museum of Art] (Philadelphia, 1987).

5. See Garvan 1987, 38–41.

6. Quoted in Hevner and Miller 1985, 32.

7. See Hevner and Miller 1985, 18–20.

8. Hevner and Miller 1985, 66–67.

9. See, for example, *Thomas Jefferson*, 1805 (New-York Historical Society); *Charles Willson Peale*, 1812 (Historical Society of Pennsylvania); and *Rubens Peale*, 1834 (Wadsworth Atheneum, Hartford). Hevner and Miller 1985, 22, 33, 55, 77.

10. Hevner and Miller 1985, 76.

11. See the entry on this painting in *The Eye of Thomas Jefferson* [exh. cat., National Gallery of Art] (Washington, D.C., 1976), 346, no. 600.

12. Margaret Bayard Smith, *First Forty Years of Washington Society*, quoted in *Eye of Jefferson*, 346.

13. Biographical information from George C. Groce and David H. Wallace, *The New-York Historical Society's Dictionary of Artists in America, 1564–1860* (New Haven, 1957), 34–35; and Edgar P. Richardson, et al., *Charles Willson Peale and his World* (New York, 1982), 110–111, 124–126, 193.

14. Quoted in Hevner and Miller 1985, 92.

15. See Hevner and Miller 1985, 37–39, 92.

16. See Jules David Prown, *John Singleton Copley*, 2 vols. (Cambridge, Mass., 1966), 1: nos. 96, 119, 122, 128, 161, 165, 170, 186, 188, 256, 258, 259, 310, 327.

17. Prown 1966, 1: nos. 273 and 327.

18. See Prown 1966, 2: no. 384.

19. See Prown 1966, 1:74–75, for a discussion of this painting.

20. See Hevner and Miller 1985, 21–22.

21. Mary Jane Peale's last will and testament, Peale-Sellers Papers, American Philosophical Society, Philadelphia.

22. *Exhibition of Portraits by Charles Willson Peale and James Peale and Rembrandt Peale* [exh. cat., The Pennsylvania Academy of the Fine Arts] (Philadephia, 1923), 75. See also, *Pennsylvania Painters* [exh. cat., The Pennsylvania State University] (Pittsburgh, 1955), no. 11; *American Art from American Collections* [exh. cat., The Metropolitan Museum of Art] (New York, 1963), 76; and Stuart B. Feld, "Loan Collection," The Metropolitan Museum of Art *Bulletin* (April 1965), 283.

23. See Carol Eaton Hevner, "*Rubens Peale with a geranium* by Rembrandt Peale," *Art at Auction: The Year at Sotheby's, 1985–86* (New York, 1986), 114–117; Carol Eaton Hevner, "Rembrandt Peale's portraits of his brother Rubens," *The Magazine Antiques* 130, no. 5 (November 1986): 1,010–1,013; and Edwin M. Betts, et al., *Thomas Jefferson's Flower Garden at Monticello*, rev. ed. (Charlottesville, Va., 1986), 72–73.

24. For his efforts to improve farming methods as well as his horticultural expertise, Rubens was elected a member of the Academy of Natural Sciences in Philadelphia in 1813.

25. "Memorandum of Rubens Peale," Peale-Sellers Papers, American Philosophical Society, Philadelphia,

1-4; quoted in Hevner, "Rembrandt Peale's portraits," 1,011.

26. Rembrandt Peale, "Reminiscences," *The Crayon* (3 June 1856), 163–164.

27. Rembrandt Peale 1856, 164–165.

28. Letter from Charles E. Letocha, M.D. (24 February 1986), in the curatorial records, National Gallery of Art, Washington.

29. John R. Levene, *Clinical Refraction and Visual Science* (London, 1977), 171.

30. Charles Coleman Sellers, quoted in Levene 1977, 171–172.

31. John McAllister to Thomas Jefferson, Philadelphia, 14 November 1806, in the Library of Congress; transcript courtesy of Charles E. Letocha, M.D., in curatorial records, National Gallery of Art.

32. Information from Charles E. Letocha, M.D., in letters to the National Gallery, 4 February 1986, 24 February 1986, and 7 March 1986; in curatorial records, National Gallery of Art.

33. Mary Jane Peale, last will, 1883.

34. Hevner, "*Rubens Peale*," 116.

35. See Levene 1977, 172.

36. Levene 1977, 172.

37. Quoted in Betts 1986, 72–73. See also Peter Hatch, *The Gardens of Monticello* (Charlottesville, Va., n.d.), 11.

38. R.W.B. Lewis, *The American Adam: Innocence, Tragedy, and Tradition in the Nineteenth Century* (Chicago, 1955), 15.

39. Thomas Jefferson, *Notes on the State of Virginia*, 1785, in *The Portable Thomas Jefferson*, ed. Merrill D. Peterson (New York, 1975), 68.

40. Quoted in Lewis 1955, 15.

41. See *The Portable Thomas Jefferson*, xx, 235.

42. Quoted in *The Portable Thomas Jefferson*, 290; see also xxx–xxxii.

43. Quoted in Lewis 1955, 5.

44. Alexander Hamilton, et al., *The Federalist Papers*, New American Library ed. (New York, 1961), 33, 104.

45. *Federalist Papers*, 313.

46. Benjamin Vaughn to Franklin, 31 January 1783, quoted in the introduction to *The Autobiography of Benjamin Franklin*, ed. Leonard W. Labaree, et al. (New Haven, 1964), 6.

47. Woodrow Wilson, introduction to *The Autobiography of Benjamin Franklin* (New York, 1901), vi–x.

48. Acknowledgment for this information to D. Dodge Thompson, National Gallery of Art.

49. See Alice DeLana and Cynthia Reik, eds., *On Common Ground: A Selection of Hartford Writers* (Hartford, Conn., 1975), 23.

50. See Jules David Prown, "Thomas Eakins' *Baby at Play*," in vol. 18, *Studies in the History of Art*, National Gallery of Art (Washington, D.C., 1985), 121–127. The ultimate footnote is that its number coincidentally corresponds to the author's age, a final focus on what is past and what is possible.

65. Detail of fig. 56

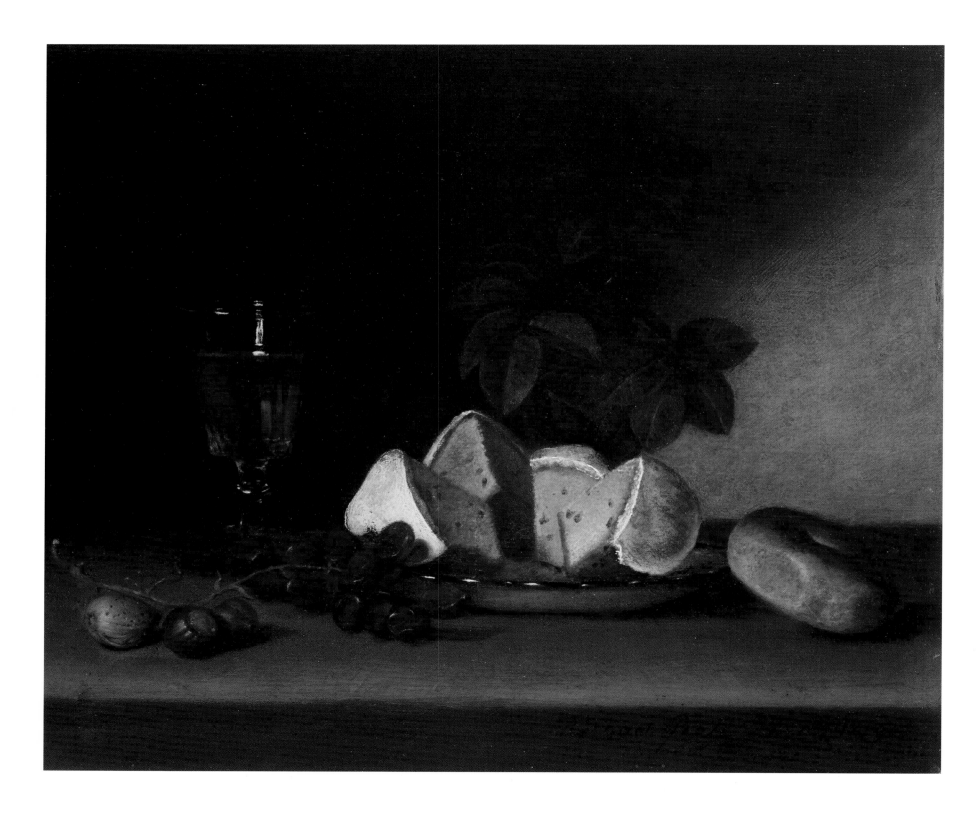

Raphaelle Peale: Texts and Documents

COMPILED BY NICOLAI CIKOVSKY, JR.

Most of what we know of Raphaelle Peale's life is the view of it, incomplete and filtered as it may be, provided by family documents, chiefly letters of his father, Charles Willson Peale. They are a revealing and deeply affecting record of physical and mental suffering; of irresponsibility, dissolution, and lack of ambition; of artistic disappointment and emotional despondency; of domestic disarray. They also reveal incessant parental scrutiny and moralizing advice, as well as touching familial care and genuine concern. There were moments of promise, diligence (with perseverance, one of his father's favorite virtues), and high critical praise, but Raphaelle Peale's life was on the whole a tragically troubled one. It was bravely endured, however, and redeemed by an artistic achievement that none of those who commented on it, often condescendingly, could equal.

This selection strives not for completeness—a number of texts and documents have been omitted, and most have been edited down—but for as continuous a record of Raphaelle Peale's life as it is possible to reconstruct from its fragmentary literary remains.

All but one of the original documents quoted here are the property of the American Philosophical Society Library, Philadelphia. The exception is document 24, owned by the Archives of American Art, Smithsonian Institution. These institutions, with the Smithsonian's Peale Family Papers (a project of the National Portrait Gallery) and the publisher, Yale University Press, have generously consented to the publication of the documents herein. References to published documents are given in notes following.

1. *Charles Willson Peale, Autobiography*

. . . Peggy Durgan . . . not only attended to all the domestic concerns but also was a nurse to all of his children.* She petted and, as some would say, spoiled them. We will cite one instance of her affection, but we will not say that it was a very judicious measure. Raphaelle, the eldest boy, in a whim would not eat bakers bread. The father, disliking such whims in his children, ordered all the bread used in the family to be had at a bakers in the neighborhood, in the idea that if the boy could not get home made bread,

* Peggy Durgan is the person standing at the right of *The Peale Family* (fig. 22).

66. Raphaelle Peale, *Still Life: Wine, Cakes, and Nuts*, 1819. The Henry E. Huntington Library and Art Gallery (*opposite page*)

that in the end he would eat bakers bread. But it was found out that Peggy Durgan constantly supplied the pettish boy with cakes which she secretly baked, saying she could not let the dear little fellow want bread.

2. *Charles Willson Peale to Rembrandt and Rubens Peale*, Philadelphia, 11 September 1803

He [Raphaelle] is much improved in many respects, and I am happy in the prospect of his making a good use of his talents he is not defficient in brotherly love, and from your hints of his laziness, I expect he will not be so neglegent of writing to you after he becomes settled again.

3. *Charles Willson Peale to Raphaelle Peale*, Philadelphia, 10 May 1806

Dear Raphaelle, your letter [presumably from Georgia] of the 25 & 26 received today, it is a joyful intelligence to us all, to hear you had recovered your intillects, is what we did not expect so soon, although Doctr Wistar* told me, it was no uncommon case, when great evacuations [bleedings] had been made, for such persons to be insane for a short time that they generally recovered in a week or two— Rubens would have been on this passage to Charleston [South Carolina] on tomorrow had not your letter thurse fortunately relieved us. . . . let not pecuniary matters keep you from your family any longer, you will find greater encouragement in your profession than heretofore,

and I will be glad to give you all the aid I can to overcome all your difficulties—I wish I could use a language strong enough to inforce your speedy return, but I can only say that it is the most ardent wish of my heart. Patty's letter which you sent me paints her anxiety for your return—and when I hastened to inform her of your recovery she was almost frantic with joy, your sweet children were insensible of your situation & could not know the cause of our joy, which appeared cries of grief rather than that of good tidings. she will after this severe tryal labour to make our circle what they ought to be.

4. *Charles Willson Peale to Angelica Peale Robinson*, Philadelphia, 17 June 1806

[Describing Raphaelle in Georgia] . . . as his head was the seat of his disorder he became insane and was for a short period so bad that he was obleged to be watched, and his whimsies humoured to keep him from raving. . . . he comforts himself that it [his illness] has given him a lesson of vast importance to his future happiness, for he says heretofore his passions governed him but that for the time to come he'l command them so that good may come from some evil.

Those who know him well know that goodness of his heart, but he always disdained courting favors from any one and therefore he often suffered injuries which he did not really merit, yet he disdained to do himself justice, by explanations of his motives of conduct.

* Dr. Caspar Wistar, Peale's family physician, and president of the American Philosophical Society.

5. *Charles Willson Peale to John Isaac Hawkins*, Philadelphia, 28 March 1807

. . . having found it necessary to give my son Raphaelle a lift through some of his difficulties, which an unfortunate trip to Georgia had brought on him—has obleged me to be more of an economist than my inclination [is] enclined to be. I expect he will succeed in a plan which he has long had in view; an exhibition of Wax Work. His figures will far exceed in natural appearance any that has been shown in this City heretofore.

6. *Charles Willson Peale to Raphaelle Peale*, Philadelphia, 1 July 1807

. . . I also gave her [Raphaelle's wife Patty] some hints how necessary to make home agreable to induce those we are connected with to stay with each other. She said we are very happy when he dont drink, and yet she said you could not do without it for if you passed one day a tremour came on & you was miserable untill you had it & she was compelled to advise you to take a little. my answer was, that it was wrong for any one to drink any thing but water, that most of the misery of the humain species was caused by a shameful habit of taking what distroyed the mind as well as the Body.

7. *Charles Willson Peale to Rembrandt Peale* [in Paris], Philadelphia, 3 July 1808

Raphaelle is about to make a tryal in oil Colours, he has painted the White-head Eagle for the Ladies to work from it *colours* for the United States, and his pensiling of the head is really fine. I think he will find more plea-

sure in painting in Oil than in Water Colours, and if he will apply with tolerable deligence it must succeed. he does not want talents, but only industry to make considerable excellence in Portrait Painting.

8. *Charles Willson Peale to Rembrandt Peale* [in Paris], Philadelphia, 11, 18 September 1808

. . . your Brother Raphaelle is continually drawing on me for Cash, for the low price he gets & withall not constantly employed renders my aid necessary— His heart is not ungrateful, and even if I distress myself, and thereby prevent him from running into excess's and despondancy, it will comfort me—It must give you pleasure to know, that he has been more reasonable in his conduct of late than when you left us, and he seems improved also in his painting. I hope I shall be able to give you a still better account of him [in] my next letters.

9. *Charles Willson Peale to Rubens Peale*, Philadelphia, 18 October 1809

Raphaelle continues still to improve, he will certainly be the best Painter in Miniature in this City in a short time, if he is not so already. I have wanted him to raise his price, for he has an abundance to do. but he says no because all his customers are not from this City but straingers, and he cannot keep any of their Portraits for Exhibition. I am fearful that his too close application will injure his health. however at present his looks is much improved.

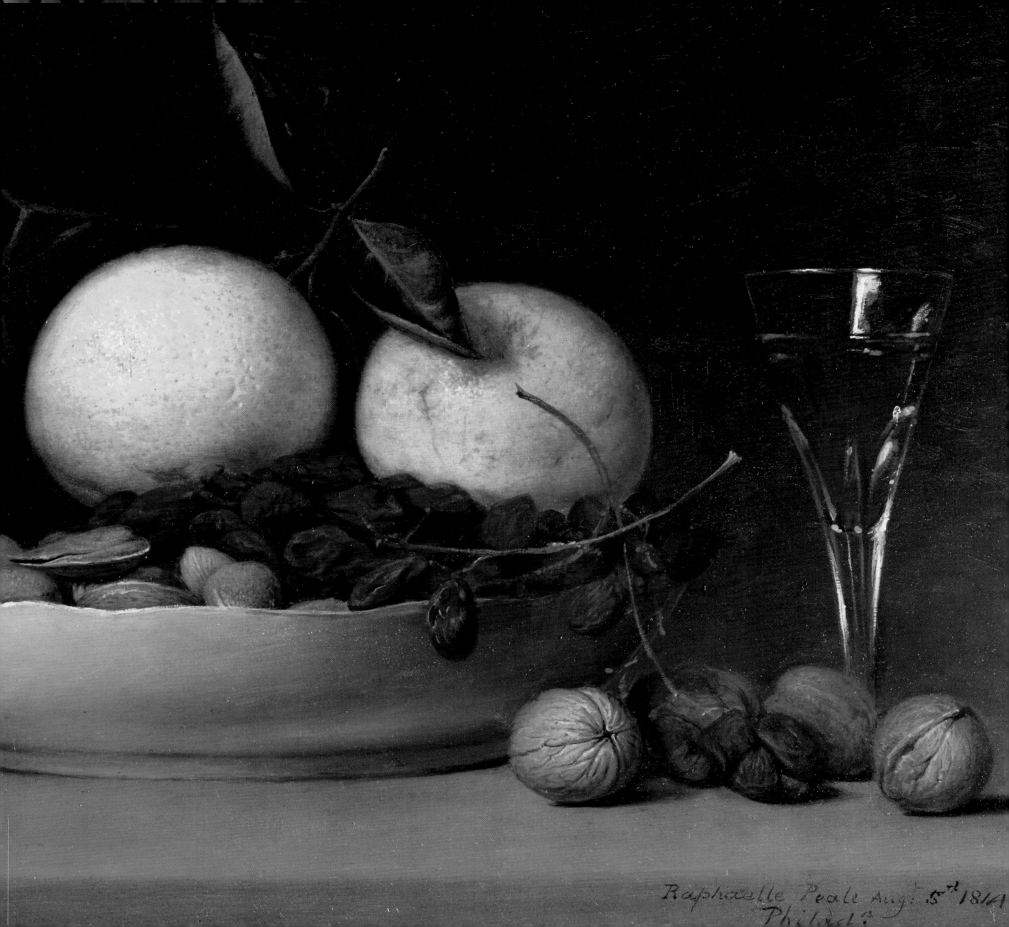

Raphaelle Peale Aug.t 5.th 1814
Philad.a

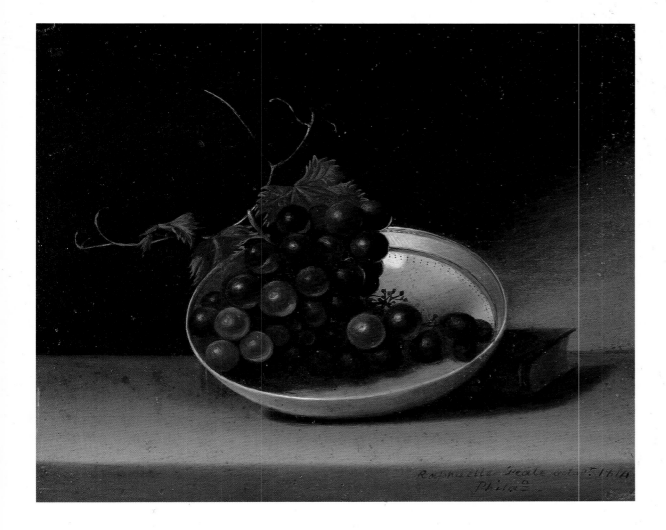

10. *Charles Willson Peale to Rubens Peale,* Philadelphia, 24, 25 October 1809

Raphaelle has more confidence in his art than he ever had, he is painting an excellent likeness of himself and made good beginning of my portrait, it will do him credit if I can find time to set for the finishing.

11. *Charles Willson Peale to Rembrandt Peale,* Persevere [Belfield], 8, 10 July 1810

Raphaelle shews at intervals great talents, yet whether from his situation he becomes disspirited or some other cause, he neglects himself— he was with me a few days so little while past, he recovered quickly from some complaints, and I enjoyed his company with much satisfaction.

68. Raphaelle Peale, *Still Life with Grapes and Dish,* 1814. Private collection

67. Detail of fig. 2 (*opposite page*)

12. George Murray, "Review of the Second Annual Exhibition [of the Pennsylvania Academy of the Fine Arts]," *The Port Folio* 8 (July 1812)

Nos. 186, 194, *are portraits by Raphael Peale.* These pictures have considerable expression and character, but the colouring is by far too cold. No. 11, a bread and cheese picture, by the same artist is a masterly production, and is certainly not inferior to many works of the Flemish School.

13. *Charles Willson Peale to Rembrandt Peale,* Belfield, 27 July 1812

I don't know that any of my Children think that I have done too much for you by the employment I gave you in france,* Raphaelle might, when in deranged state have said something like it. I never heard him say so. if it was the case, it was my pleasure, which none of my Children have any right to controll what is done for the Museum is for the equal advantage of you *all. . . .*

P.S. Raphaelle was with us yesterday, he looks well, and feels the importance of his change. he is payg off his debts. takes pleasure in painting, and improves in the art.

* Rembrandt Peale made two trips to France, one in 1808, the other in 1809–1810.

14. *Charles Willson Peale to Angelica Peale Robinson,* Belfield, 3, 10 January 1813

Your brother Raphaelle continues to deserve much Credit for his persevering industry as well as very high admiration of Connoisseurs for this great excellence in the fine arts. when I was last in the City he was finishing a Portrait of a Gentleman who had sat to some of the first artists without success, and Raphaelles work gave perfect satisfaction to every one that had seen it.

15. *Charles Willson Peale to (Nathaniel?) Ramsay,* Belfield, 13 March 1813

Raphaelle has been unfortunate in some things—and neglectful of himself. he possesses a good heart and is blest with genius and many good qualities—is now very industrious and gives high satisfaction in his art—he has done some pieces of *still-life* equal if not superior to any thing I have seen! I hope and pray that he may continue to conduct himself in future as well as he has done for a considerable time past.

16. George Murray, "Review of the Third Annual Exhibition of the Columbian Society of Artists and Pennsylvania Academy of Fine Arts," *The Port Folio* n.s. 2 (August 1813)

16. *Fruit Piece.*—Raphael Peale. This is a most exquisite production of art, and we sincerely congratulate the artist on the effects produced on the public mind by viewing his valuable pictures in the present exhibition. Before our annual exhibitions this artist was but little known. The last year he exhibited two pictures of still life, that deservedly drew the public attention, and were highly appreciated by the best judges. We are extremely gratified to find that he has directed his talents to a branch of the

arts in which he appears to be so well fitted to excel. We recollect to have seen in the famous collection of the duke of Orleans (that was brought to London and there exhibited in 1790) two small pictures of flowers and fruit by Van Os, that were there sold for one thousand guineas. Raphael Peale has demonstrated talents so transcendant in subjects of still life, that with proper attention and encouragement, he will, in our opinion, rival the first artists, ancient or modern, in that department of painting. . . . We have seen fourteen annual exhibitions of the Royal Academy, and one of the Incorporated Society of Artists, in London; and we are bold as well as proud to say, that there were in no one of these celebrated exhibitions, so great a number of pictures on this particular branch of the arts as those now exhibited by Raphael Peale. . . .

36. *Fruit.*—Raphael Peale. We have already spoken generally of the works of this artist, as pictures of uncommon merit: some of them, however, are not without defects. The individual objects in this picture are represented with great truth. There appears however a deficiency in perspective; it has too much the appearance of what painters call a *birds-eye view.* We recommend particularly to the attention of this artist the necessity of *foreshortening,* and to make his backgrounds more subservient to the principal objects, and also to make such arrangement in the grouping as will best comport with the harmony of the whole; and to endeavor as much as possible in the formation of his groups, to make the natural colours of the objects represented assist in the general distribution of light and shade.

17. *Rubens Peale to Angelica Peale Robinson,* Philadelphia, 6 November 1813

Raphaelle has had a severe attack of the gout in both legs which confined him to his bed for a week past but is up about the house now with crutches.

18. *Charles Willson Peale to Benjamin Franklin Peale and Titian Ramsay Peale,* Belfield, 15, 27, 29 March 1814

I have the Pleasure to inform you that your Brother Raphaelle is doing very well, it is a joyfull and happy change in him. He comes with Patty and the children to see us [] and Patty says that no man can possibly behave better than he does. He looks well and what is much better he *works well.* He still progresses to improve in his art, His composition in Still Life is better, and in his Portrait painting gives considerable satisfaction.

19. George Murray, "Review of the Fourth Annual Exhibition of the Columbian Society of Artists and the Pennsylvania Academy," *The Port Folio* 3, series 3 (July 1814)

No. 75. *Peaches and Grapes*—Raphael Peale. This artist has again furnished the present exhibition with a great variety of very excellent pictures, consisting chiefly of fruit pieces, &c. We admire exceedingly the correct manner in which he represents each individual object, and if he displayed more judgment in the *arrangement* and *grouping* of his pictures, they would rival the best productions of the Flemish or Dutch School.

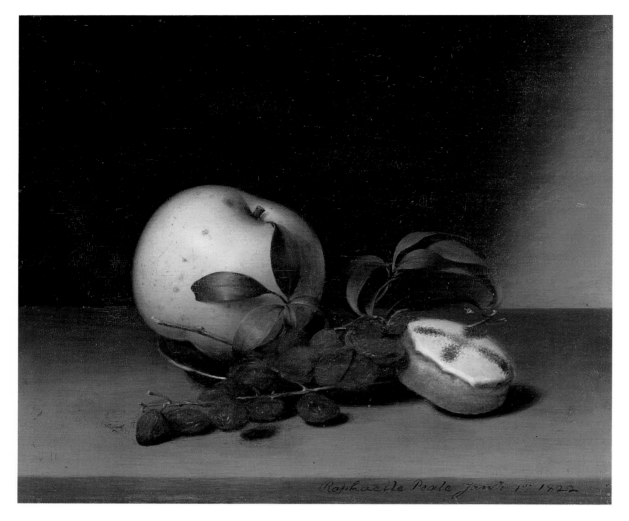

69. Raphaelle Peale, *Still Life with Cake,* 1822. The Brooklyn Museum, Museum Collection Fund

20. *Charles Willson Peale to Benjamin West,* Belfield, 11 September 1815

Raphaelle seems to possess considerable talents for such paintings [still lifes]. He paints in portraits the striking likeness, but does not give them that dignity and pleasing effects which is absolutely necessary to ensure a great demand for the labours of his Pensil.

21. *Charles Willson Peale to Rembrandt Peale,* Belfield, 9 October 1815

Your Brother Raphaelle is in great danger from an attack of the Gout in his stomack, he had been too closely employed for some time in painting Miniatures, and took no exercise. Perhaps indulging too much his appetite at the same time with Pickles &c which every prudent man ought to banish from his table as being neither good for the old or the young— stimulous condiments are ever ruinous to the Stomach—simple food makes good blood, good spirits, good health. . . . Raphaelle is still in the same dangerous state that the Physicians have very little hopes of his life. I could not go down yesterday having the hurry of painting some Portraits of a Carrolina family who are to go in the next Packet to Charlestown— I have since Raphaelles illness painted in the morning and gone down in the afternoon & returned before Breakfast time. as soon as I have finished this letter will go—but I now go with less hopes than ever that he will live long, he has been last night more delirious & dozed but little the whole night, if he should have any change for the better I will add it in a postscript, yet I cannot believe he can survive many days— he eats nothing, has no passage, and violent pain almost continually— a Mortification will shortly take place—

22. *Rubens Peale to Linnaeus Peale,*
Philadelphia, 18 October 1815

Dear Brother.
I suppose you must be very anxious to know how your brother Raphaelle is. As I promised you, if he had got much worse you should have heard of it

Raphaelle continued much as you saw him, till Thursday night, and friday he began to improve, but has the gout in his feet and right hand very bad, but yesterday it began to shift very much, varying from his head to his lungs &c. which is generally the case when he is on the recovery. He was more than 5 days without having any stool.

23. *Andrew Summers* to Linnaeus Peale,*
Philadelphia, 19 October 1815

Raphaele is doing bravely, and I am in hopes of his getting perfectly well before long.

* Andrew Summers married Sybilla Miriam Peale, daughter of Charles Willson Peale and his second wife, Elizabeth De Peyster, in 1815.

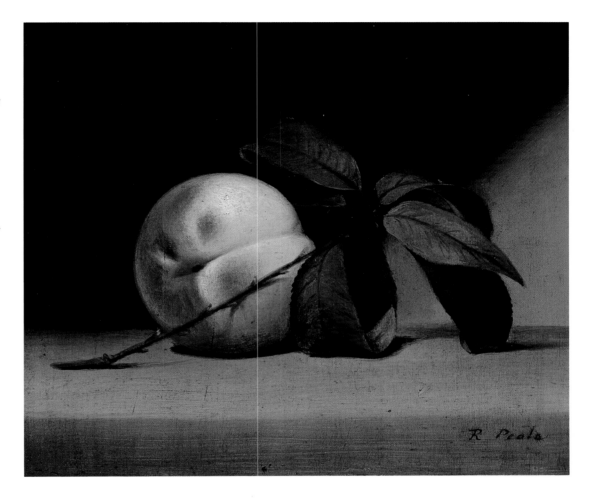

70. Raphaelle Peale, *Still Life with Peach*, c. 1816. San Diego Museum of Art, Purchased through funds provided by the Earle W. Grant Acquisition Fund

24. *Raphaelle Peale to Charles Graff,*
Philadelphia, 6 September 1816

My old and inveterate enemy, the Gout, has commenced a most violent attack on me, two months previous, to its regular time—and most unfortunately on the day that I was to Commence still life in the most beautifull productions of Fruit. I therefore fear that the Season will pass without producing a single Picture, I meant to have devoted all my time, Principally, to Painting of fine Peaches [fig. 70] & instead of whole Water Melons, merely single Slices on which I could bestow a finish that would have made them valuable—. if the disease was only confined to my feet I still would have some hope of doing something, But unfortunately my left hand is in a most dreadfull situation, & my Right Getting so bad as to be scarcely able to hold my Pen—[in] this situation it is necessary to dispose of the Picture the fruit of which you so much admired, any alterations you may desire in the Picture on my recovery I will Exicute with a great deal of Pleasure, my fixt price was &

would have been, but for this unfortunate attack, 40 dollars— therefore Sir if you feel disposed to Serve me I make a tender of this Picture to you for 30 Dˢ.

My Father & my Brother seperately on their own accounts have from the beginning of my Labours in this line engaged to take all the Pictures I can Paint, But I know well.—the enormous & continued expence of the Gas lights, for want of experience and in consiquence of the Museum being closed so frequently to repair—likewise the expences that my Father is at in building & Establishing several of his son[s] in a manufactory of Cotton spinning, induces me rather to offer to you

with respect your humble Servᵗ
Raphaelle Peale

25. *Charles Willson Peale to Raphaelle Peale,* Belfield, 17 February 1817

Dear Raphaelle
You have long wished me to paint a Portrait of you. I have now worked myself out of work at the farm, and I have good canvas just prepared and dont wish to go into the City before a change of weather because sleeping out of a bed accustomed to, I am not so comfortable, especially without your mother to cover me up and she is not willing to leave the family at this time. Therefore I beg of you to wrap yourself in an abundance of clothing and come either in the sleigh or in my Chaise and Jacob will drive,* so that you will not be liable to take cold. I send him on purpose to bring you to the farm.

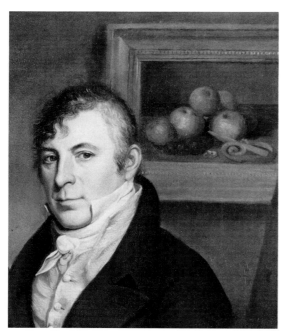

71. Detail of fig. 23

* Jacob Gerhart, who worked at Belfield.

26. *Charles Willson Peale to Rubens Peale,* Belfield, 17 February 1817

Dear Rubens
Hearing that Raphaelle is not doing anything I have thought it advisable to send Jacob down for the purpose of bringing him up, and I have written to him that I have got out of work and wish at this time to comply with a request that he some time past he expressed that I would paint a portrait of him, that it might be a lesson to help him in his colouring— I wish you to take the trouble to urge him to come either in the Sleigh or in the Chaize. . . .

27. *Charles Willson Peale to Raphaelle Peale,* Belfield, 15 November 1817

I well know your talents, and am fully confident that if you applied [yourself] as you ought to do, you would be the first painter in America. . . . Your pictures of still-life are acknowledged to be, even by the Painters here, far exceeding all other works of that kind—and you have often heard me say that I thought with such talents of exact immitation your portraits ought also to be more excellent— My dear Raph. then why will you neglect yourself—? Why not govern every unruly Passion? why not act the *man,* and with a firm determination act according to your best judgement? Wealth, honors and happiness would then be your lot! . . .

I must change the subject, to invite you to take lessons from me in painting— The system of colouring which we had from Rembrandt [Peale], I considered as excellent, but he has now given me one much superior, much more simple, and more easy in execution— I am certain of your great im-

provement in portrait as soon as you make tryal of it. The effect of the mode of colouring is beautiful in every kind of complection, and so easy that the mind is not troubled over colouring while making out all the parts of drawing, shading and rounding, making the hair, limbs. . . .

28. *Charles Willson Peale to Raphaelle Peale,* Belfield, 2 February 1818

My dear Raphaelle
It gives me pain to think how wretchedly you govern yourself. I am not uninformed of your associations you are possessed of superior talents to most men, and yet you will associate with beings that disgrace you— you have promised time after time to refrain from intemperance and you have nearly destroyed, or thrown away your life; you have been on the brink of the Grave, and you must certainly know the cause of all your sufferings! then why not act the Man and respect your self— which if you once would take the firm resolution to do, others would then respect you— How can you expect encouragement to your superior powers in the Arts, which would in a little time make you independent, unless you change your company— will creditable people go into a House of *Rendevous* to sitt for their portraits, or give any other encouragement— but why should I name these things, you know as well as I do how you should conduct yourself, you have an infinity of knowledge, but do you not lack common sense? After you left Philad.[a] I have made every excuse I possibly could to those who enquired after you; I have told your children that I expected in a little time that you would return and aid them, can it

be possible that you have no sympathy; no love for them?— This cannot seriously be possible. . . .

In some of your letters you said you had pictures engaged— It is wonderfully strange that you cannot maintain yourself alone— how can you expect that Patty should maintain herself and all her children? and your time in ——— Oh! how painful is my task to write this— Raphaelle compare your powers with mine, and see how I sink in the scale. . . .

Your Mother loves you, she knows the goodness of your heart think of her, of me, of your brothers & sisters and know that you can if you *will it* make us all happy— then think also of your wife & children and put a *value on yourself.* . . .

29. *Charles Willson Peale to Raphaelle Peale,* Belfield, 1 March 1818

Dear Raphaelle yesterday Patty sent for me and when I see her she told me that she wanted me to prevail on her Children to consent to be separated, as she was not able to keep them together by her exertions alone, she said by putting them out amongst her friends, she might by taking a Room with the work of her needle maintain herself and the youngest of them. She thinks that you ought to come home and help her along in their expences, & advises that you should sell your House, pay your debts, and do what you can to gain a support for the family. She seemed fearful that you would abuse her and said that she did not know that she would be able to bear it. . . . I wrote to you on 2[d] Feb It contained some censure of your conduct, do you not deserve it? It gave me pain to write such complaints, but I

72. Raphaelle Peale, *Still Life with Steak,* c. 1817.
Munson-Williams-Proctor Institute Museum of Art

hoped that I might rouse you from your
lethargy, might stir up your pride to honor-
able actions. If I did not know your capacity
to earn a genteel living, my feelings would
be different— I know you possess a good
head—, I know you possess super[ior?] qual-
ifications, yet what does it all avail, since

you have no resolution to act as you must
know you ought to do? . . . I am certain that
you do not want a monitor in your breast,
then why not reflect on what you ought to
do? If you feel disease do you not know that
you are deserving of pain? that some indis-
cretion, some neglect of a necessary case

have brought affliction which by a proper prudence could have been prevented. . . . I speak to a Man of superior Powers of the Mind, shall I always speak in vain? I hope not. Then dear Raphaelle have respect for your self, and firmly determine to honor yourself, and in doing so, know how much happiness you may give to those who ought to be near and dear to you, nay carry it much farther, for know that many Gentlemen of my acquaintance lament the prostitution of your talents. I want no more promises, let actions continue to speak your praise. Covet, only, the admiration of good men—all others are beneath your notice. . . .

30. *Charles Willson Peale to Titian Ramsay Peale*, Belfield, 7 March 1818

It is a considerable length of time since I have heard from Raphaelle. I don't know what he is doing at Norfolk. I have wrote twice to him of late giving him by best advice. I fear he is not doing so well as he ought to do with his superior talents in some department of the Arts.

31. *Charles Willson Peale to Raphaelle Peale*, Belfield, 26 June 1818

. . . But I fear, Raphaelle that you are not right. I am led to think so by seeing the word *Suicide* in your letter [to Patty]. He is a miserable poor wretch who has not sense enough to know the folly of such rash actions, he can have but little intellect, who thinks that he can justify himself in the oppinion that he can dispose of himself as he pleases fearless of the consequences. Has not every man numerous obligations to ful-

fill? We do not live for ourselves alone. Is it not one of our first duties, to endeavor to make all other beings happy? by such conduct, do we not enjoy the most sublime felicity? this being granted, is it not criminal in us to neglect our duties to those who ought to be dear to us? I hope you will not think that [I] write with too much severity to you, my intention is only to rouse you up from a stupor or lethargy that may have seiged thee, for I well know your powers of intellect are equal if not superior to most men, I only mean to try to bring you to serious reflection, and if you have courage you will do every thing in your power or we could wish you to do. I will here drop this subject. . . .

32. *Charles Willson Peale to Angelica Peale Robinson*, Belfield, 24 July 1818

you ask me where Raphaelle is, The other day I received a letter from him, which informs me that he has been almost at deaths door, reduced to a Skeleton by a fitt of the Gout [which] confined him 8 weeks— I have wrote to advise him to get from the country as soon as possible as I have always considered the neighbourhood of Norfolk an unhealthy country.

33. *Charles Willson Peale to Angelica Peale Robinson*, Belfield, 23 September 1818

. . . it is not too late to recover his wanted stamina, provided he will follow my advice and to encourage him to be diligent in painting still life, I will purchase every piece that he cannot sell, provided it is well painted, he tells me he has improved in portrait painting and that he is fonder of doing

them than he was formerly. If so I know he will excell in a high degree, if his immitations of the human face is like those faithful tints he produces of still-life. For he has not his equal in that line of painting.

34. *Charles Willson Peale to Rubens and Raphaelle Peale,* Washington, 19 November 1818

Dear Raphaelle you ought not to expect a high price for every picture you paint. These kinds of pictures would give you a good profit at 15$ provided you employed the greater part of your time in producing them as with constant production you might paint 2 or 3 of them in a week. You can never want subjects to immitate, any common objects grouped together might form a picture, and instead of having only one picture for sale, you might soon have a Dozn, and such a number would be a curiosity of the lovers of the art to see them, . . . I fear you loose as much time in shewing your pictures or more than it would take you to produce them. I feel sensibly for all your difficulties and would be very sorry to say that, which would hurt your feelings, you know my affection for you, How often have I praised your talents? and how often have I given you the best advice in my power, and had I the means I would most gladly relieve you from duns.

35. *Charles Willson Peale to Rembrandt Peale,* Belfield, 23 February 1819

Raphaelle has painted some still-life pieces equally good, if not superior to any he has ever painted— He works *diligently* but at a low price, and conducts himself very well.

36. *Sarah Miriam Peale to Titian Ramsay Peale,* Philadelphia, 1 May 1819

—Raphael has had the gout very bad in his right hand, but I believe it is getting better—

37. *Charles Willson Peale to Angelica Peale Robinson,* Belfield, 19 July 1819

Raphaelle I am happy to say is very diligent in painting Portraits mostly in miniature, and enjoys good health, though now and then he has some twinges of the Gout— however he looks well and may be called a handsome *Man.*

38. *Sarah Miriam Peale to Titian Ramsay Peale,* Philadelphia, 7 November 1819

Raphael . . . has had as much work as he could do for four, or five, weeks past. I hope it may continue so.—

39. *Charles Willson Peale to Titian Ramsay Peale,* Belfield, 21 February 1820

Raphaelle has a tolerable share of work his prices being small—

73. James Peale, *Still Life with Fruit*, 1824–1826?
Munson-Williams-Proctor Institute Museum of
Art, Museum Purchase in Memory of William C.
Murray

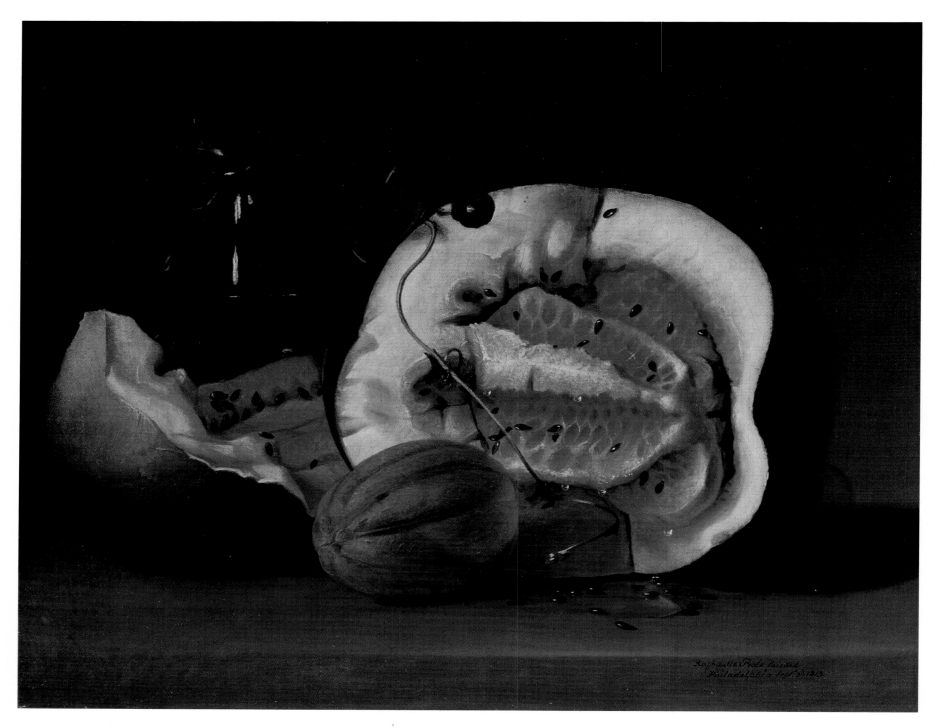

74. Raphaelle Peale, *Melons and Morning Glories,*
1813. National Museum of American Art,
Smithsonian Institution, Gift of Paul Mellon

40. *Charles Willson Peale to Raphaelle Peale,* Belfield, 4 July 1820

I hope on the next annual Exhibition [at the Pennsylvania Academy of the Fine Arts] that you will shine as a Portrait Painter—for as I have always said, if you could have confidence in yourself, and paint portraits with the same exactness of finish as you have done in still life, that no artist could be your superior in that line.

41. *Charles Willson Peale to Raphaelle Peale,* Belfield, 22 July 1821

My Dear Raphaelle
It is long since we have heard from you, I fear your sufferings are great, your letter to Eliza [Raphaelle's daughter] spoke of your returning so far to health as to enable you to resume your Pencil, although much debilitated, why do you not write to some of the family, or if you are not able, get some person where you are to do it for you? I have been once or twice in the City of late, and going to your House, each time Patty said, that my rap at the door made her expect it was the Postman with letters, and week after week they expect in vain, it is cause of much distress to all the family.

42. *Rubens Peale to Benjamin Franklin Peale(?),* Baltimore, 11 June 1822

[Raphaelle's] promises and fair words . . . are like the dust that is now rising, promising a severe storm but it all ends in dust and but little sprinkling. *Or a soap bubble.*

43. *Charles Willson Peale to Rembrandt Peale,* Philadelphia, 15 August 1822

Raphaelle is diligent at his pieces of still life, but of portraits he has nothing to do for some time past, & he very seldom can get any thing for what he does, of course I am obliged to find him market money—

44. *Charles Willson Peale to Rubens Peale,* Philadelphia, 19 January 1823

And poor Raphaelle with every exertion he cannot get a support.— He is now painting some fruit pieces to send to Vendues[?]— He tells me that he has wrote to you to propose to get a sale of his fruit pieces you have by a raffle & he thinks that painting some smaller pieces that each person according to their lott may each have a picture— and he says it may save expence & when you write to me, mentioning your Ideas on the subject.

45. *Charles Willson Peale to Rubens Peale,* Philadelphia, 5 March 1823

Raphaelle has no work at present, yet he is not Idle, he paints some fruit pieces— also he paints such persons as will give him anything for his painting. He is engaged to take carpenters work for a Portrait, thus he gets what is wanting in repair of his house, streching frames &c. he hopes that when the Steam boats run & people travel more that he may then get some work for the support of his family—

46. *Charles Willson Peale to Rubens Peale,* Philadelphia, 5 April 1823

Raphaelle being out of work is in need of support— he requests you to send to him the pictures remaining with you as soon as you can conveniently do it— as he must try to sell some or all of them by some means to get money to meet expenses

47. *Charles Willson Peale to Rubens Peale,* Philadelphia, 5 August 1823

I am much troubled with Raphaelle's bad conduct, and his difficulties are encreasing on him. . . . Patty wants to get the property secured to her support and payments on the debts— a Law of Pennsyl.[a] enables the nearest relations of a drunken spen[d]thrift to apply and have appointed two persons to act as trustee's— I was applyed to this business— my reply was that I would not have any thing to do at such business, The breaking up of a family is a serious thing. I some time past told Patty that I would not give her money, that what they got of me must be through Raphaelle this I did in order to oblige her to be more attentive to his comforts. and finding some time of late that he was getting into his old habits, I told him that he displeased me, nay deceived me by saying that he drank nothing but water, at the same time I was supply[g] the family, but also giving him the means to indulge his vile habit. and I have determined that he shall work for what I must give him— and if he will not do it I cannot be longer a sufferer, except in my sorrow for an unfortunate Son. Patty's violent temper I conceive is a principle cause of his bad habits. I have said enough on a disagreeable subject.

48. *Charles Willson Peale to Rubens Peale,* Philadelphia, 23 November 1823

Raphaelle has his baggage on board a Schooner bound to Charleston and will Sail tomorrow or next day, he has one or two pictures engaged there. this will serve as a beginning, . . . He says that He now expects to make money, having rid himself of a load, [and] intends to be very industrious & prudint. and he will remit to me occasionally money to pay what Debts he owes.

Patty takes boarders and she has 7 at present, but at a low price 2½ & 3$ per week Those finding their bedding the lesser price making the present amount 19$ per week.

and possibly she may make out to live, yet her Sons Charles & Edmond I much suspect will be a burden on her— I told Raphaelle not to give me any trouble with her—as it is my absolute determination to do nothing for her. You know my sentiments of her disposition and believe think [*sic*] with me that Raphaelle would have been a better man if she had conducted herself with kindness towards him. His natural disposition is affectionate and she had power to win him to noble actions had she willed it.

49. *Charles Willson Peale to Rubens Peale,* Philadelphia, 30 November 1823

Raphaelle is about this time near the coast of South Carolina. I go, he said to me unencumbered, tho' poor yet with good prospects before me I will be industorus, and prudent and I hope to make money by this undertaking. I gave him my best advice

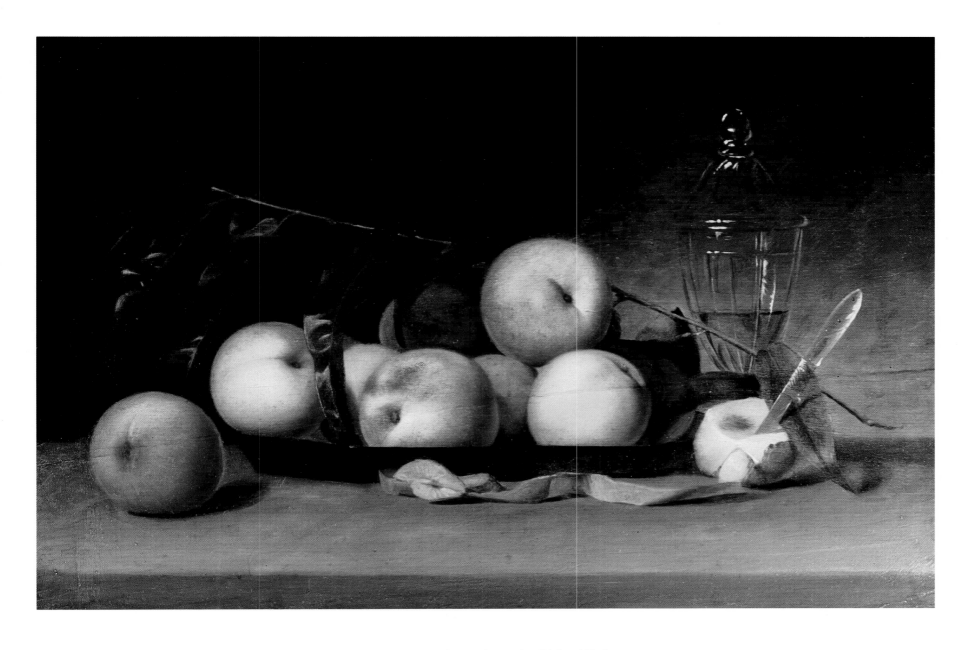

75. Raphaelle Peale, *Peaches*, c. 1817. Richard York
Gallery, New York

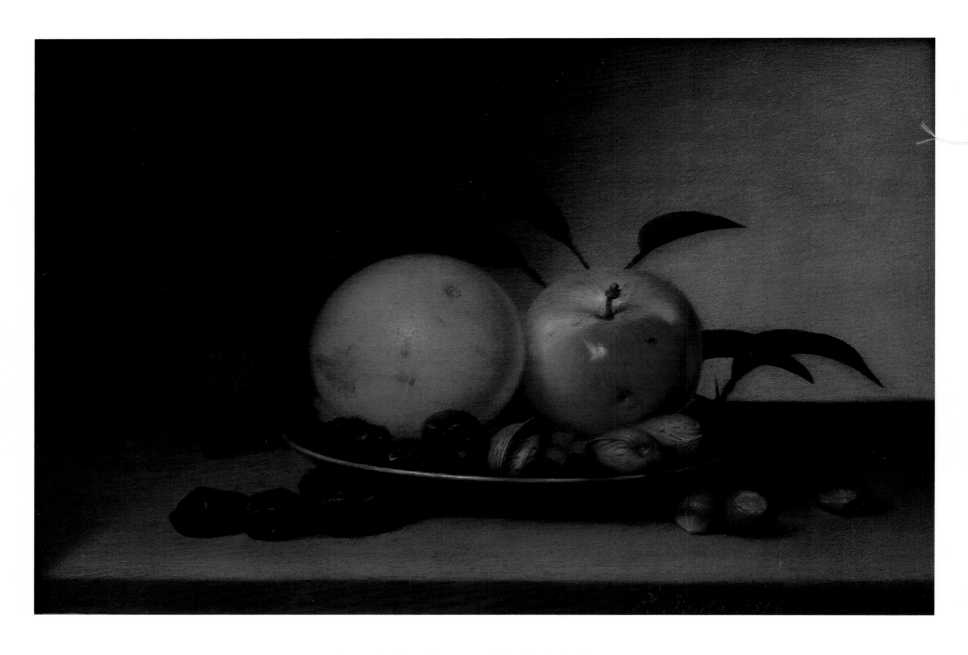

76. Raphaelle Peale, *Fruits and Nuts in a Dish*, 1818.
Courtesy Mr. and Mrs. Robert C. Graham, Sr.

saying you may yet by temperance restore your powers of body & mind but otherwise you will soon die in misery.

50. *Charles Willson Peale to Raphaelle Peale,* Philadelphia, 21 February 1824

when you write to me say nothing about your drinking only water, as some that see your letters will not give credit to you. It is better to practice and not speak of it, as the result of good conduct will be more powerful than words to do you justice. It will make me happy to hear of your success in business and that you are comfortable . . . without a family to maintain by a little industry.

51. *Charles Willson Peale, Autobiography*

. . . he has to record the death of his eldest son Raphaelle, the talents of whom has been mentioned in a former part of this history, and he will only say that he possessed a heart of universal benevolence, and just before his departure when his father was setting before him meditating on the uncertainty of human life; on the causes of many miseries which men go through in their journeying here, Raphaelle's daughter setting near him, knowing his father's want of hearing, he desired Eliza to tell his father *that he loved and respected him, and that he was desireous that he should know that he was perfectly resigned to his fate, that he was happy, and should die contented,* for he said, *that he never did injury to any man, and he was easy in his present condition.* This character of himself is undoubtedly a correct one, as far as the au-

thor knows and believes of this son. and he has the consolation of believing that he did as much as he was able to promote that sons happiness throughout the short space of his days years [*sic*].

52. William Dunlap, *History of the Rise and Progress of the Arts of Design in the United States* 2 (New York, 1834)

Mr. R[embrandt]. P[eale]. says, "all these children but two [of Charles Willson Peale] were named after painters, although only two of the number adopted the profession. Raphael was a painter of portraits in oil and miniature, but excelled more in compositions of still life. He may perhaps be considered the first in point of time who adopted this branch of painting in America, and many of his pictures are in the collections of men of taste and highly esteemed." He died early in life, perhaps at the age of forty, after severe affliction from gout.

53. *Reminiscences, George Escol Sellers* to Coleman Sellers,* Crestview, 21 January 1897

. . . Uncle Raphael . . . was in reality the most talented of Grandpa's sons and it was the Revolution that made him the wreck he was.

* George Escol Sellers (1808–1899) was the son of Charles Willson Peale's daughter Sophonisba Angusciola Sellers. These "Reminiscences" were written when he was eighty-nine, of events that occurred more than seventy years earlier.

54. *Reminiscences, George Escol Sellers to Horace Wells Sellers,* Crestview, 2 February 1897

I have alluded to the distortion of Uncle Raphael's hands with chalk knuckles which his Father always attributed to gout from early high living and intemperance. . . . how much more likely was Uncle Raphael's case one of mercury and all his gouty suffering also from the same cause. He was a very accomplished Taxidermist and . . . did all of the larger animal preparation for the Museum. Arsenic was all that was used for birds and small animals, but by its use the skins and the hair of larger animals were not protected from the ravages of moths and other insects and Bichloride of Mercury, Corrosive Sublimate, was resorted to. The skins were soaked in a liquid solution (Alkali) and this was freely handled by Uncle Raphael for days together. . . .

The reference Grandfather makes to the death of his son Raphael [in his "Autobiography"?] recalls one of the saddest recollections of my early life.* It was on a morning of a cold raw March day that Uncle Raphael came into the Market St. store, and shivering took a seat on the bench behind the old six plate wood stove. They were in very straitened circumstances, but I will here remark that it was Grandfather's rule to keep posted as to circumstances through Eliza Peale and through her to keep them from absolute want, but never through Aunt Patty. Raphael called me to him and showed me several closely written cap pages and said that a confectioner and candy maker on Market St. below 4th St. paid him a certain price for couplets, for what at that time were called secrets, but that he preferred comic to lovesick. He amused me by reading many of them. He said it seemed hard that art was at so low an ebb that an artist was obliged to write doggeral for his bread and butter. He left to deliver his work and get his pay.

Late in the afternoon of the same day the police officer of the Markets came and told us that Mr. Raphael Peale was in the 3rd St. market house, dead drunk. . . . He was sitting on a stall, supported by the men with whom the officer had left him in charge. He was insensible and it was some time before Father and Copper [a friend of Raphaelle's] succeeded in arousing him and then it did not seem like a man recovering from a drunken sleep. . . . He said that while at the confectioner's he was suddenly attacked with the gout in his stomach which doubled him up and that the confectioner had given him a drink of hot toddy which gave some relief, and when he thought he could walk home he started for a grocery store for some provisions he wanted to take, but how he got into the market house he did not know. Father and Copper had great difficulty in getting him home in consequence of the attacks of pain. I do not remember how long he lived but his suffering was very great. At the time grandfather refers to he was entirely free from pain for mortification had set in, and his death was what might be called a living death, for gangrene was doing its work while he was still conscious. . . .

* George Escoll Sellers was seventeen years old when Raphaelle Peale died in 1825.

Notes

1. *The Collected Papers of Charles Willson Peale and His Family*, ed. Lillian B. Miller (Millwood, N.Y., 1980, microfiche edition), series II-C.

2. *The Selected Papers of Charles Willson Peale and His Family*, vol. 2, *Charles Willson Peale: The Artist as Museum Keeper, 1791–1810*, ed. Lillian B. Miller (New Haven, 1988), pt. 1, p. 604.

3. *Selected Papers* 2, pt. 2, pp. 960–962.

4. *Selected Papers* 2, pt. 2., p. 967.

5. *Selected Papers* 2, pt. 2, pp. 1,008–1,009.

6. *Selected Papers* 2, pt. 2, p. 1,021.

7. *Selected Papers* 2. pt. 2, pp. 1,096–1,097.

8. *Selected Papers* 2, pt. 2, p. 1,140.

9. *Selected Papers* 2, pt. 2, p. 1,231.

10. *Collected Papers*, series II-A/48.

11. *Collected Papers*, series II-A/49.

12. See document heading.

13. *Collected Papers*, series II-A/51.

14. *Collected Papers*, series II-A/52.

15. *Collected Papers*, series II-A/52.

16. See document heading.

17. *Collected Papers*, series II-A/2.

18. *Collected Papers*, series II-A/53.

19. See document heading.

20. *Collected Papers*, series II-A/56.

21. *Collected Papers*, series II-A/56.

22. *Collected Papers*, series VIIA/3.

23. *Collected Papers*, series XD/1.

24. *Collected Papers*, series V/1.

25. *Collected Papers*, series II-A/59.

26. *Collected Papers*, series II-A/59.

27. *Collected Papers*, series II-A/60.

28. *Collected Papers*, series II-A/60.

29. *Collected Papers*, series II-A/60.

30. *Collected Papers*, series II-A/60.

32. *Collected Papers*, series II-A/61.

33. *Collected Papers*, series II-A/61.

34. *Collected Papers*, series II-A/61.

35. *Collected Papers*, series II-A/62.

36. *Collected Papers*, series III/4.

37. *Collected Papers*, series II-A/62.

38. *Collected Papers*, series III/4.

39. *Collected Papers*, series II-A/63.

40. *Collected Papers*, series II-A/64.

41. *Collected Papers*, series II-A/66.

42. *Collected Papers*, series VIIA/4.

43. *Collected Papers*, series II-A/67.

44. *Collected Papers*, series II-A/68.

45. *Collected Papers*, series II-A/68.

46. *Collected Papers*, series II-A/68.

47. *Collected Papers*, series II-A/69.

48. *Collected Papers*, series II-A/69.

49. *Collected Papers*, series II-A/69.

50. *Collected Papers*, series II-A/70.

51. *Collected Papers*, series II-C.

52. See document heading.

53. Unpublished, American Philosophical Society Library, Philadelphia.

54. Unpublished, American Philosophical Society Library, Philadelphia.

77. Detail of fig. 40

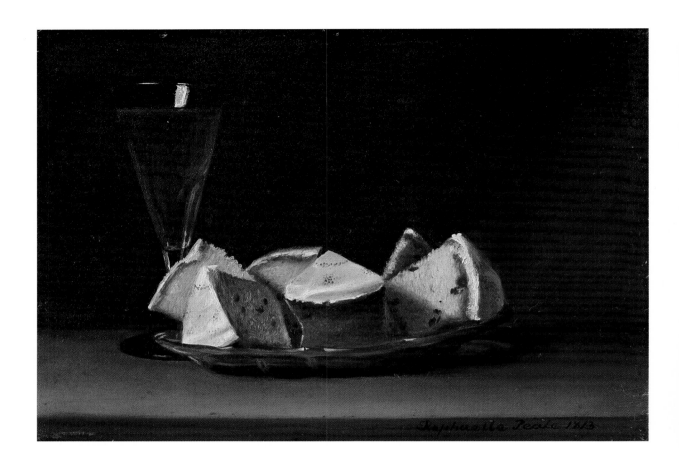

78. Raphaelle Peale, *Cake and Wine*, 1813. Private
collection

A Checklist of Contemporary Exhibitions

The still lifes Raphaelle Peale exhibited during his lifetime as listed in catalogues of the Columbianum exhibition in 1795 and exhibitions of the Pennsylvania Academy of the Fine Arts from 1812 through 1824 (the year before his death) indicate, more than do his surviving paintings alone, something like the true range of his enterprise as a still-life painter. We learn, for example, that he painted more deceptions than the single painting that has come down to us, and that he painted such things as eggs, jelly, bread and butter, apricots, persimmons, and radishes, none of which occur in the still lifes we now know. Not only does this suggest a considerably richer and more varied subject matter than the known works indicate, it also shows that the number of still lifes Peale exhibited greatly exceeds the most generous count of surviving ones. From the exhibition record at the Pennsylvania Academy particularly, it is possible to monitor the intensity of Raphaelle Peale's activity as a still-life painter by the number of still lifes he exhibited, by the proportion of still lifes to portraits, and by the way he listed his professional specialties (miniature painter in 1811, portrait, miniature, and still-life painter in 1814, still life, fruit, portrait in 1818).

Raphaelle Peale clearly exhibited the same pictures in several exhibitions, and when titles are general, such as *Still Life—Peaches,* it is impossible to tell which are new paintings and which old. It is difficult to know, too, if works with general titles correspond to known paintings. Whenever there appears to be a plausible correspondence of subject and date to paintings in the present exhibition, appropriate reference is made. Peale's professional specialties, when given in the catalogues, appear in parentheses following the date of the exhibition. When he showed paintings other than still lifes, their number and kind are given in brackets following the list of still lifes.

THE EXHIBITION OF THE COLUMBIANUM

1795 (PORTRAIT PAINTER AT THE MUSEUM)
 A Shad
 Herrings
 Small Fish
 A Covered Painting
 Still Life
 Still Life
 A Bill
 A Deception
 [5 portraits]

PENNSYLVANIA ACADEMY
OF THE FINE ARTS

1811 (MINIATURE PAINTER)
[2 miniatures]

1812 (MINIATURE PAINTER)
Bread, Cheese, &c.
Fruit, &c.
Eggs, &c.
Catalogue for the Use of the Room.
 A Deception
[1 miniature, 2 portraits]

See fig. 12

1813 (PORTRAIT AND MINIATURE PAINTER)
Fruit Piece. FOR SALE
Fruit
Fruit. FOR SALE
Still Life
Fruit
Vegetables
Mackerel
Fruit Piece. FOR SALE
Still Life
Still Life
Bread and Butter
Still Life
Water Melon [fig. 74 ?]
[2 miniatures, 2 portraits]

1814 (PORTRAIT, MINIATURE, AND STILL-LIFE
PAINTER)
Peaches and Grapes
Lemons
Peaches
Blackberries [fig. 44?]
Cheese and Crackers [fig. 12?]
Jelly
Apple
Apricots
Jelly
Pound cake
Cherries
Lemons
Peaches
Corn and Cantaloupe
Persimmons
Smoked Shad, Cabbage, &c.
Oranges
Water Melon
[2 portraits]

1815 *Water Melon*
Still Life
Herring [fig. 29?]
Orange and Book [fig. 3?]

See fig. 74

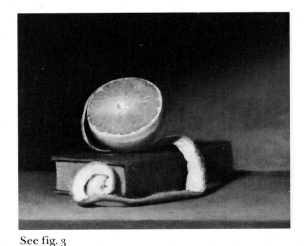

See fig. 3

79. Detail of fig. 44 (*opposite page*)

121

1816 *Fruit, Still Life, Peaches and Fox Grapes*
 [fig. 9]
 Fruit, Still Life, Apples and Fox Grapes
 [fig. 17]
 Fruit, Still Life, Peaches and Grapes
 Fruit, Still Life, Peaches

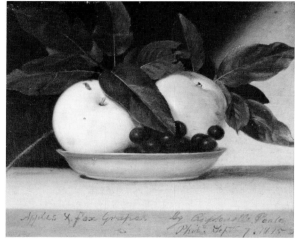

See fig. 17

1817 (PORTRAIT AND MINIATURE PAINTER)
 Still Life—Cheese and Crackers. FOR SALE
 Still Life—Cakes and Jelly. FOR SALE
 Still Life—Book and Orange. FOR SALE
 Still Life—Peaches
 Still Life—Radishes. FOR SALE
 Still Life—Apples
 Still Life—Apples and Melon
 Still Life—Peaches
 Still Life—Water Melon. FOR SALE
 Still Life—Strawberries and Cream.
 FOR SALE
 Still Life—Bread and Butter. FOR SALE
 Still Life—Beef and Cabbage. FOR SALE
 [fig. 72?]
 Still Life—Peach. FOR SALE
 [fig. 70 or 43?]

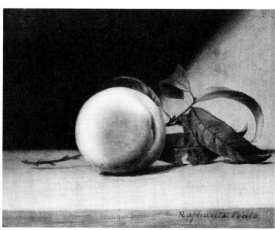

See fig. 43

Still-Life—Cherries. FOR SALE
Still-Life—Peach. FOR SALE [fig. 70 or 43?]
Still Life—Wine and Cake
Still Life—Blackberries
Still Life—Wine and Cake
Still Life—Peaches. FOR SALE
Still Life—Peaches. FOR SALE
Still Life—A Catalogue and Papers Filed

1818 (STILL LIFE, FRUIT, PORTRAIT, &C.)
 [May]
 Still Life—Apples
 Still Life—Peaches
 [July]
 Still Life—Peaches and Grapes (1811)
 Still Life—Apples and Grapes (1811)
 Still Life—A Catalogue and Papers Filed
 (1813)

1819 (PORTRAIT AND STILL-LIFE PAINTER)
 Still Life—Wine, Cakes, &c. [fig. 66?]
 Still Life—Wine, Cakes, Grapes, &c.
 [fig. 50?]
 Still Life—Orange, Apple, Prunes, &c.
 Still Life—Apples, &c.
 Still Life—Peaches
 Still Life—File of Papers, &c.

 [2 portraits]

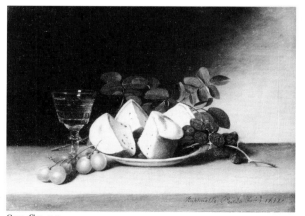

See fig. 50

1820 (STILL LIFE, FRUIT, PORTRAIT, &C.)
Still Life—Apples and Fox Grapes
Still Life—Peaches and Fox Grapes
Still Life—File of Papers, &c.

1821 (STILL-LIFE AND PORTRAIT PAINTER)
Still Life—Peaches and Grapes
Apples, Grapes, &c.

1822 (PORTRAIT, MINIATURE, AND STILL-LIFE
PAINTER)
Still Life—Apple, Cake, and Raisins.
 FOR SALE *[fig. 5?]*
Still Life—Fruit
Still Life—Fruit
Venus Rising from the Sea—A Deception
 (1822). FOR SALE *[fig. 37?]*
Still Life—Apples, Wine, Cake, &c.
 FOR SALE
Still Life—Peaches and Grapes. FOR SALE
Still Life—Water Melon and Grapes.
 FOR SALE *[fig. 51?]*
Still Life—Peaches and Grapes. FOR SALE
Cakes, Wine, &c.
Still Life—Oranges, &c., and a Miniature
 Portrait of a Lady
Yellow Peaches and Grapes
Still Life—Heath Peaches and Grapes
[2 portraits]

1823 (PORTRAIT AND STILL-LIFE PAINTER)
Still Life—Lemons, Flowers, &c.
Still Life—Peaches
Still Life—Fruit
Still Life—Fruit

1824 (STILL-LIFE, PORTRAIT, AND MINIATURE
PAINTER)
Still Life—Water Melon, Grapes, Peaches,
 &c.
Still Life—Strawberries, Nuts, &c.
 [fig. 41?]
Still Life—Peaches and Grapes
Still Life—Peaches
Still Life—Cakes, Wine, Apples, &c.
Still Life—Lemons, &c.
Peaches and Grapes
Apples and Grapes

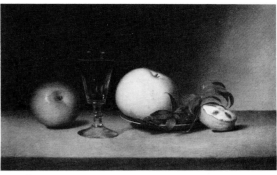

See fig. 5

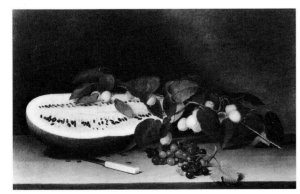

See fig. 51

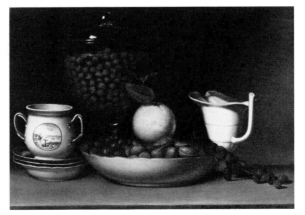

See fig. 41

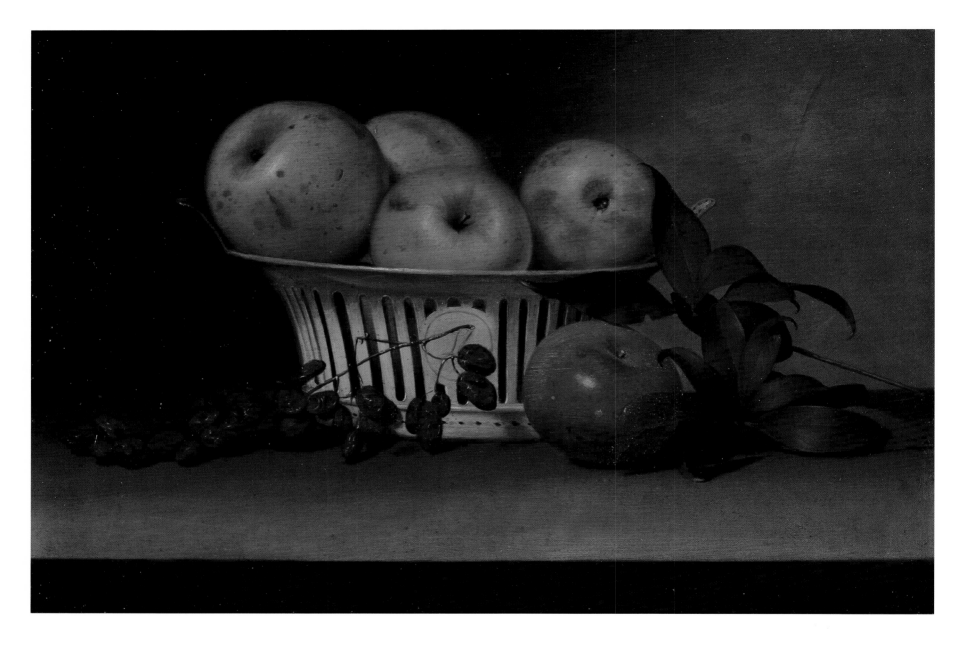

80. Raphaelle Peale, *Still Life with Raisins, Yellow and Red Apples in Porcelain Basket*, c. 1820–1822. The Baltimore Museum of Art, Gift of Mrs. Francis White, from the Collection of Mrs. Miles White, Jr.

Lenders to the Exhibition

The Baltimore Museum of Art

Berry-Hill Galleries, Inc., New York

The Brooklyn Museum

Detroit Institute of Art

JoAnn and Julian Ganz, Jr.

Mr. and Mrs. Robert C. Graham, Sr.

The Henry E. Huntington Library and
Art Gallery

The Historical Society of Pennsylvania

Jeanne Rowe Mathison Trust

Eleanor Searle Whitney McCollum

The Metropolitan Museum of Art

Munson-Williams-Proctor Institute
Museum of Art

Museum of Fine Arts, Springfield,
Massachusetts

National Museum of American Art,
Smithsonian Institution

The Nelson-Atkins Museum of Art,
Kansas City, Missouri

The New-York Historical Society

Pennsylvania Academy of the Fine Arts,
Philadelphia

Philadelphia Museum of Art

Private collectors

Reading Public Museum and Art Gallery

San Diego Museum of Art

Mrs. Frank S. Schwarz

Kathryn and Robert Steinberg

The Toledo Museum of Art

Eric M. Wunsch

Richard York Gallery, New York

List of Illustrations

Asterisks denote works in the exhibition.
Dimensions are given height before width.

*1. Raphaelle Peale, *Still Life with
 Oranges*, c. 1818
 oil on panel, 18⅝ x 22¹⁵/₁₆ in.
 The Toledo Museum of Art, Gift of
 Florence Scott Libbey
 signed across bottom: *Painted for the
 Collection of John A Alston Esqʳ. / The
 Patron of living American Artists
 Raphaelle Peale Philᵃ.*

*2. Raphaelle Peale, *A Dessert* [*Still Life
 with Lemons and Oranges*], 1814
 oil on panel, 13⅜ x 19 in.
 Collection of JoAnn and Julian
 Ganz, Jr.
 signed lower right: *Raphaelle Peale
 Augᵗ. 5ᵗʰ 1814 / Philadelphia*

*3. Raphaelle Peale, *Still Life with Orange
 and Book*, c. 1815
 oil on panel, 8¾ x 11 in.
 private collection

4. Detail of fig. 19

5. Raphaelle Peale, *Still Life with Apples,
 Sherry, and Tea Cake*, 1822
 oil on panel, 10½ x 16⅜ in.
 Collection of Mr. and Mrs. Paul
 Mellon, Upperville, Virginia
 signed lower right: *Raphaelle Peale
 Janʸ. 1822*

6. John Lewis Krimmel, *Fourth of July in
 Centre Square*, 1812
 oil on canvas, 22¾ x 29 in.
 Courtesy of the Pennsylvania Academy
 of the Fine Arts, Philadelphia, Acad-
 emy Purchase Fund

7. William Birch, *An Unfinished House, in
 Chestnut Street Philadelphia*, 1800
 etching and engraving, 10 x 8⅞ in.
 Courtesy of the Pennsylvania Acad-
 emy of the Fine Arts, Philadelphia,
 John S. Phillips Collection

*8. Raphaelle Peale, *Peaches and Unripe
 Grapes*, 1815
 oil on panel, 14½ x 17½ in.
 Kathryn and Robert Steinberg
 signed at bottom: *Peaches & unripe
 Grapes by Raphaelle Peale Septʳ. 1815*

*9. Raphaelle Peale, *Fox Grapes and Peaches*, 1815
oil on panel, 9¾ x 11½ in.
Courtesy of the Pennsylvania Academy of the Fine Arts, Philadelphia
signed at bottom: *Fox Grapes & Peaches by Raphaelle Peale / August 1815*

*10. James Peale, *Still Life No. 2*, 1821
oil on panel, 18¹/₁₆ x 26⁷/₁₆ in.
Courtesy of the Pennsylvania Academy of the Fine Arts, Philadelphia,
Henry D. Gilpin Fund

11. Detail of fig. 69

*12. Raphaelle Peale, *Cheese and Three Crackers*, 1813
oil on panel, 7 x 10½ in.
Mrs. Frank S. Schwarz
signed lower right: *Raphaelle Peale 1813*

*13. Raphaelle Peale, *Still Life with Watermelon*, 1822
oil on canvas, 24½ x 29½ in.
Museum of Fine Arts, Springfield, Massachusetts, The James Philip Gray Collection
signed lower right: *Raphaelle Peale 1822*

*14. Raphaelle Peale, *Fruit and Silver Bowl*, 1814
oil on panel, 12 x 19 in.
private collection
signed lower right: *Raphaelle Peale Octʳ. 8 1814*

15. Benjamin Tanner after J. J. Barralet, *Pennsylvania Academy of the Fine Arts* [first building], 1809
engraving and etching, 5 x 6¹¹/₁₆ in.
Courtesy of the Pennsylvania Academy of the Fine Arts, Philadelphia, John S. Phillips Collection

*16. Raphaelle Peale, *Still Life with Celery and Wine*, 1816
oil on panel, 12³/₈ x 17¹/₈ in.
Munson-Williams-Proctor Institute Museum of Art
signed lower right: *Raphaelle Peale 1816*

*17. Raphaelle Peale, *Apples and Fox Grapes*, 1815
oil on panel, 9¾ x 11⁷/₁₆ in.
Courtesy of the Pennsylvania Academy of the Fine Arts, Philadelphia
signed at bottom: *Apples & Fox Grapes by Raphaelle Peale / Philᵃ. Sept 7 1815*

18. Detail of fig. 22

*19. Raphaelle Peale, *Still Life with Wine Glass*, 1818
oil on panel, 10¹/₄ x 13⁵/₈ in.
Detroit Institute of Arts, Founders Society Purchase, Laura H. Murphy Fund
signed lower right: *Raphaelle Peale Pinxᵗ A.D. 1818*

20. Charles Willson Peale, *The Artist in His Museum*, 1822
oil on canvas, 103³/₄ x 79⁷/₈ in.
Courtesy of the Pennsylvania Academy of the Fine Arts, Philadelphia, Gift of Mrs. Sarah Harrison (The Joseph Harrison, Jr., Collection)

*21. James Peale, *Fruit in a Basket,* 1820–1825
oil on canvas, 16³⁄₁₆ x 22 in.
Eric M. Wunsch

*22. Charles Willson Peale, *The Peale Family,*
c. 1771–1773 and 1808
oil on canvas, 56³⁄₄ x 89¹⁄₂ in.
The New-York Historical Society,
New York, Bryan Collection

*23. Charles Willson Peale, *Portrait of
Raphaelle Peale,* c. 1817
oil on canvas, 29 x 24 in.
private collection

24. Charles Willson Peale, *William Smith
and His Grandson,* 1788
oil on canvas, 51¹⁄₄ x 40³⁄₈ in.
The Virginia Museum of Fine Arts,
The Robert G. Cabell III and Maude
Morgan Cabell Foundation and the
Glasgow Fund

*25. Charles Willson Peale, *The Staircase
Group,* 1795
oil on canvas, 89⁵⁄₈ x 39¹⁄₂ in.
Philadelphia Museum of Art,
The George W. Elkins Collection
[shown only in Philadelphia]

26. Sir Joshua Reynolds, *Self Portrait,*
c. 1780
oil on panel, 50 x 40 in.
The Royal Academy of Arts

27. John Trumbull, *Self Portrait,* 1777
oil on canvas, 29³⁄₄ x 23³⁄₄ in.
Museum of Fine Arts, Boston, Bequest
of George Nixon Black

28. Detail of fig. 37

*29. Raphaelle Peale, *Still Life with Dried
Fish [A Herring],* 1815
oil on panel, 9⁵⁄₈ x 14¹⁄₄ in.
The Historical Society of
Pennsylvania
signed lower right: *Raphaelle Peale
Febʸ. 22 1815 / Philadelphia*

30. William Michael Harnett, *The Banker's
Table,* 1877
oil on canvas, 8¹⁄₈ x 12¹⁄₈ in.
The Metropolitan Musum of Art,
Elihu Root, Jr., Gift, 1956

31. John F. Peto, *Cake, Lemon, Strawberries,
and Glass,* 1890
oil on canvas, 10¹⁄₈ x 14 in.
Collection of Mr. and Mrs. Paul
Mellon, Upperville, Virginia

32. Juan Sánchez Cotán, *Quince, Cabbage,
Melon, and Cucumber,* c. 1602
oil on canvas, 27¹⁄₈ x 33¹⁄₄ in.
San Diego Museum of Art, Purchased
for the Museum by the Misses Anne R.
and Amy Putnam, 1945

33. Follower of Caravaggio, *Still Life,*
1573–1610
oil on canvas, 19⁷⁄₈ x 28¹⁄₄ in.
National Gallery of Art, Washington,
Samuel H. Kress Collection

34. Rembrandt Peale, *George Washington,
Patriae Pater,* c. 1824
oil on canvas, 72¹⁄₂ x 54¹⁄₄ in.
Courtesy of the Pennsylvania Acad-
emy of the Fine Arts, Philadelphia,
Bequest of Mrs. Sarah Harrison (The
Joseph Harrison, Jr., Collection)

35. Margaretta Angelica Peale, *Catalogue of the Peale Museum*, 1813
James Ogelsby Peale Collection (from *American Art Journal* 18, no. 2 [1986]: 9)

36. Joseph Wright of Derby, *The Corinthian Maid*, 1783–1784
oil on canvas, 41⅞ x 51½ in.
National Gallery of Art, Washington, Paul Mellon Collection

*37. Raphaelle Peale, *Venus Rising from the Sea—A Deception [After the Bath]*, 1822?
oil on canvas, 29 x 24 in.
The Nelson-Atkins Museum of Art, Kansas City, Missouri (Nelson Fund)
signed lower right: *Raphaelle Peale 182[?] / Pinx^t.*

38. Willem Claesz. Heda, *Still Life*, 1656
oil on canvas, 44 x 60 in.
The Museum of Fine Arts, Houston, Gift of Mr. and Mrs. Raymond H. Goodrich

*39. Raphaelle Peale, *Still Life with Strawberries and Ostrich Egg Cup*, 1814
oil on panel, 12¼ x 19¼ in.
private collection
signed lower left: *Raphaelle Peale June 1814*

*40. Raphaelle Peale, *Lemons and Sugar*, c. 1822
oil on panel, 12¾ x 15⅞ in.
Courtesy of the Reading Public Museum and Art Gallery
inscribed (falsely) lower left: *R. Peale 1847*

41. Raphaelle Peale, *Still Life with Wild Strawberries*, 1822
oil on panel, 16⅜ x 22¾ in.
The Art Institute of Chicago, Lent by Jamee and Marshall Field
signed lower right: *Raphaelle Peale Pinx^t. 1822*

*42. Raphaelle Peale, *Still Life with Raisin Cake*, 1813
oil on panel, 7⅞ x 11⅛ in.
private collection
signed lower right: *Raphaelle Peale 1813*

*43. Raphaelle Peale, *Still Life with Peach*, c. 1816
oil on panel, 7⅜ x 9 in.
San Diego Museum of Art, Purchased through funds provided by the Earle W. Grant Acquisition Fund
signed lower right: *Raphaelle Peale*

*44. Raphaelle Peale, *Blackberries*, c. 1813
oil on panel, 7¼ x 10¼ in.
private collection

45. Raphaelle Peale, *Strawberries and Cream*, 1818
oil on panel, 13⅛ x 9½ in.
Collection of Mr. and Mrs. Paul Mellon, Upperville, Virginia
signed lower right: *Raphaelle Peale 1818*

*46. Raphaelle Peale, *Fruit Piece with Peaches Covered by a Handkerchief [Covered Peaches]*, c. 1819
oil on panel, 12½ x 18⅛ in.
private collection
signed lower right: *Raphaelle Peale Pinx.*

47. Samuel F. B. Morse, *The Old House of Representatives*, 1822
oil on canvas, 86½ x 130¾ in.
The Corcoran Gallery of Art, Museum Purchase, Gallery Fund, 1911

48. Samuel F. B. Morse, *Gallery of the Louvre*, 1831–1833
oil on canvas, 73¾ x 108 in.
Courtesy of the Daniel J. Terra Collection, Terra Museum of American Art, Chicago

49. John Vanderlyn, *The Palace and Garden of Versailles*, panorama, 1816–1819
oil on canvas, 12 x 165 ft. [length of both panels combined]
The Metropolitan Museum of Art, Gift of the Senate House Association, Kingston, New York, 1952

*50. Raphaelle Peale, *Still Life with Cake*, 1818
oil on panel, 10¾ x 15¼ in.
Lent by The Metropolitan Museum of Art, Maria DeWitt Jesup Fund, 1959
signed lower right: *Raphaelle Peale Feb 9 1818*

*51. Raphaelle Peale, *Still Life with Watermelon*, 1822
oil on canvas, 16¾ x 26½ in.
Berry-Hill Galleries, New York
signed lower right: *Raphaelle Peale Pinxᵗ. 1822 Philᵃ.*

52. Advertisement, *Poulson's American Daily Advertiser,* 10 October 1801

*53. Raphaelle Peale, *Still Life with Liqueur and Fruit,* c. 1814
oil on panel, 13¼ x 19½ in.
Eleanor Searle Whitney McCollum, Houston, Texas
signed lower right: *Raphaelle Peale Augᵗ. 18[?]*

54. Cover drawing by Sempé, © 1988, The New York Magazine, Inc.

55. Detail of fig. 44

*56. Rembrandt Peale, *Rubens Peale with a Geranium*, 1801
oil on canvas, 28 x 24 in.
National Gallery of Art, Patrons' Permanent Fund

57. Charles Willson Peale, *Benjamin and Eleanor Ridgely Laming*, 1788
oil on canvas, 42 x 60¼ in.
National Gallery of Art, Washington, Gift of Morris Schapiro

*58. James Peale, *Fruit Still Life with Chinese Export Basket*, 1824
oil on panel, 14⅞ x 17⅝ in.
Jeanne Rowe Mathison Family in Memory of Robert Vincent Mathison

59. Ralph Earl, *Daniel Boardman*, 1789
oil on canvas, 81⅝ x 55¼ in.
National Gallery of Art, Washington, Gift of Mrs. W. Murray Crane

60. Gilbert Stuart, *Mrs. Richard Yates*, 1793–1794
oil on canvas, 30¼ x 25 in.
National Gallery of Art, Washington, Andrew W. Mellon Collection

61. Detail of fig. 56

62. Detail of fig. 56

63. Detail of fig. 56

64. Thomas Eakins, *Baby at Play*, 1876
 oil on canvas, 32¼ x 48⅜ in.
 National Gallery of Art, Washington,
 John Hay Whitney Collection

65. Detail of fig. 56

*66. Raphaelle Peale, *Still Life: Wine, Cakes,
 and Nuts*, 1819
 oil on panel, 12¾ x 14¾ in.
 The Henry E. Huntington Library
 and Art Gallery
 signed lower right: *Raphael Peale Phil^a.
 1819*

67. Detail fig. 2

*68. Raphaelle Peale, *Still Life with Grapes
 and Dish*, 1814
 oil on panel, 8½ x 10½ in.
 private collection
 signed lower right: *Raphaelle Peale
 Octob^r. 1814 / Philad^a.*

*69. Raphaelle Peale, *Still Life with Cake*,
 1822
 oil on panel, 9½ x 11⅜ in.
 The Brooklyn Museum, Museum
 Collection Fund
 signed lower right: *Raphaelle Peale
 Jan^y. 1^st 1822*

*70. Raphaelle Peale, *Still Life with Peach*,
 c. 1816
 oil on panel, 7⅜ x 8⅜ in.
 San Diego Museum of Art, Purchased
 through funds provided by the Earle
 W. Grant Acquisition Fund
 signed lower right: *R. Peale*

71. Detail of fig. 23

*72. Raphaelle Peale, *Still Life with Steak*,
 c. 1817
 oil on panel, 13⅜ x 19½ in.
 Munson-Williams-Proctor Institute
 Museum of Art
 signed lower right: *Painted by Raphaelle
 Peale*

*73. James Peale, *Still Life with Fruit*,
 1824–1826?
 oil on canvas, 18⅛ x 26½ in.
 Munson-Williams-Proctor Institute
 Museum of Art, Museum Purchase in
 Memory of William C. Murray
 [shown only in Washington]

*74. Raphaelle Peale, *Melons and Morning
 Glories*, 1813
 oil on canvas, 20¾ x 25¾ in.
 National Museum of American Art,
 Smithsonian Institution, Gift of
 Paul Mellon
 signed lower right: *Raphaelle Peale
 Painted / Philadelphia Sep^t. 3^d. 1813*

*75. Raphaelle Peale, *Peaches*, c. 1817
 oil on panel, 13⅛ x 19¾ in.
 Richard York Gallery, New York

*76. Raphaelle Peale, *Fruits and Nuts in a Dish,* 1818
 oil on panel, 10 x 15¼ in.
 Courtesy Mr. and Mrs. Robert C.
 Graham, Sr.
 signed lower right: *R. Peale 1818*

 77. Detail of fig. 40

*78. Raphaelle Peale, *Cake and Wine,* 1813
 oil on panel, 7⅞ x 11⅛ in.
 private collection
 signed lower right: *Raphaelle Peale 1813*

 79. Detail of fig. 44

*80. Raphaelle Peale, *Still Life with Raisins, Yellow and Red Apples in Porcelain Basket,* c. 1820–1822
 oil on panel, 12¾ x 19 in.
 The Baltimore Museum of Art, Gift
 of Mrs. Francis White, from the
 Collection of Mrs. Miles White, Jr.
 signed lower right: *R. Peale*